SINATRA

SINA

A BOB ADELMAN BOOK

stewart tabori & chang
A Company of La Martinière Groupe

TRA

AN INTIMATE PORTRAIT OF A VERY GOOD YEAR
PHOTOGRAPHS BY JOHN DOMINIS

TEXT BY
RICHARD B. STOLLEY

DESIGNED BY
HOPKINS/BAUMANN

I dedicate this book to all of the
LIFE magazine editors, writers
and reporters who developed story
ideas, worked with me on
assignments, conducted interviews,
supplied captions, and in the bad
old days burned many fingers
changing flashbulbs for my
complicated lighting setups.

John Dominis

Photographs copyright © 2002 John Dominis
and Bob Adelman Books, Inc.

Text copyright © 2002 Richard B. Stolley and
Bob Adelman Books, Inc.

Jacket and interior design by Hopkins/Baumann

Published in 2002 by
Stewart, Tabori & Chang
A Company of La Martinière Groupe
115 West 18th Street
New York, NY 10011

Canadian Distribution:
Canadian Manda Group
One Atlantic Avenue, Suite 105
Toronto, Ontario M6K 3E7
Canada

Library of Congress Cataloging-in-Publication Data
Dominis, John.
 Sinatra: an intimate portrait of a very good year /
photographs by John Dominis; text by Richard B. Stolley.
 p. cm.
 ISBN 1-58479-246-9
 1. Sinatra, Frank, 1915—Pictorial works. I. Stolley,
Richard B. II. Title.
 ML420.S565 D64 2002
 782.42164'092—dc21
 [B] 2002026925

The text of this book was composed in Bauer Bodoni,
Poster Bodoni Compressed and Bodoni Book.

Printed in Italy
10 9 8 7 6 5 4 3 2 1
First printing

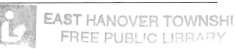

DAYS OF WINE AND ROSES

In late 1964 and early 1965, photographer John Dominis shadowed Frank Sinatra around America for the better part of four months. This was at the peak of the singer's career, when he released, among other classics, "It Was a Very Good Year." Sinatra was famous for avoiding — indeed, disliking — the press. But because he was turning 50 in December 1965, he agreed to a story in LIFE magazine. Dominis, a longtime staff photographer, got the assignment in part because of his low-key manner. Of the 4,000 pictures he shot of Sinatra at work and at play, only a handful were used in the cover story and since; the rest remained in the magazine's archives until now.

SINATRA THOUGHT HE WAS SAYING YES TO AN interview and a few pictures. Famous people did not realize how intense the coverage by a LIFE photographer could be. It wasn't just a portrait that took a few minutes.

Knowing his reputation, I couldn't just barge in. When it comes to doing real pictures of real people, they buck. They don't want a photographer hanging in their hair every minute of the day and night. That of course is what I wanted to do with Frank. But I wasn't going to bring that up yet. Everybody told me to be careful. I had to blend in with the wallpaper.

For the first few days after we were introduced, I didn't even carry a camera. I wanted to play it real cool. Then I started carrying one Leica on my shoulder and shooting some pictures of him performing. No flash. I was allowed backstage, but I didn't shoot anything candid or personal there. I think he liked that.

Every now and then, somebody would come up and say, "Hi, Frankie," and Sinatra would ask, "Hey, John, take a picture of my old pal Joe and me." I'd snap one frame, and later give the prints to Frank.

Then I started shooting some candid stuff while he was still in public places. But I kept hearing about these great parties, about Sinatra going to a pizza place and sailing pizzas across the room. Terrific pictures. He was a pretty wild guy, and childish, in a way.

On a flight to Las Vegas, I went over and said, "I'm doing fine, but I keep hearing about your parties late at night with your old buddies, and I'd like to start getting some of that."

So he invited me to a party. He had all these guys and girls up to his suite after his show. He was very sociable, and he liked all the adoration. He was considered a great host, watching out for everybody, making sure their drinks were poured. He and Joe E. Lewis got smashed, and they were singing and telling jokes in the closet. It was good stuff.

By the time we got to Miami, I was familiar enough with Frank that I was able to photograph him in the hotel steam room. I couldn't go inside because my lenses would have fogged up. But the steam room had a glass window, and Frank sat right next to it. I didn't ask him to, so maybe he did that for me.

He never told me not to take a picture. I just had to decide when to photograph and when not to. One time I didn't was in Florida. Some guys came in with a string bag full of jewels they emptied on the bed, pearls and diamonds, a big pile. Frank picked out two or three diamonds, a necklace and a brooch. The guys put the rest back in the bag and left. I didn't know if the jewels were hot, or if Frank was going to pay for them, or if it was just a friendly gesture. I decided not to ask and not to shoot.

I knew his reputation, but at rehearsals he never screamed at the musicians, and he was never nasty to me. I suppose if the paparazzi were following him around, there would have been big trouble. He just didn't like outsiders. He was a tough guy, but I really did not experience the negative stuff. Once I was in with Frank, he was very nice. He was serious and businesslike and very generous to all his friends and everybody else.

John Dominis, New York City, July 2002

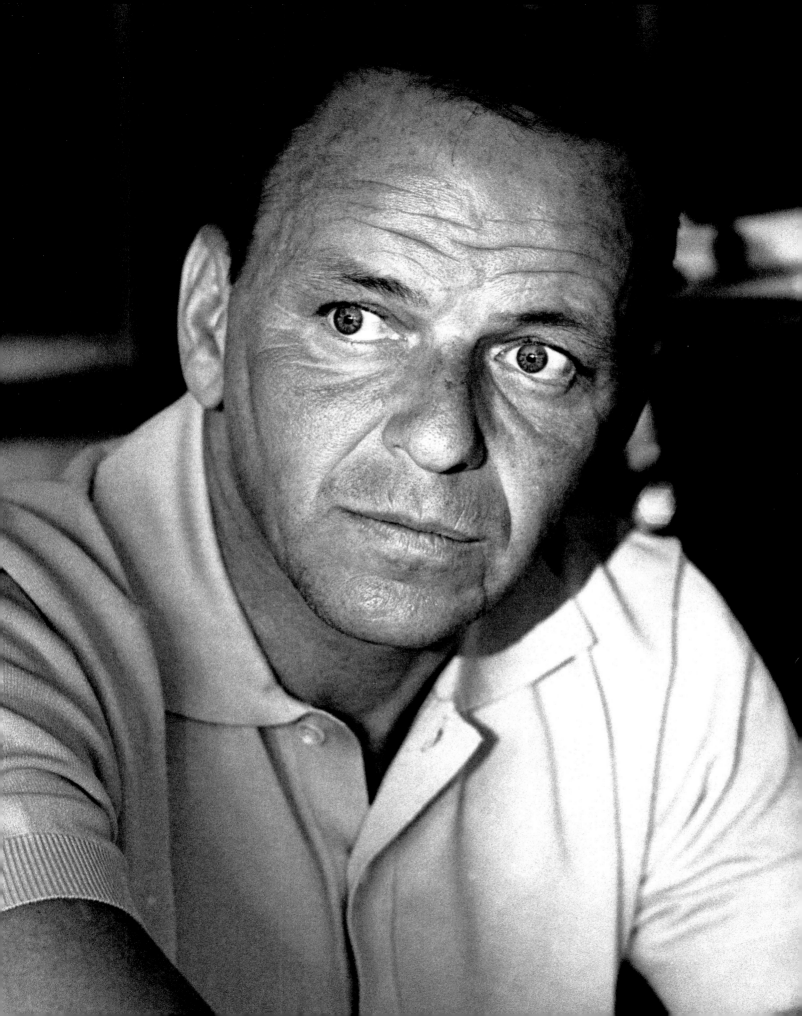

THE BEST IS YET TO COME

FRANCIS ALBERT SINATRA HAD BEGINNINGS that define humble in America. He was born at home in Hoboken, New Jersey. His mother, Dolly, was a chocolate dipper in a candy store. His father, Martin, was a fireman. Frank was a huge baby, 13½ pounds, and his cheek and neck were scarred by forceps (scars that he later refused to have fixed by plastic surgery). Frank tried singing in high school, and liked the applause, but never got his diploma. He joined a singing group, the Hoboken Four, that won a nationwide amateur contest. Then he went solo and hit the local nightclub circuit – and was still at it three decades later, but in considerably more elegant surroundings.

Sinatra confers with pianist Bill Miller, his musical partner on stage and off for more than 40 years. Of Sinatra's meticulous attention to his recordings, Miller said: "He would pick the tunes, and he would even position them on the album."

Trailing clouds of cigarette smoke, Frank rehearses at the Eden Roc Hotel in Miami. A heavy smoker, he once cracked, "Fresh air makes me throw up. I can't handle it."

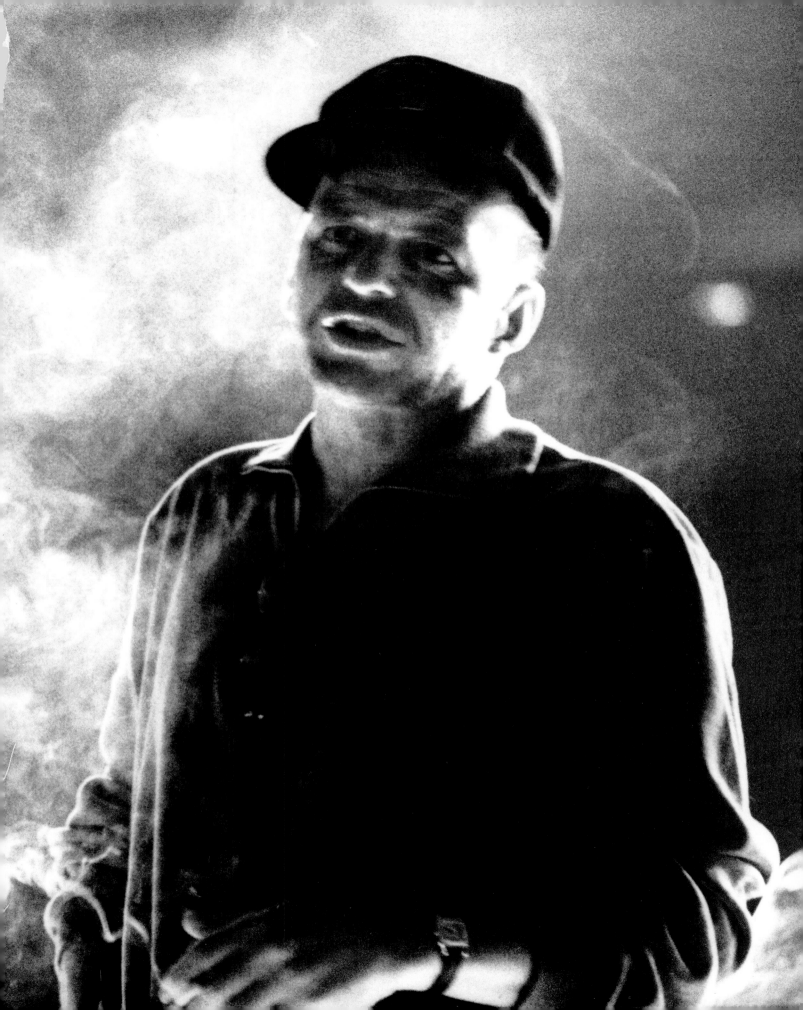

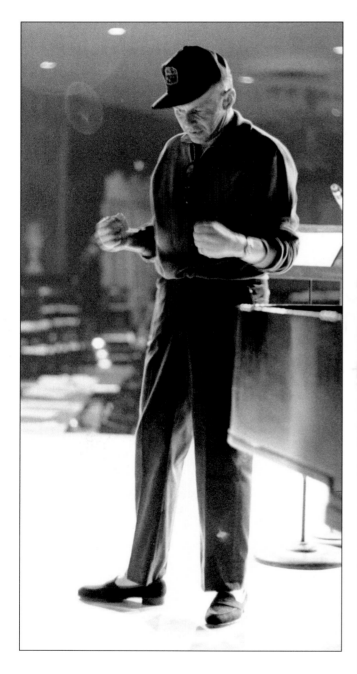
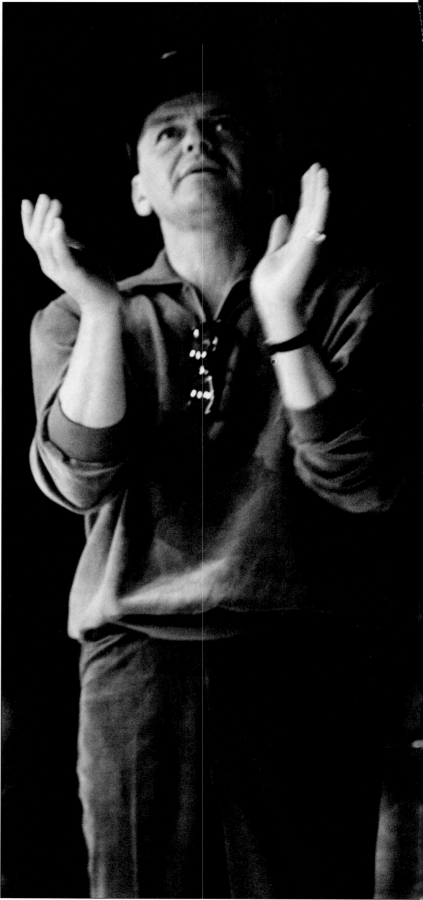

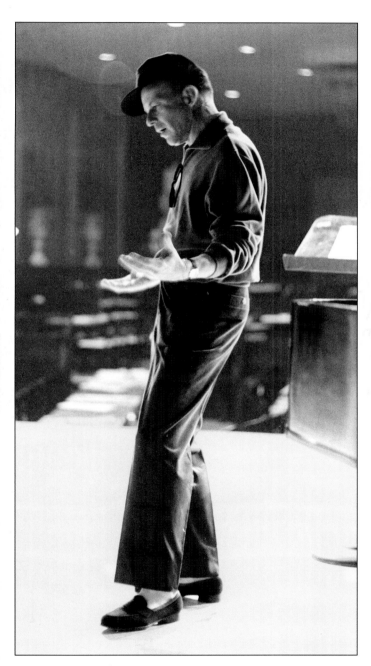

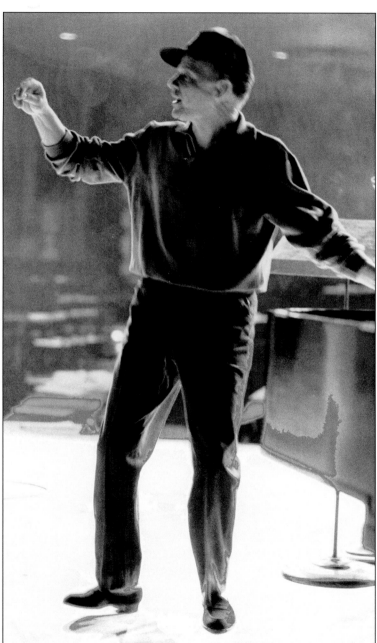

Sinatra was a kinetic singer, moving to the beat, clapping, trying out little dance steps. His performances always seemed natural, but they were the product of careful practice and obsession with details.

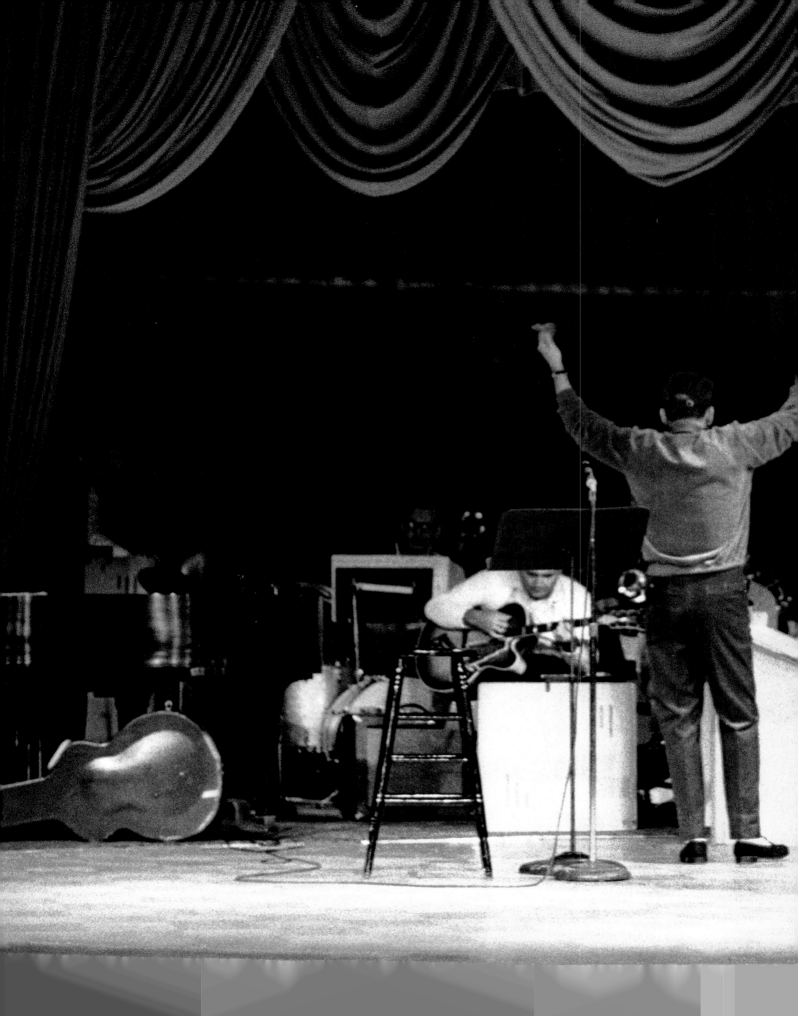

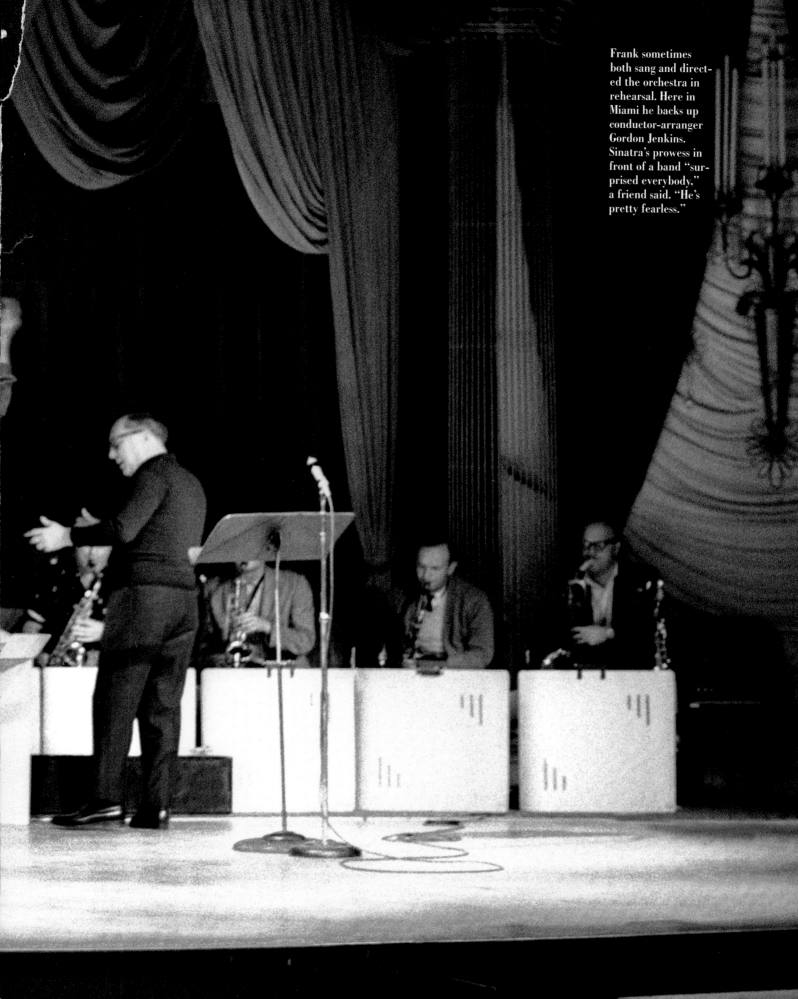

Frank sometimes both sang and directed the orchestra in rehearsal. Here in Miami he backs up conductor-arranger Gordon Jenkins. Sinatra's prowess in front of a band "surprised everybody," a friend said. "He's pretty fearless."

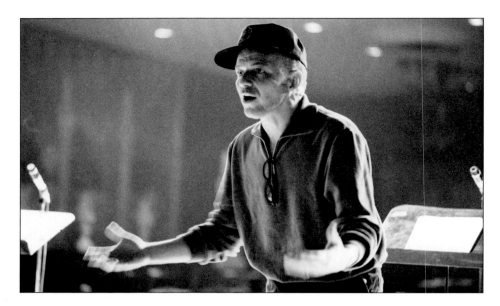

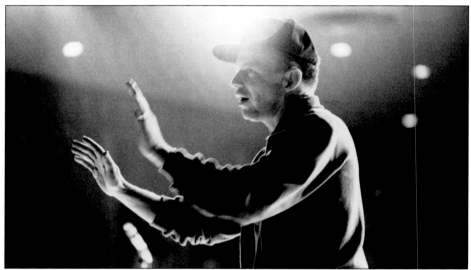

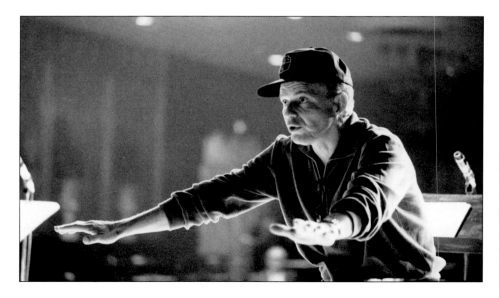

Perfectionist Sinatra exhorts the band with a demand for "pianissimo," then snaps at a musician who made a mistake, "I could have sworn you were here yesterday when we rehearsed."

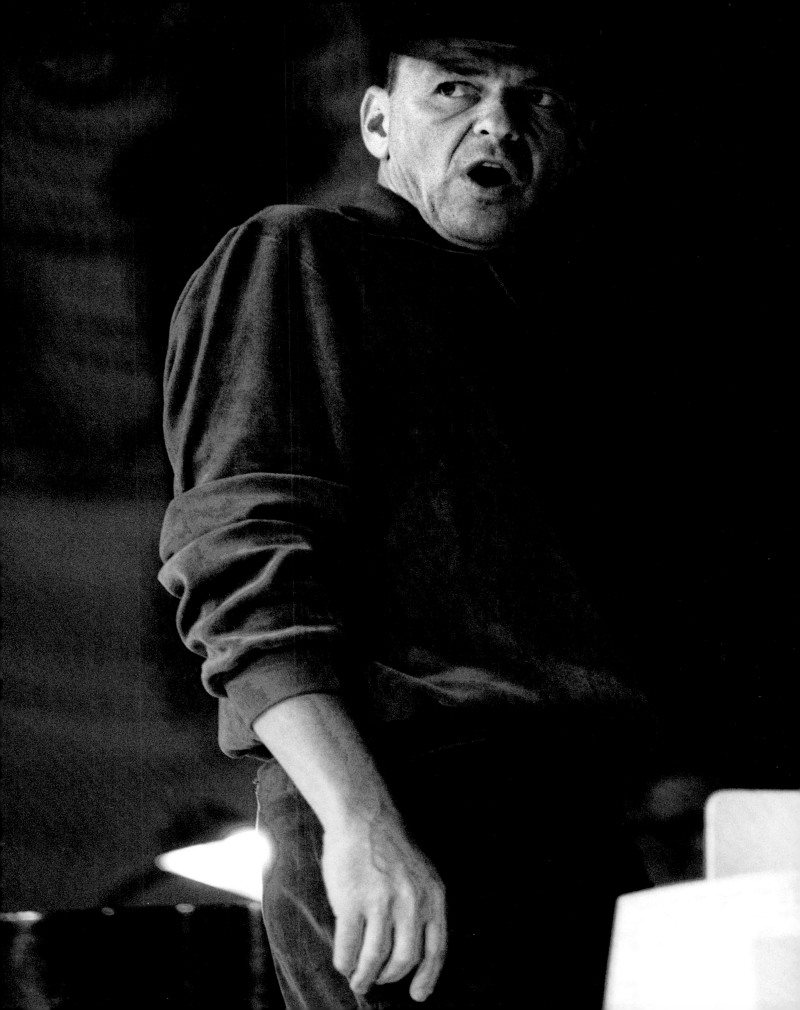

Sinatra and comedian Joe E. Lewis, an old drinking buddy, sometimes performed together. At the Eden Roc, they also share a suite. In 1957, the singer portrayed Lewis in a movie about his life, THE JOKER IS WILD.

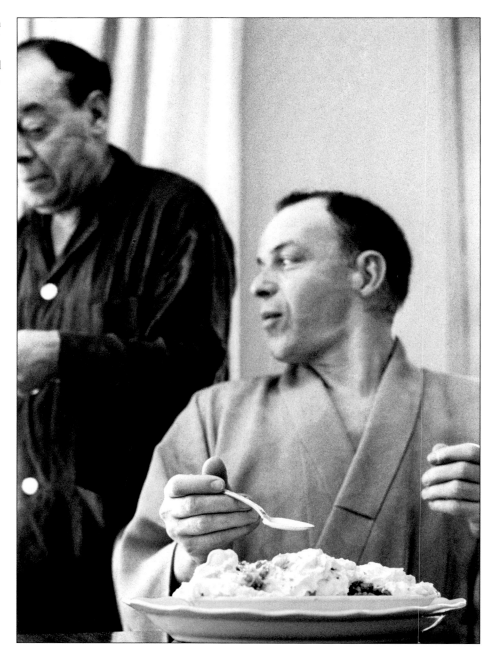

The reference to RFK in the headline on Sinatra's newspaper is ironic. Frank helped John Kennedy get elected in 1960. Then brother Bobby (RFK) warned the president to stay clear of Sinatra because of the singer's Mafia pals. Frank neither forgave the Kennedys nor forgot.

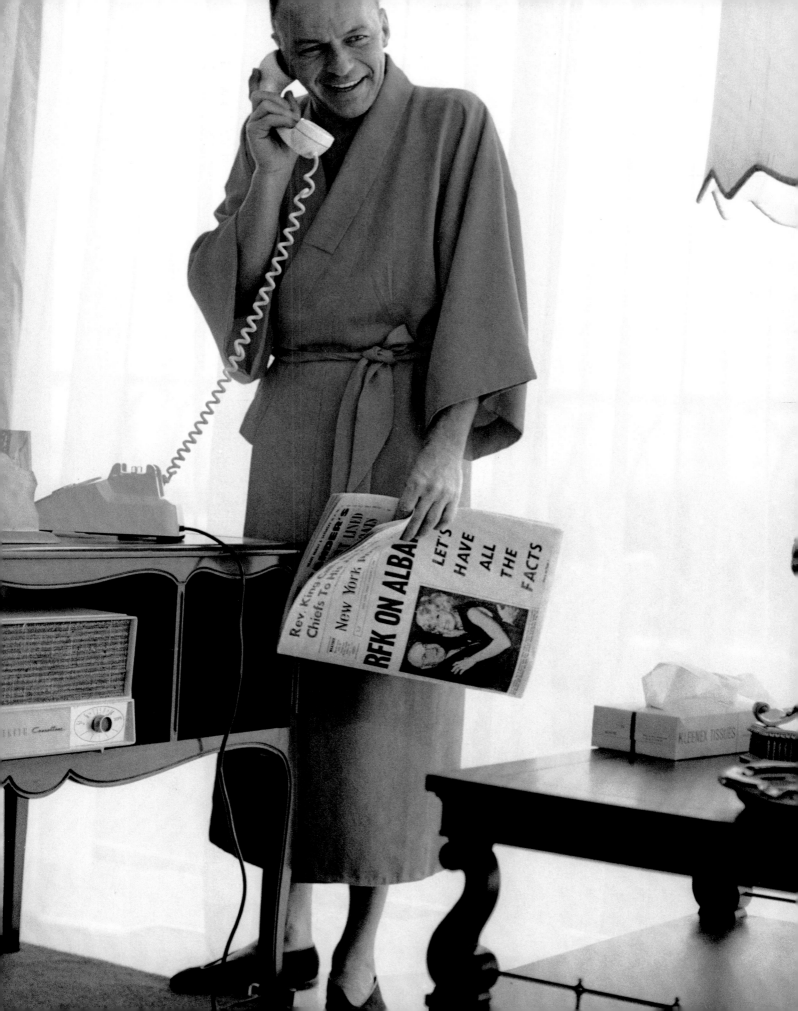

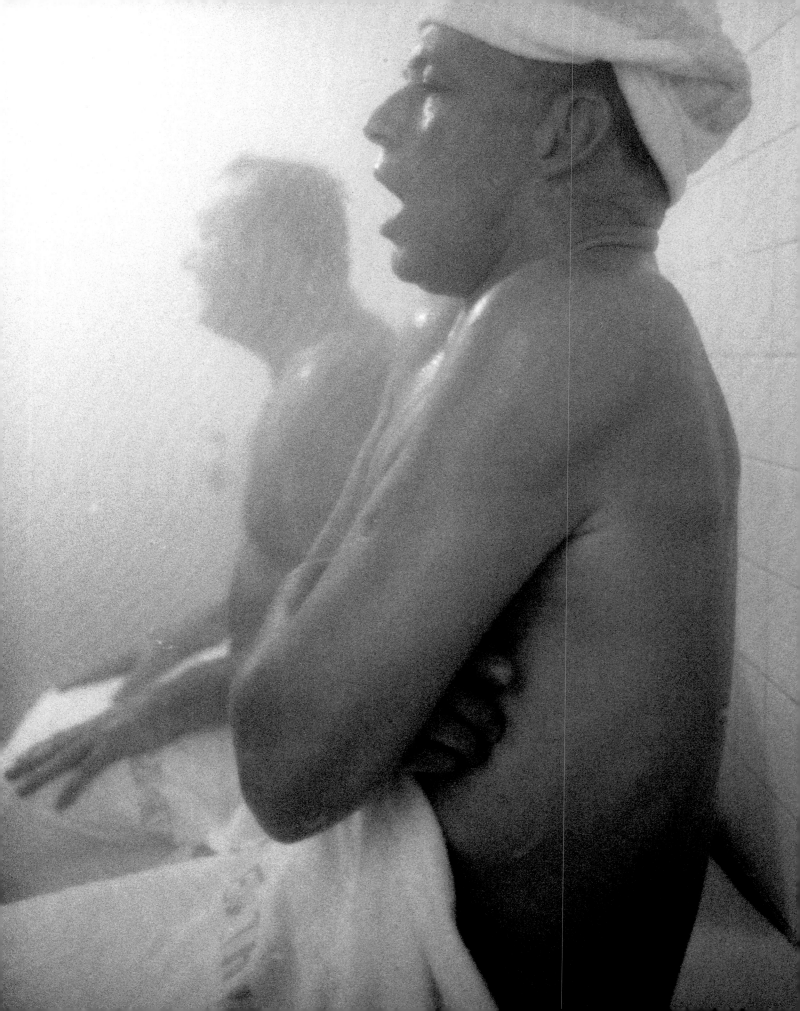

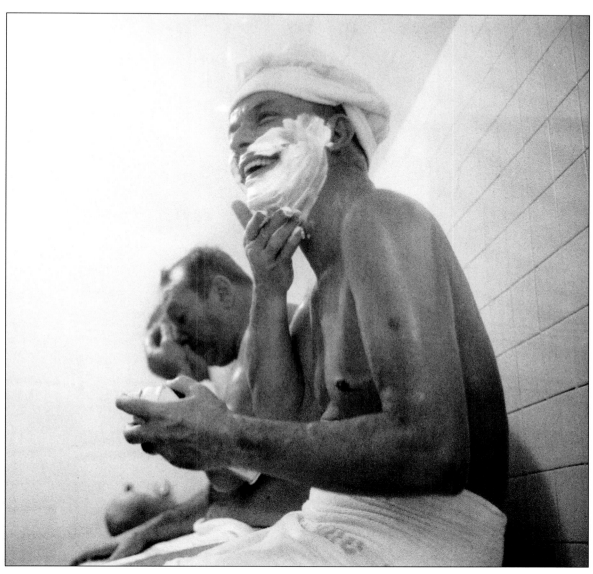

Taking a steam bath clears his head of the night's smoke and liquor. The "skinny kid with a big Adam's apple," as he was once described, worries about putting on weight. "I'm up to 150 pounds, and I think I'd better take a few off."

Fastidious about his appearance, he lathers his steam-softened beard. The towel around his head helps cover his receding hairline, a particularly sore topic. In later years, he compensated with hats and expensive toupees.

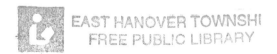

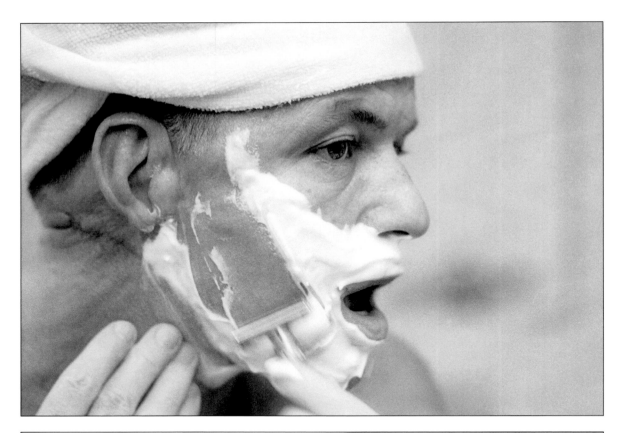

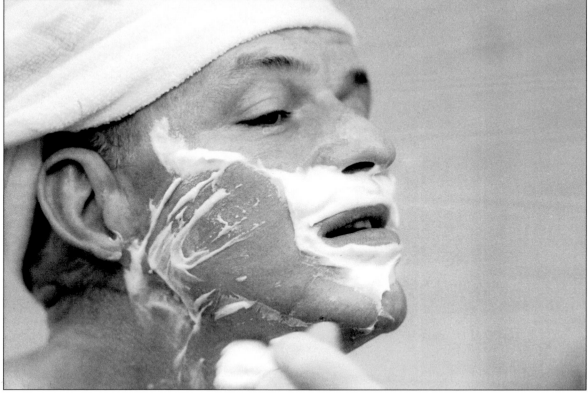

In the Eden Roc locker room, Frank scrapes off his whiskers. For most men, this is an early morning ritual. For Sinatra, it's early afternoon. His show and partying consume the night. Mornings are for sleep.

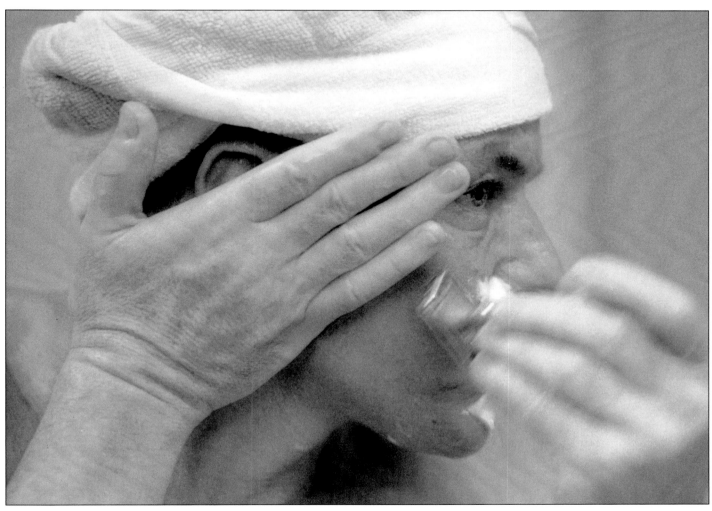

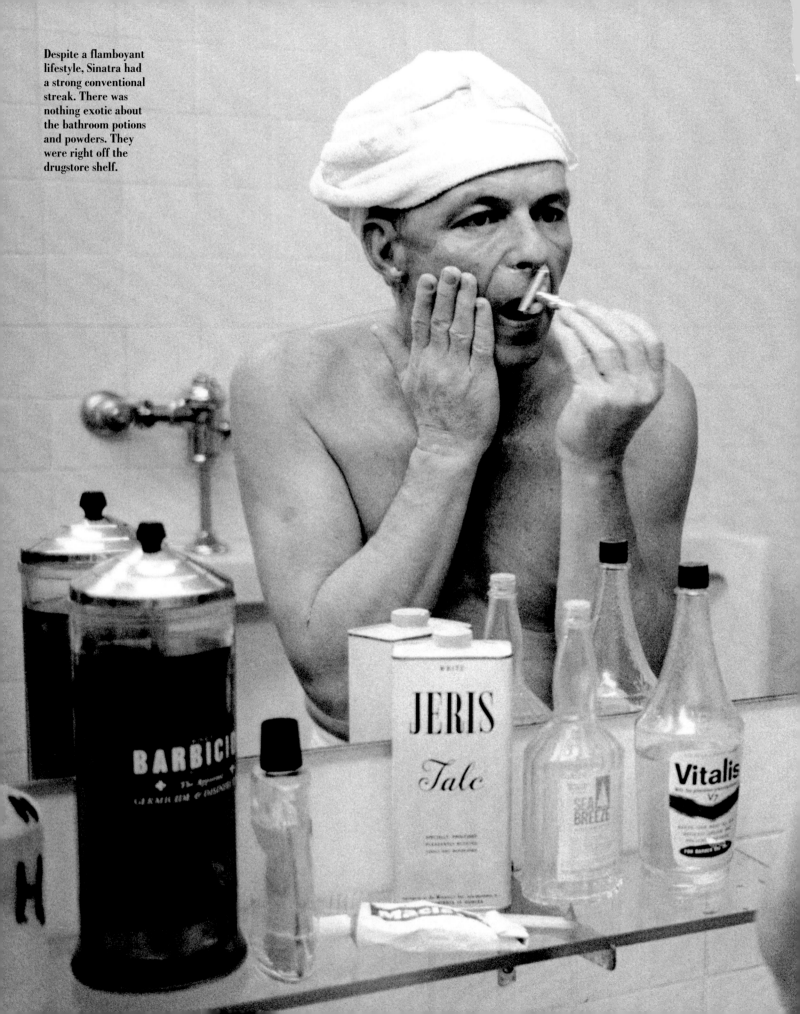

Despite a flamboyant lifestyle, Sinatra had a strong conventional streak. There was nothing exotic about the bathroom potions and powders. They were right off the drugstore shelf.

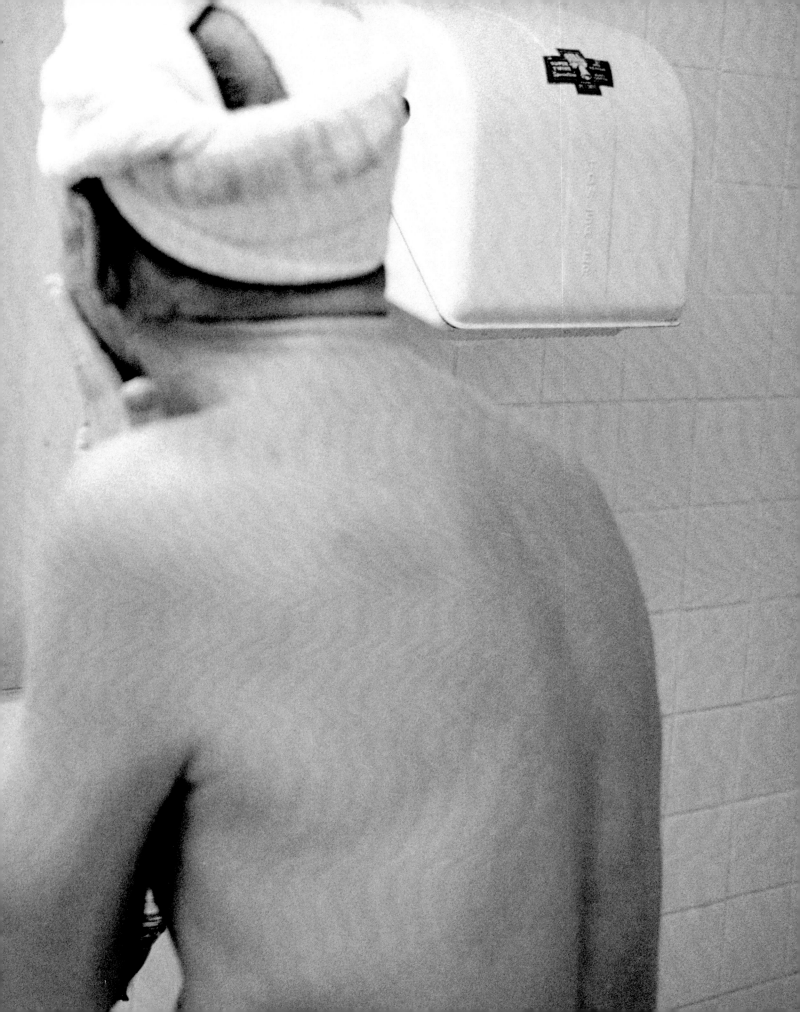

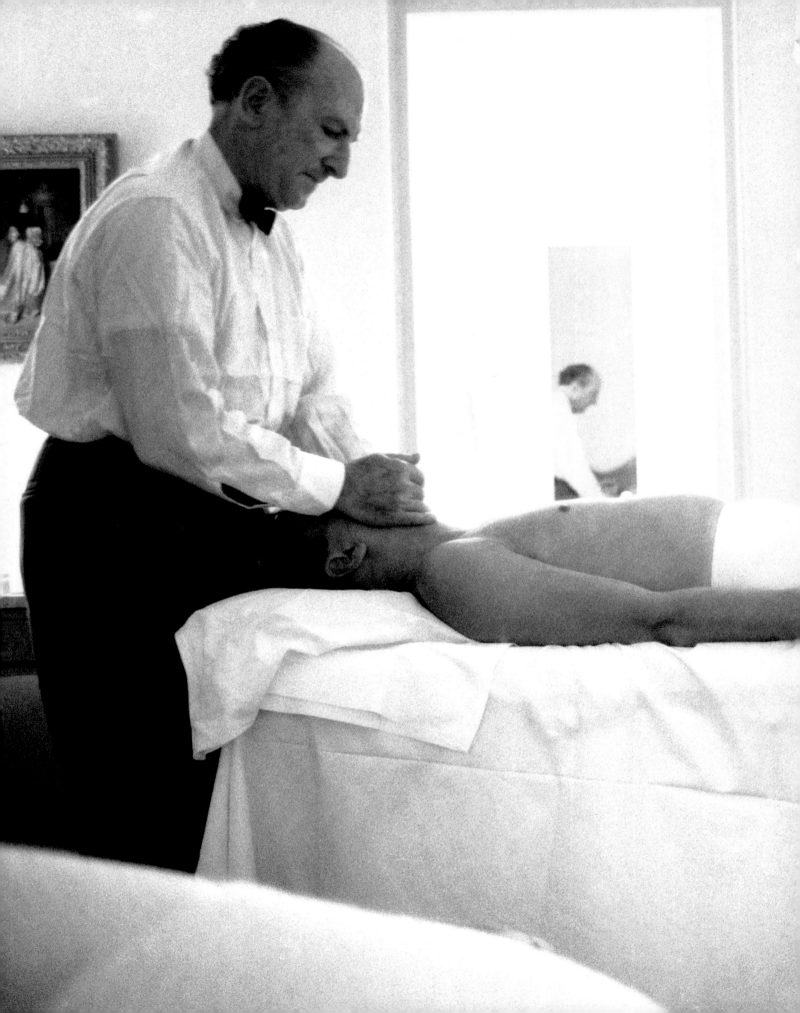

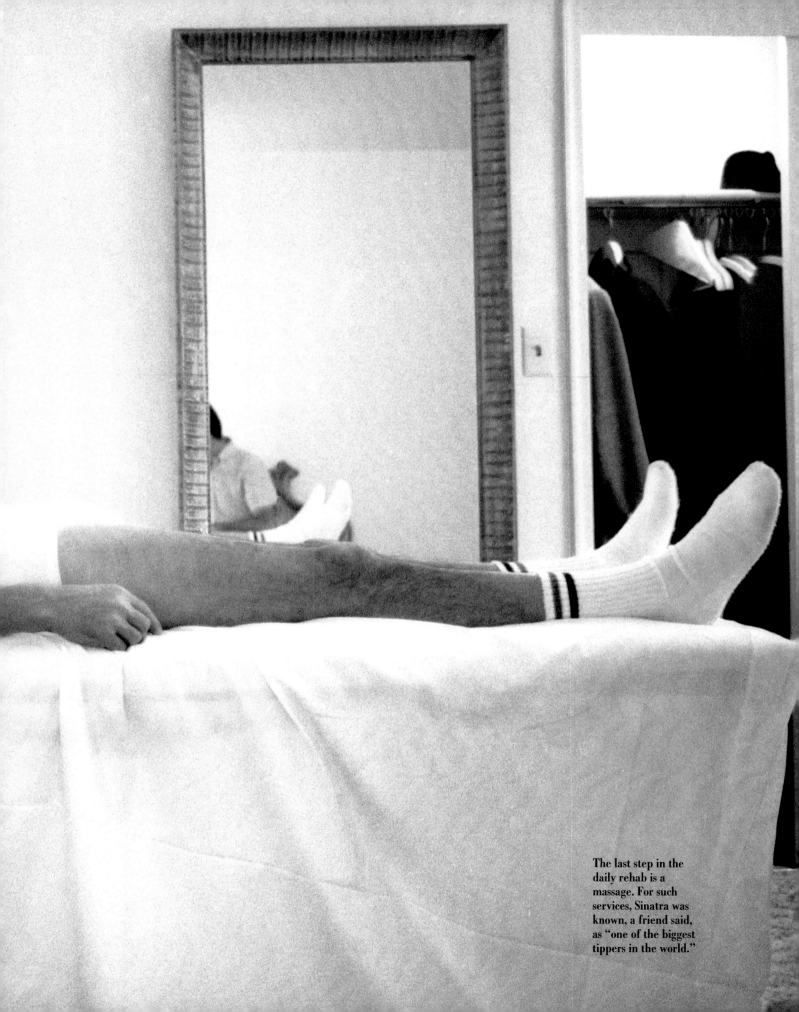

The last step in the daily rehab is a massage. For such services, Sinatra was known, a friend said, as "one of the biggest tippers in the world."

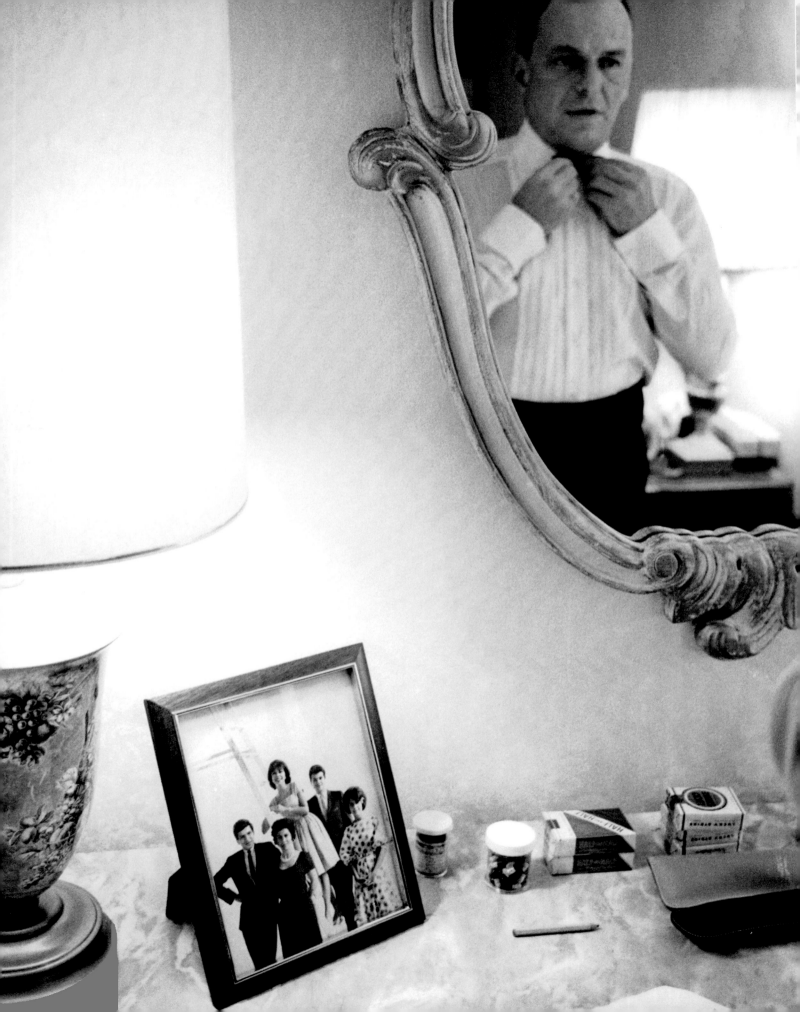

Sinatra suits and freshens up before his show. "For me," he says, "a tuxedo is a way of life." He once heckled pal Sammy Davis Jr. onstage, "What are you doing in a cockamamy street suit? You're supposed to wear a dinner jacket!" He dislikes cummerbunds though, preferring a vest instead. The portrait on the bureau is of the Sinatra clan.

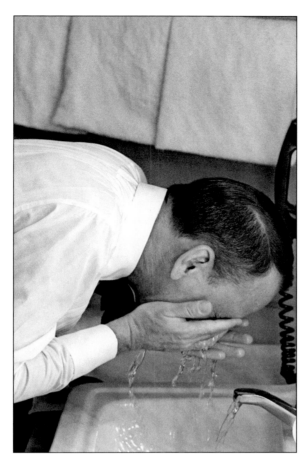

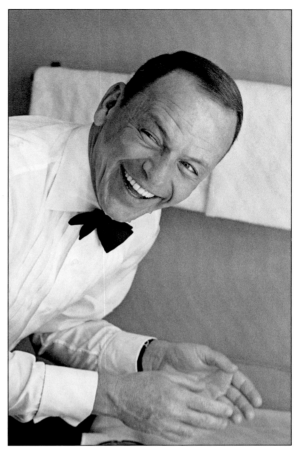

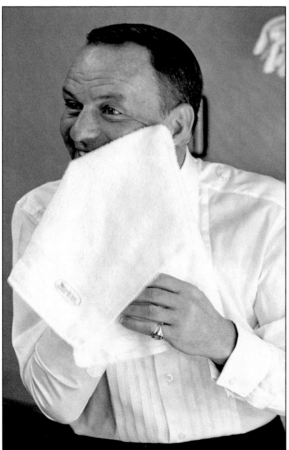

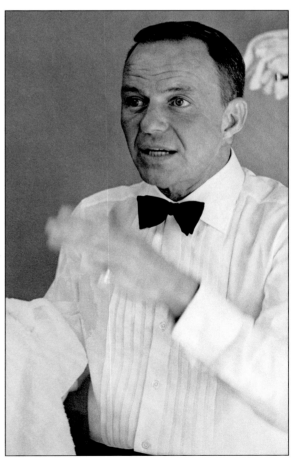

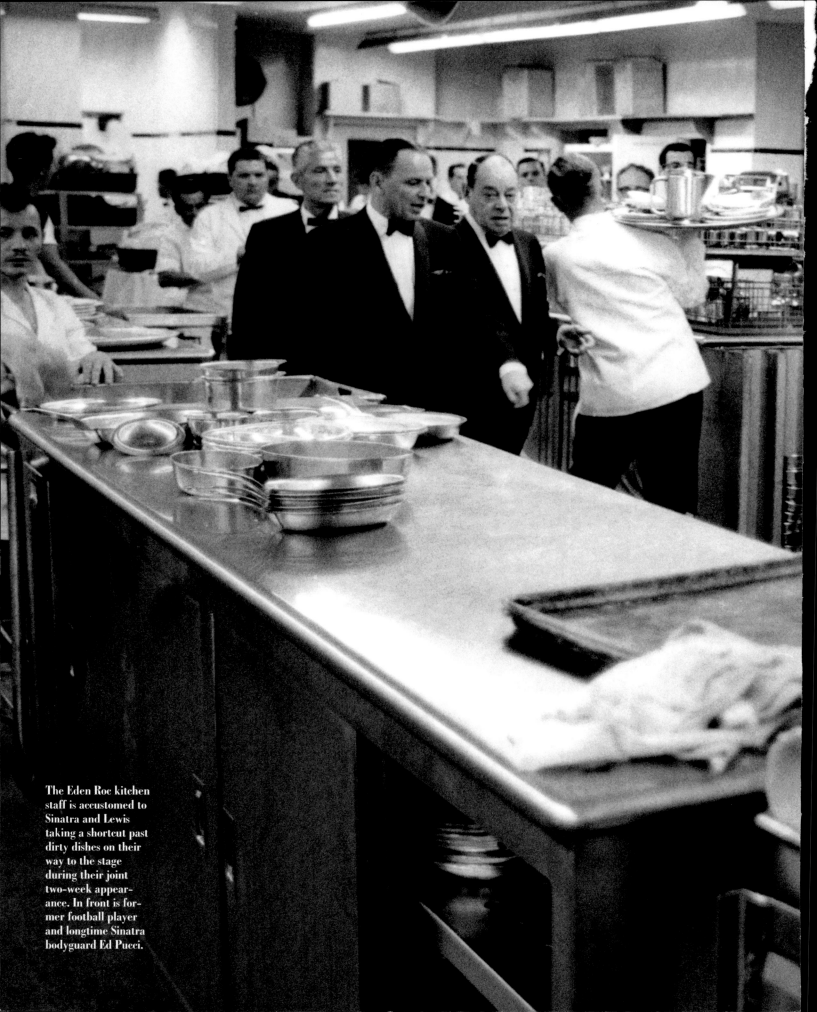

The Eden Roc kitchen staff is accustomed to Sinatra and Lewis taking a shortcut past dirty dishes on their way to the stage during their joint two-week appearance. In front is former football player and longtime Sinatra bodyguard Ed Pucci.

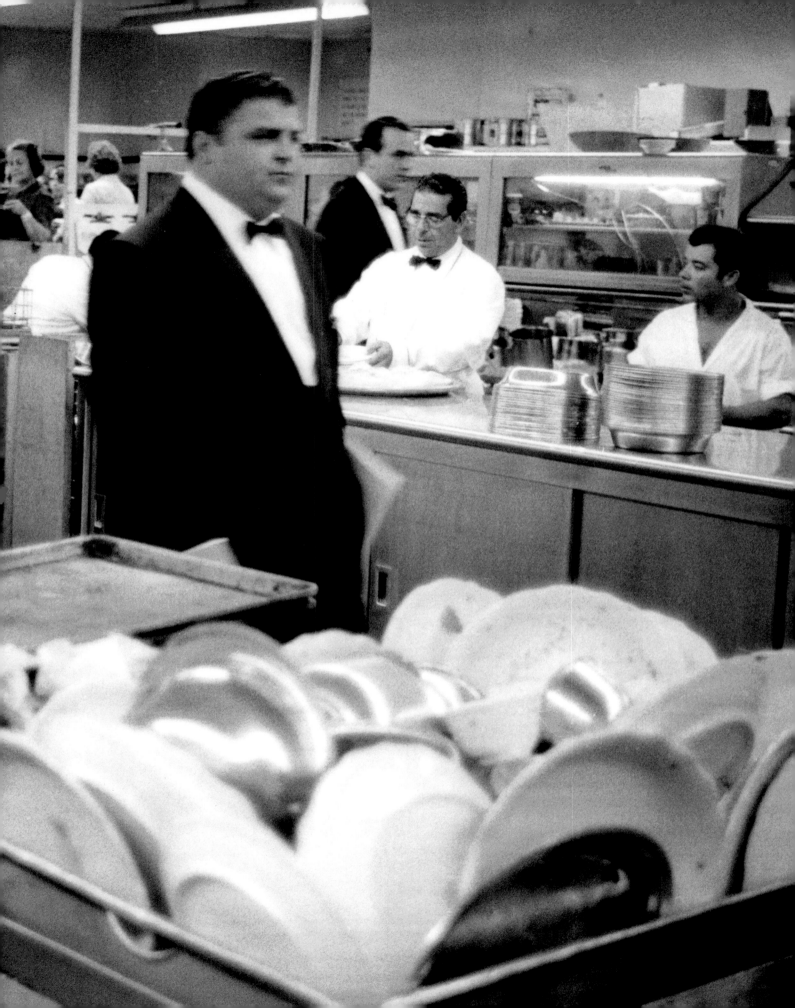

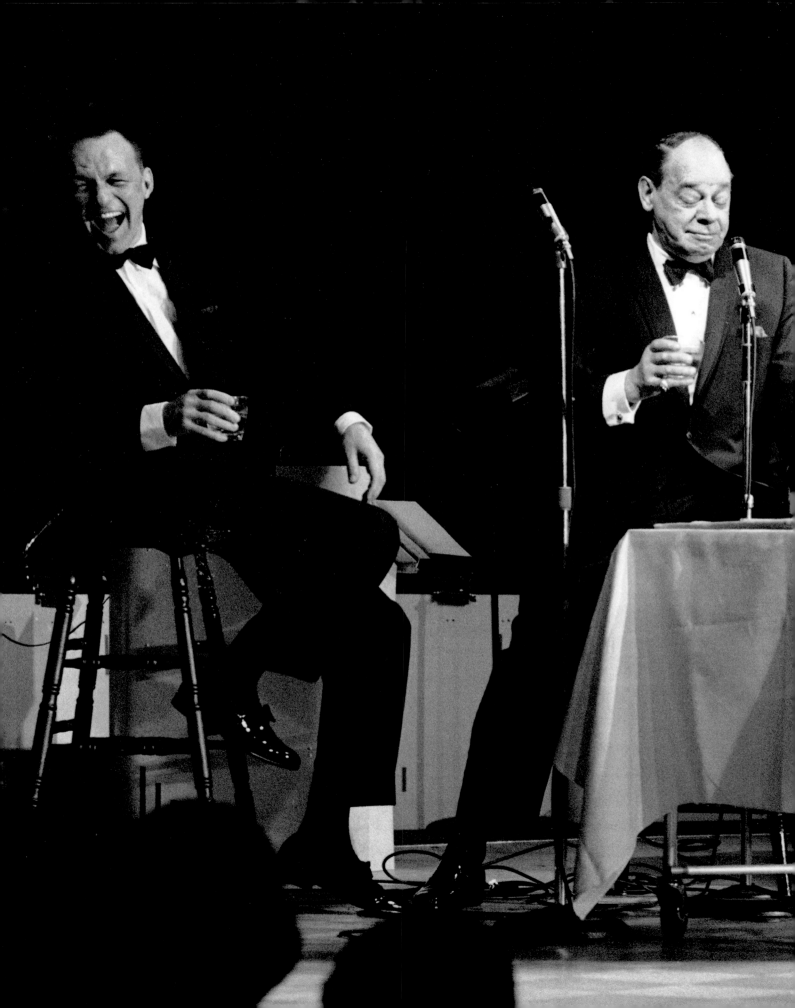

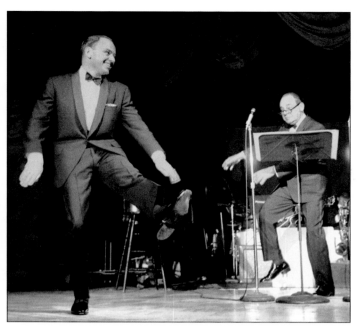

Sinatra and Lewis
cavort onstage, fueled
by a minibar of wine,
beer and the ubiq-
uitous Kentucky
bourbon. Of it, Frank
said, "I'm for any-
thing that gets you
through the night,
be it prayer, tranquil-
izers or a bottle of
Jack Daniel's."

After the jokes,
Sinatra gets serious
about singing.
"I don't read a note of
music," he admits.
"I learn songs by
having them played
for me a couple of
times…I learn the
lyrics by writing them
out in longhand."

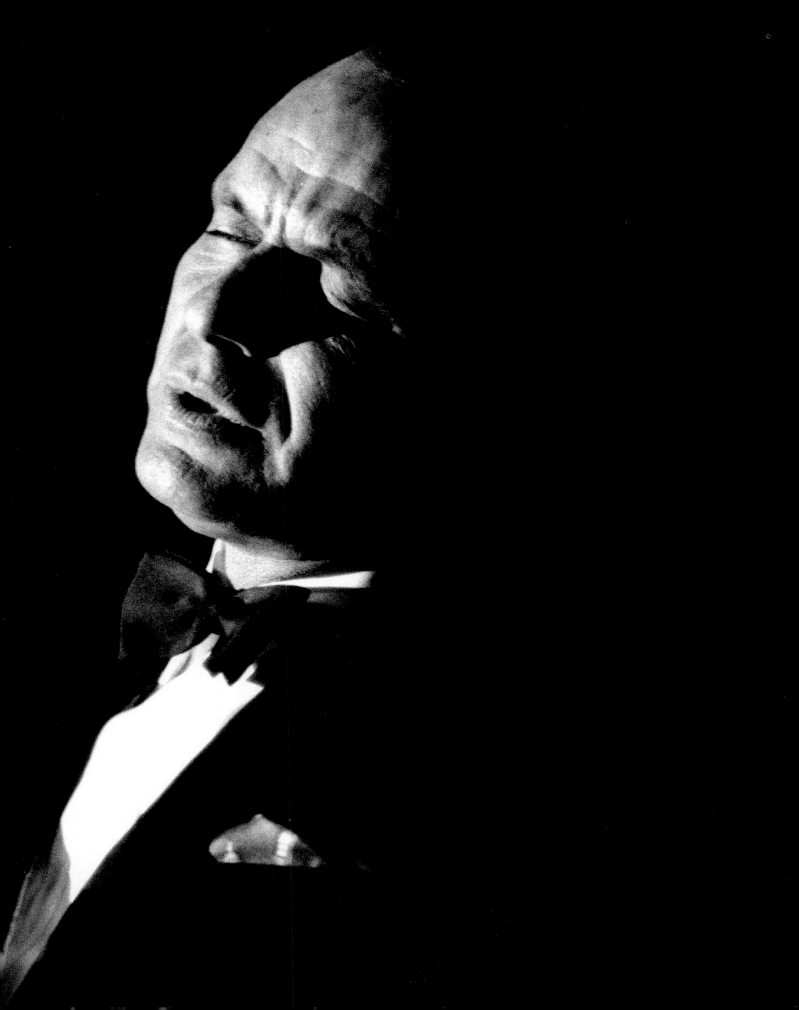

IN THE WEE SMALL HOURS

FRANK SINATRA WAS A PARTY ANIMAL before the term was invented. He works hard ("I'll do my job and you do yours" is his motto) and carouses hard, sleeping only four or five hours a night. His off-duty "gasoline" intake (as he calls booze) is prodigious. It never interferes with his singing but has led to some highly publicized scrapes. After a fistfight with a Hearst newspaper columnist, he admitted, "I'm known as the Eichmann of song." Always loyal to friends, usually courteous to strangers, he packs an explosive personality. As Tommy Dorsey put it: "He's the most fascinating man in the world, but don't stick your hand in the cage."

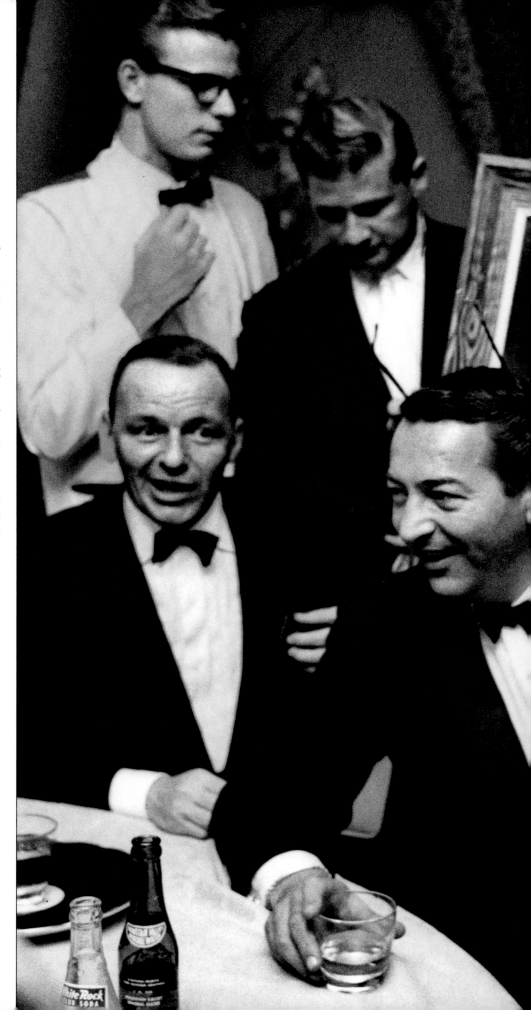

After the second show at the Eden Roc in Miami, Sinatra drops by the lounge for a drink, as a favor to the hotel owners. It's a chance for the public to approach, sometimes with offerings like this painting.

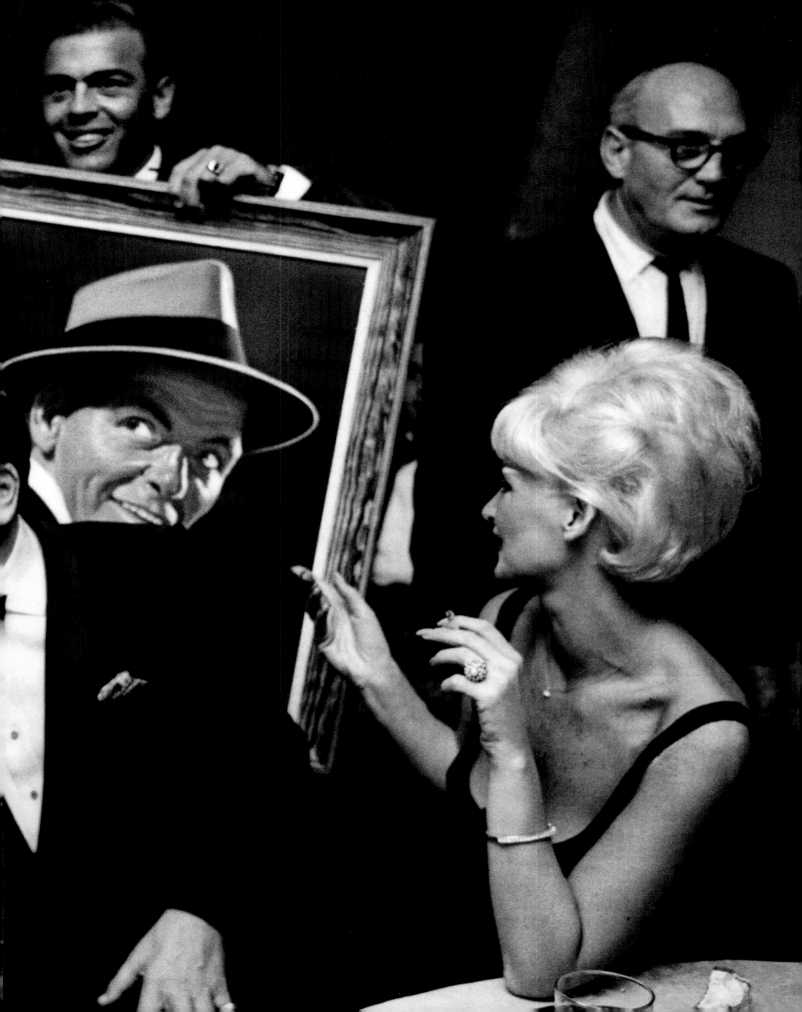

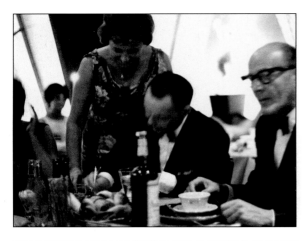

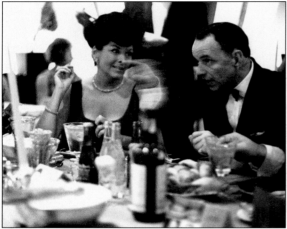

When autograph seekers come by, he signs and says thank you. "They never come out and ask for themselves," he muses. "It's always for their kid or their niece. I guess they're embarrassed." Friends are always welcome to sit down.

Newspaper columnist and TV host Ed Sullivan drops by. By this time, the two men had patched up a bitter feud over Sullivan's refusal to pay Sinatra for an appearance on his show. It was to promote the movie version of GUYS AND DOLLS, starring the singer, plus Marlon Brando and Jean Simmons.

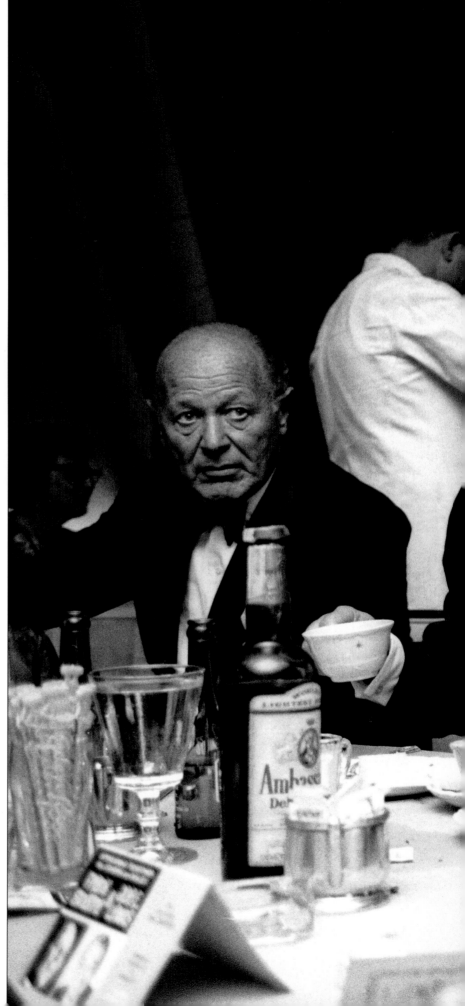

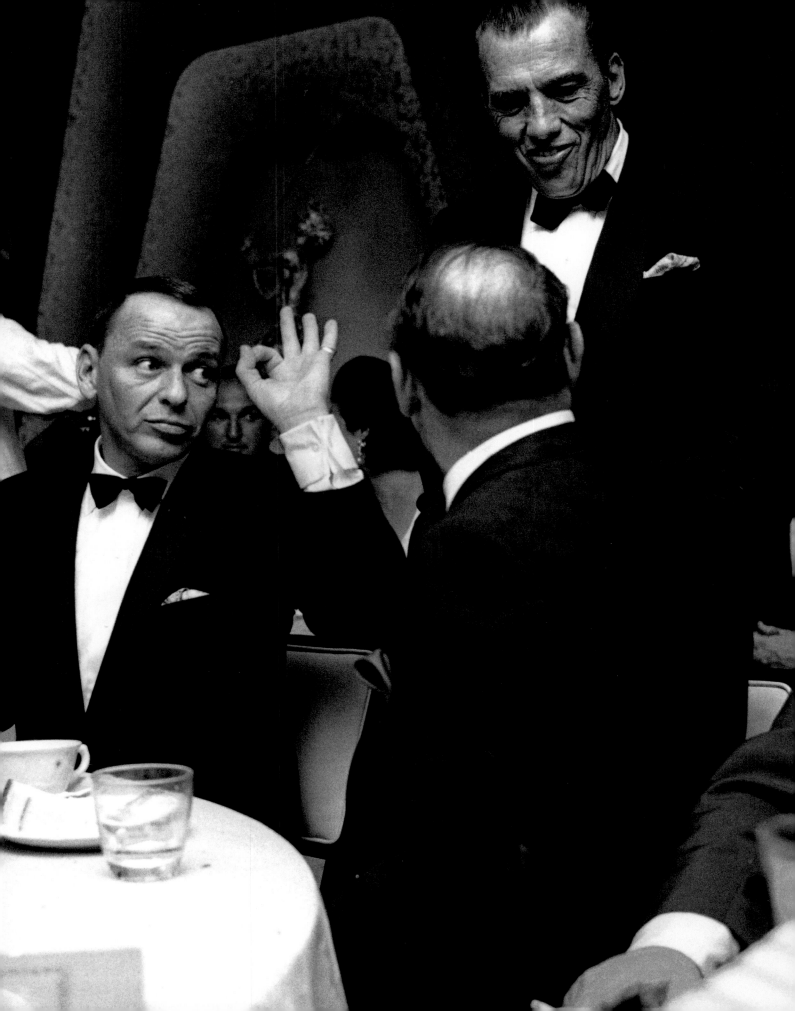

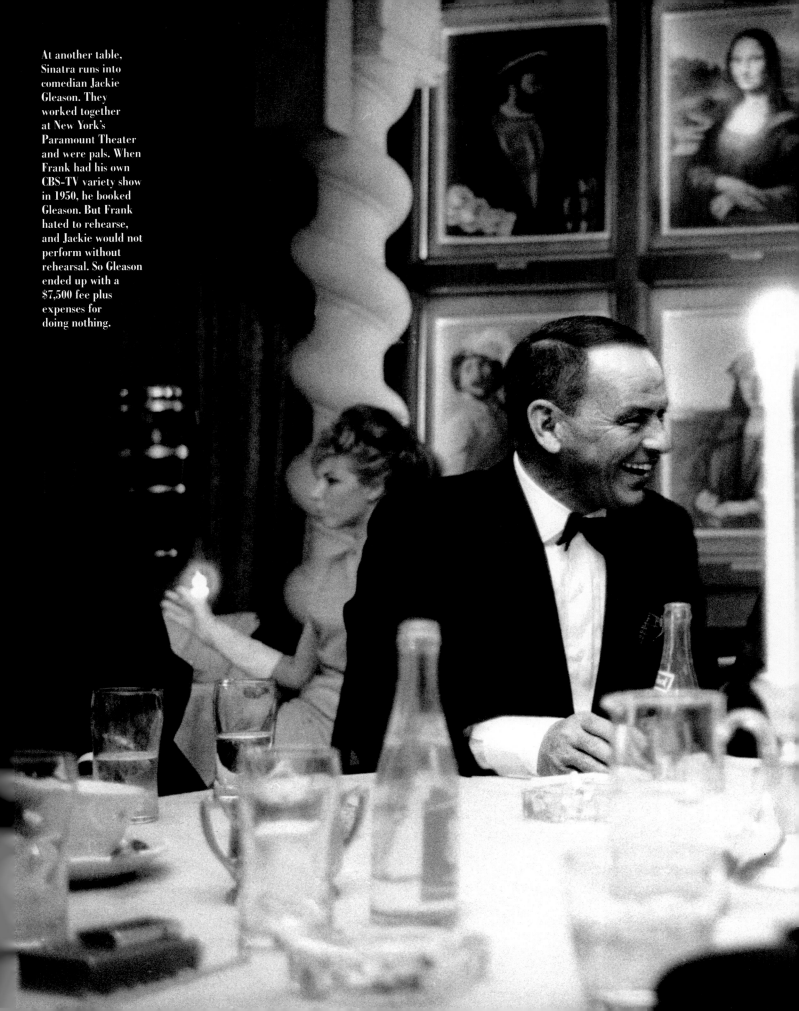

At another table, Sinatra runs into comedian Jackie Gleason. They worked together at New York's Paramount Theater and were pals. When Frank had his own CBS-TV variety show in 1950, he booked Gleason. But Frank hated to rehearse, and Jackie would not perform without rehearsal. So Gleason ended up with a $7,500 fee plus expenses for doing nothing.

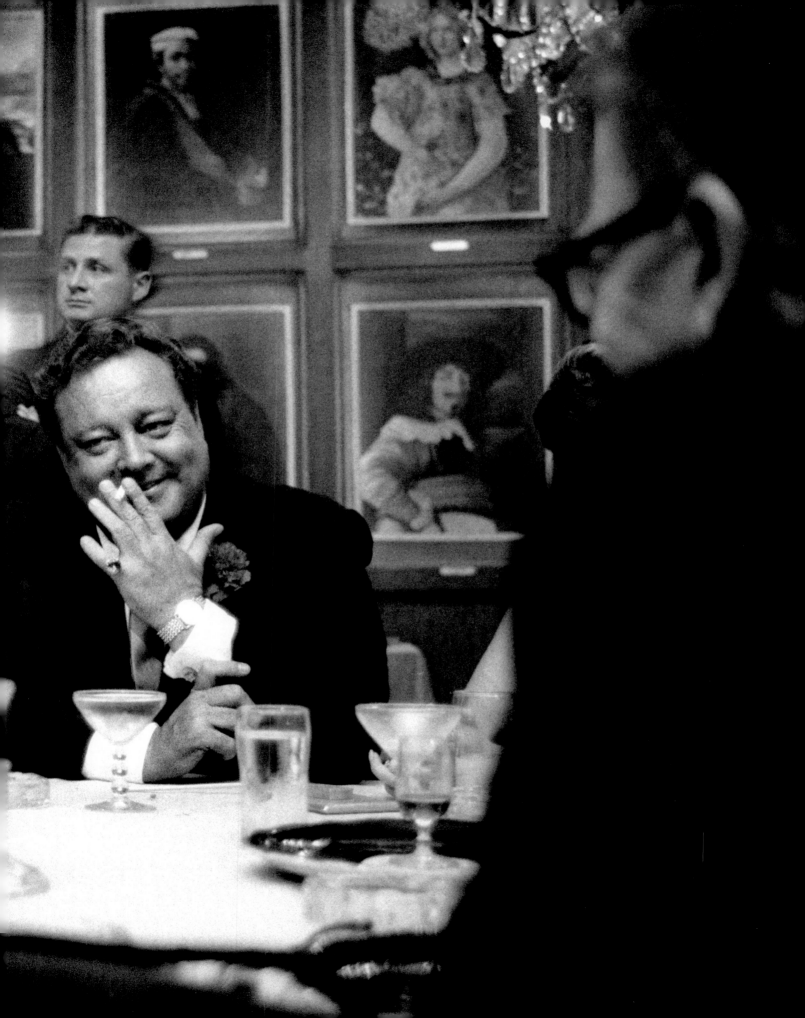

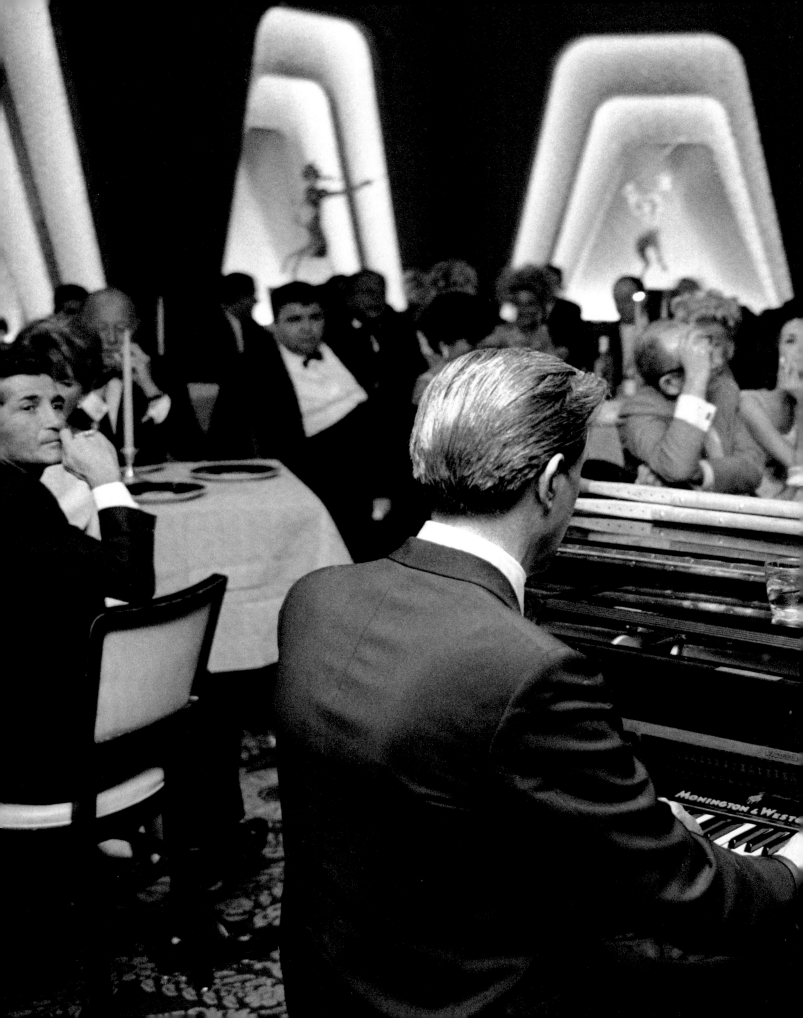

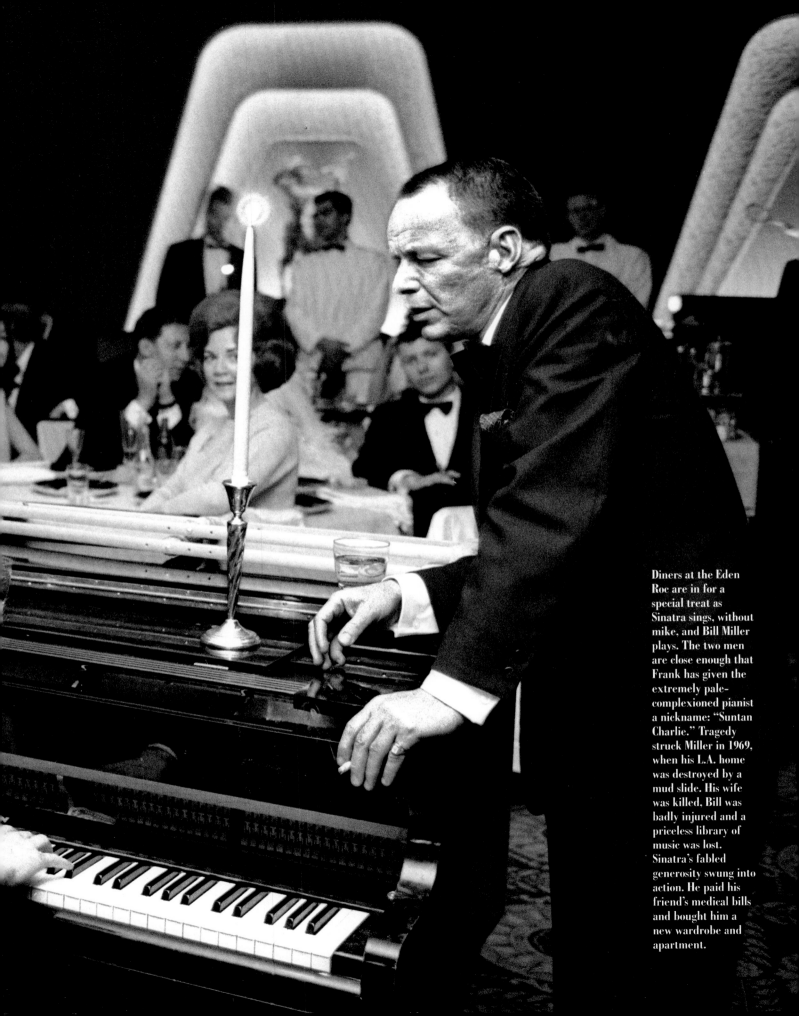

Diners at the Eden Roc are in for a special treat as Sinatra sings, without mike, and Bill Miller plays. The two men are close enough that Frank has given the extremely pale-complexioned pianist a nickname: "Suntan Charlie." Tragedy struck Miller in 1969, when his L.A. home was destroyed by a mud slide. His wife was killed, Bill was badly injured and a priceless library of music was lost. Sinatra's fabled generosity swung into action. He paid his friend's medical bills and bought him a new wardrobe and apartment.

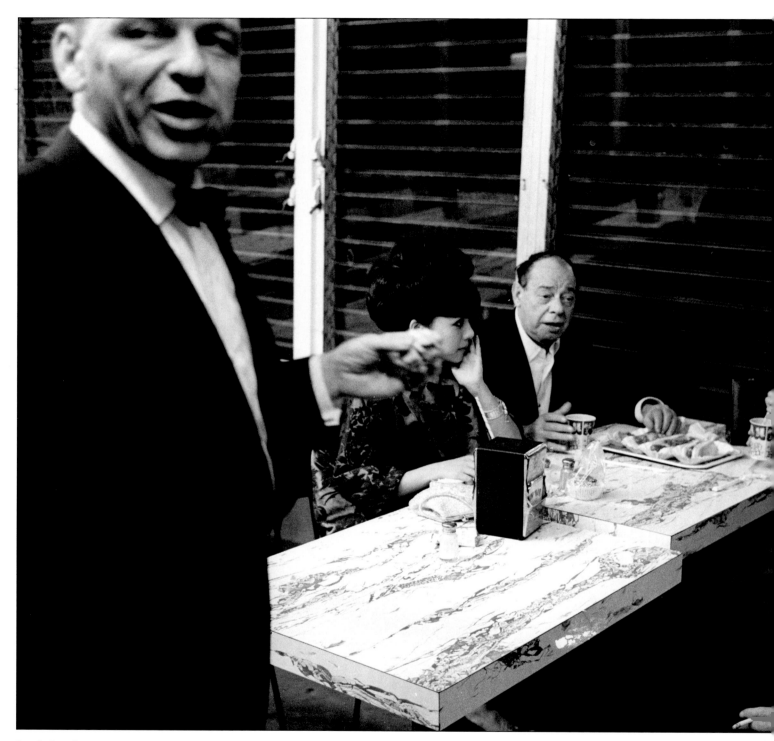

Just before dawn,
Sinatra and party
stop at a hot dog
joint. On this evening,
the singer's entou-
rage, which always
included attractive
women, grew from
four to nearly twenty.
Chauffeured cars
took them from
club to club.

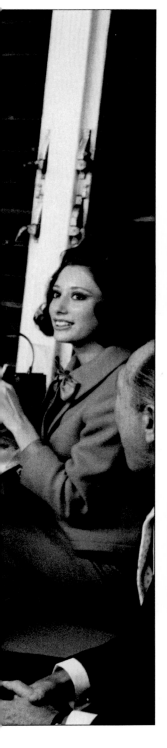

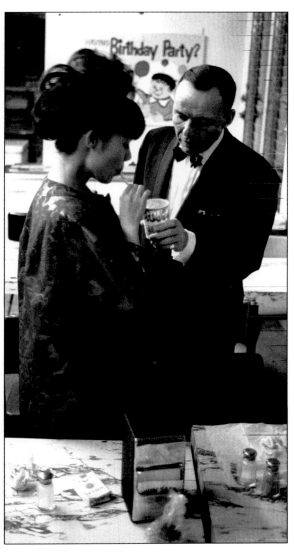

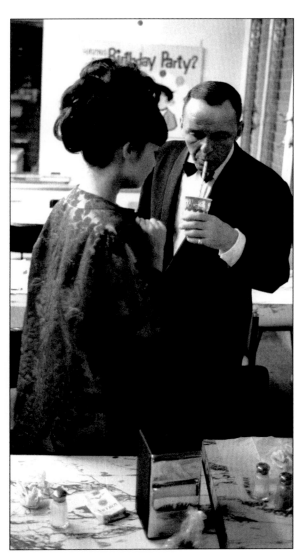

Frank's date is Eden Roc cigarette girl Yumi Akutsu, with whom he gallantly shares his (soft) drink. For years, Sinatra insisted that his reputation with women was exaggerated. "If I had as many love affairs as you have given me credit for," he told reporters in 1965, "I would now be speaking to you from a jar in the Harvard Medical School."

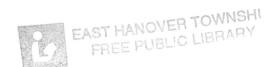

The bill for the hot dogs amuses big spender Sinatra. The man in back is Jilly Rizzo, longtime crony and owner of Frank's favorite saloon in Manhattan.

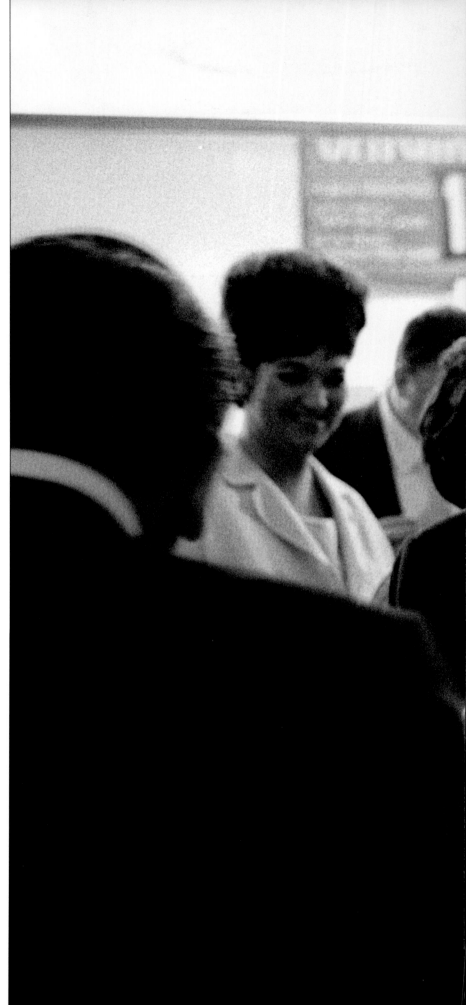

Tony Bennett, an old friend, has joined the group. Early in his career, Bennett asked Sinatra how he handled nerves onstage. Frank's reply: "It's good to be nervous. People like it when you're nervous. It shows you care. If you don't care, why should they?"

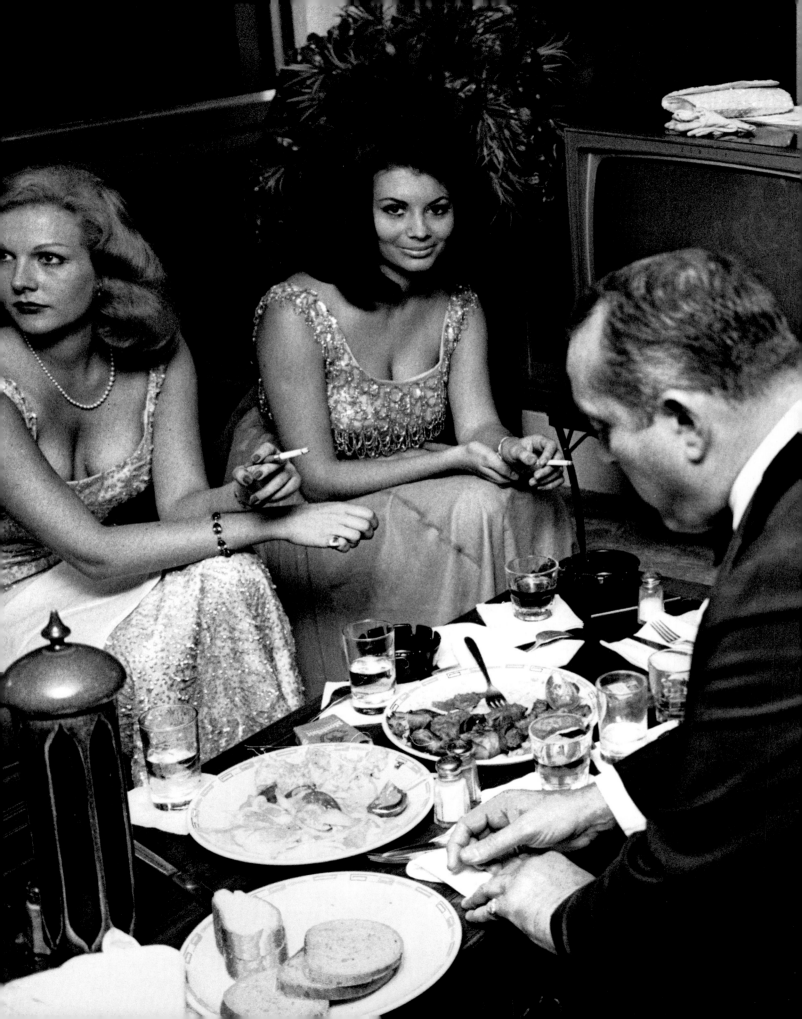

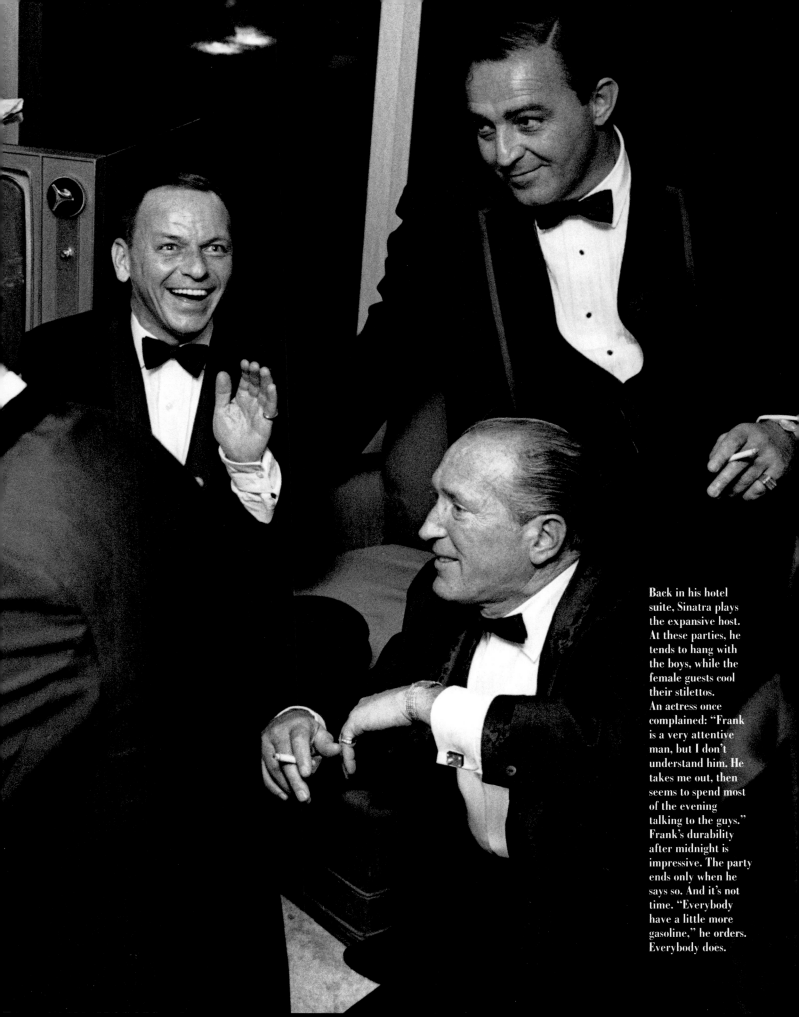

Back in his hotel suite, Sinatra plays the expansive host. At these parties, he tends to hang with the boys, while the female guests cool their stilettos. An actress once complained: "Frank is a very attentive man, but I don't understand him. He takes me out, then seems to spend most of the evening talking to the guys." Frank's durability after midnight is impressive. The party ends only when he says so. And it's not time. "Everybody have a little more gasoline," he orders. Everybody does.

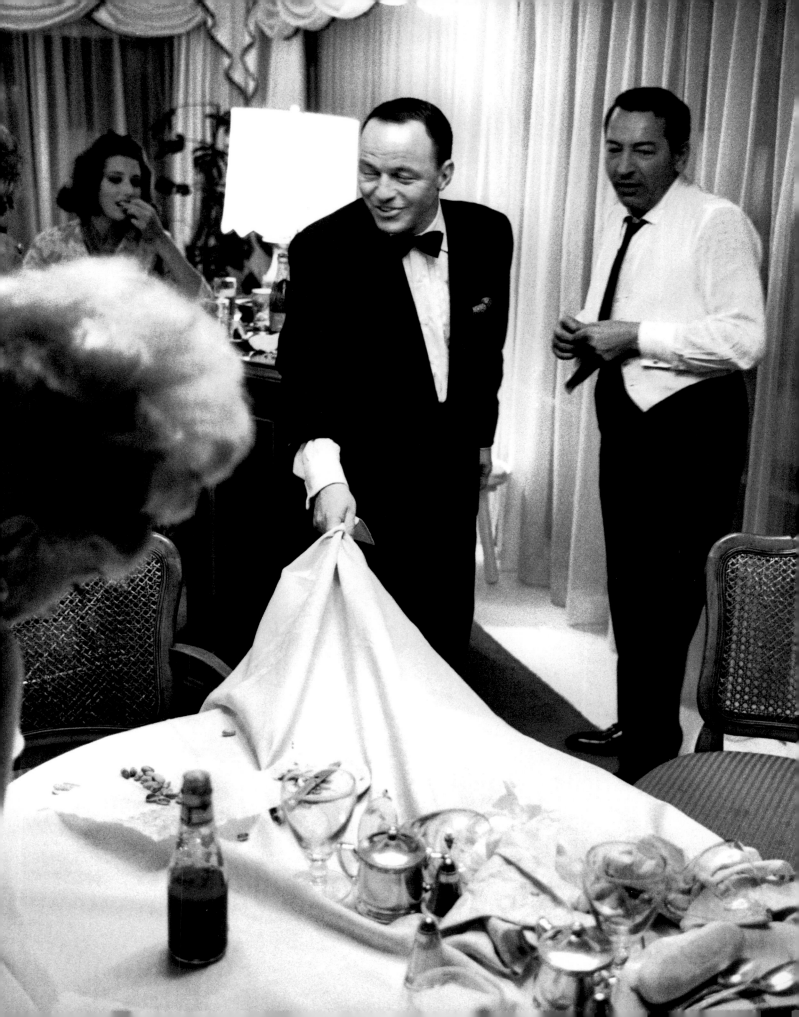

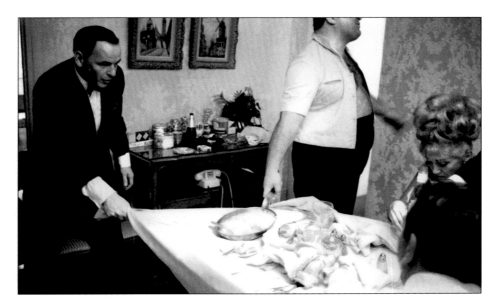

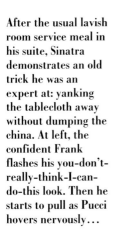

After the usual lavish room service meal in his suite, Sinatra demonstrates an old trick he was an expert at: yanking the tablecloth away without dumping the china. At left, the confident Frank flashes his you-don't-really-think-I-can-do-this look. Then he starts to pull as Pucci hovers nervously...

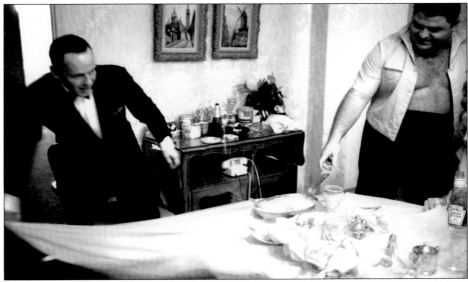

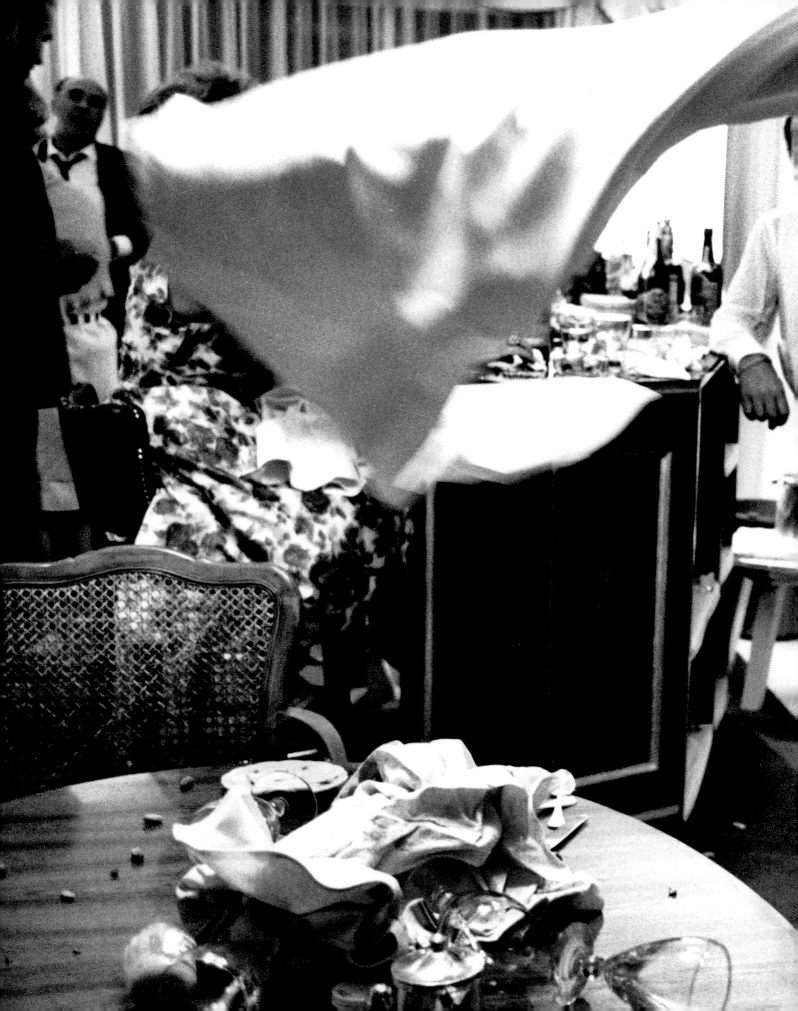

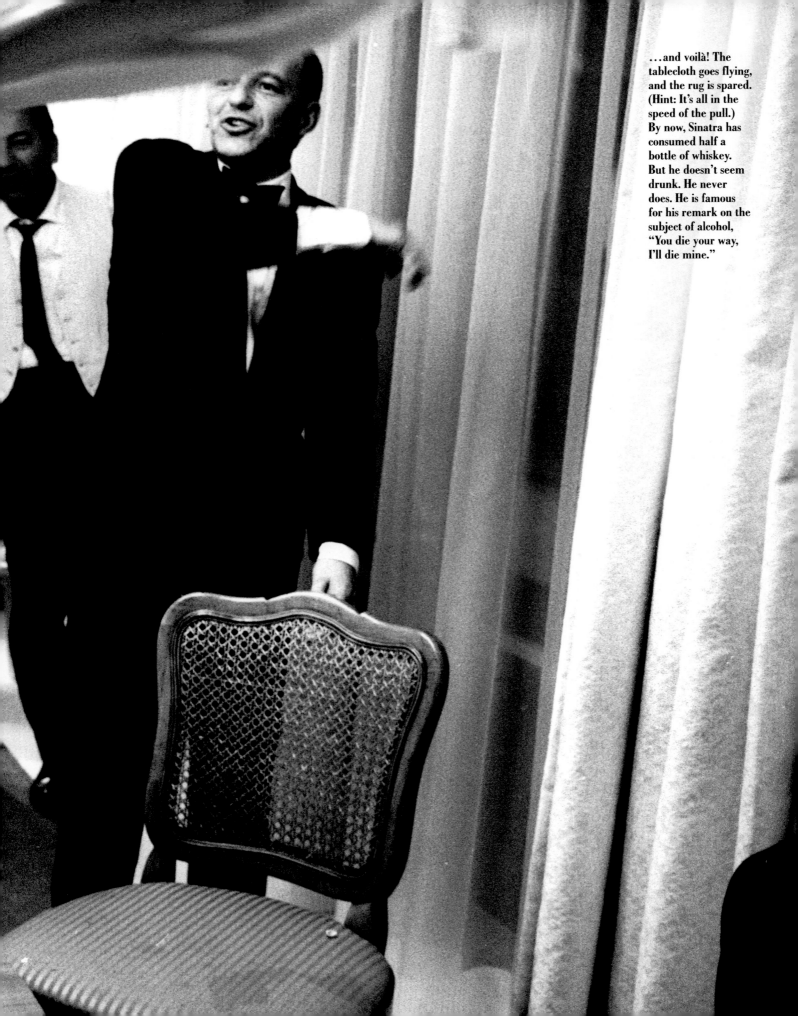

…and voilà! The tablecloth goes flying, and the rug is spared. (Hint: It's all in the speed of the pull.) By now, Sinatra has consumed half a bottle of whiskey. But he doesn't seem drunk. He never does. He is famous for his remark on the subject of alcohol, "You die your way, I'll die mine."

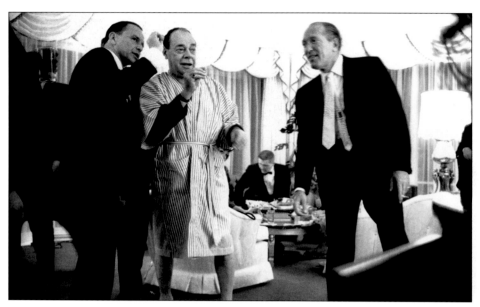

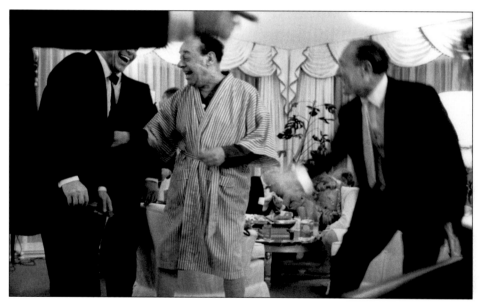

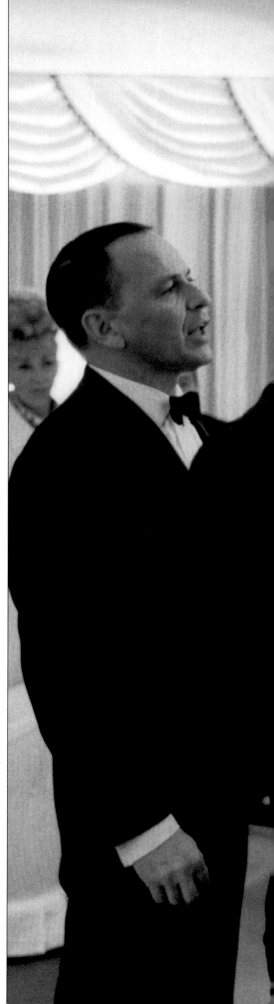

The fun and games in the suite isn't over yet, so Frank drags Joe E. Lewis out of bed for a round of darts. Despite the booze, Frank has a steady hand and sharp aim. But after nights like this, he could be tough on himself, as when he once muttered during a TV rehearsal: "Drink, drink, drink. Smoke, smoke, smoke. Shmuck, shmuck, shmuck."

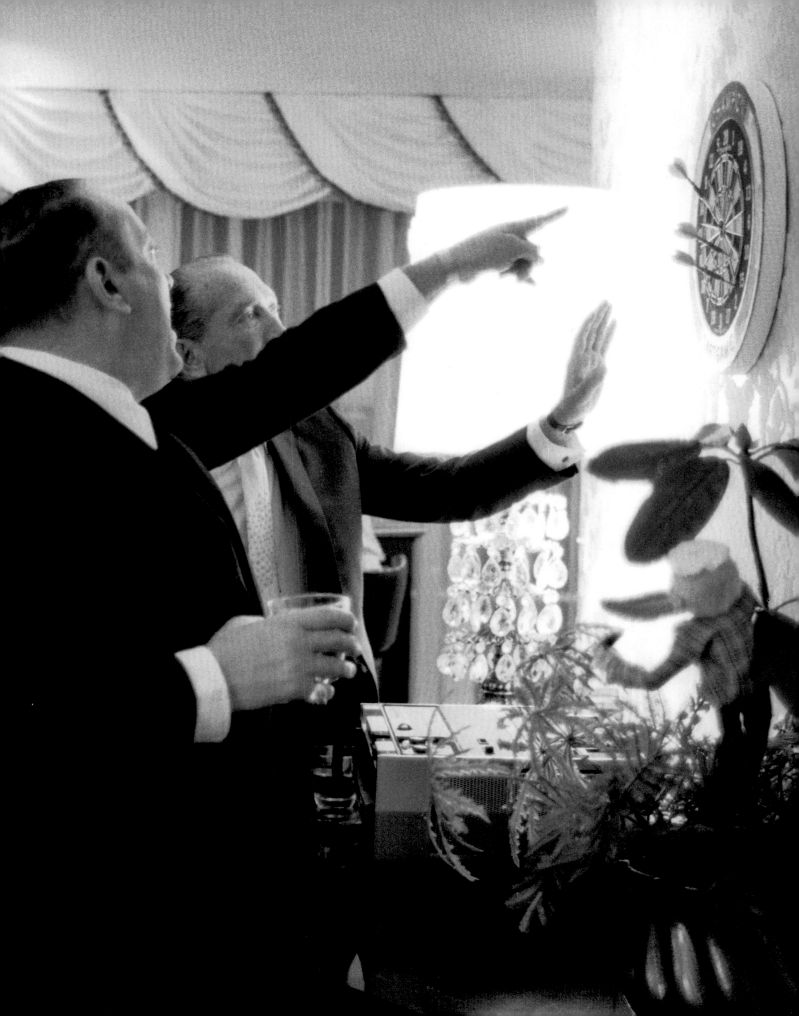

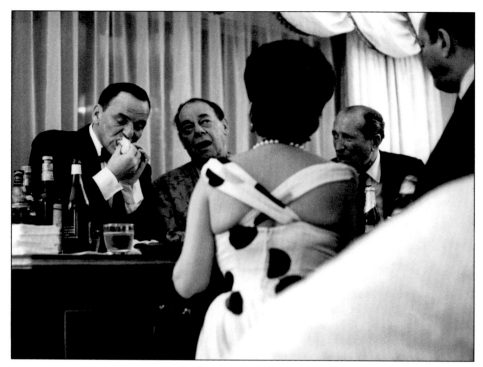

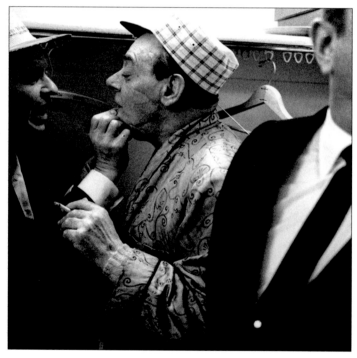

On another late night, Sinatra and Lewis grab a quick bite. Then they sneak into a closet to sing, because they like the resonance of their voices there, and swap jokes.

Sinatra is an appreciative audience for Lewis's bar room humor — to the point of falling off his chair. One of Frank's favorites (and appropriate for this evening) is Joe's observation: "You're not drunk if you can lie on the floor without holding on." At seven a.m., the sun up, Frank announces he's had enough. He is going to bed. His guests clear out instantly. He turns on some music, reads a while, and finally falls asleep.

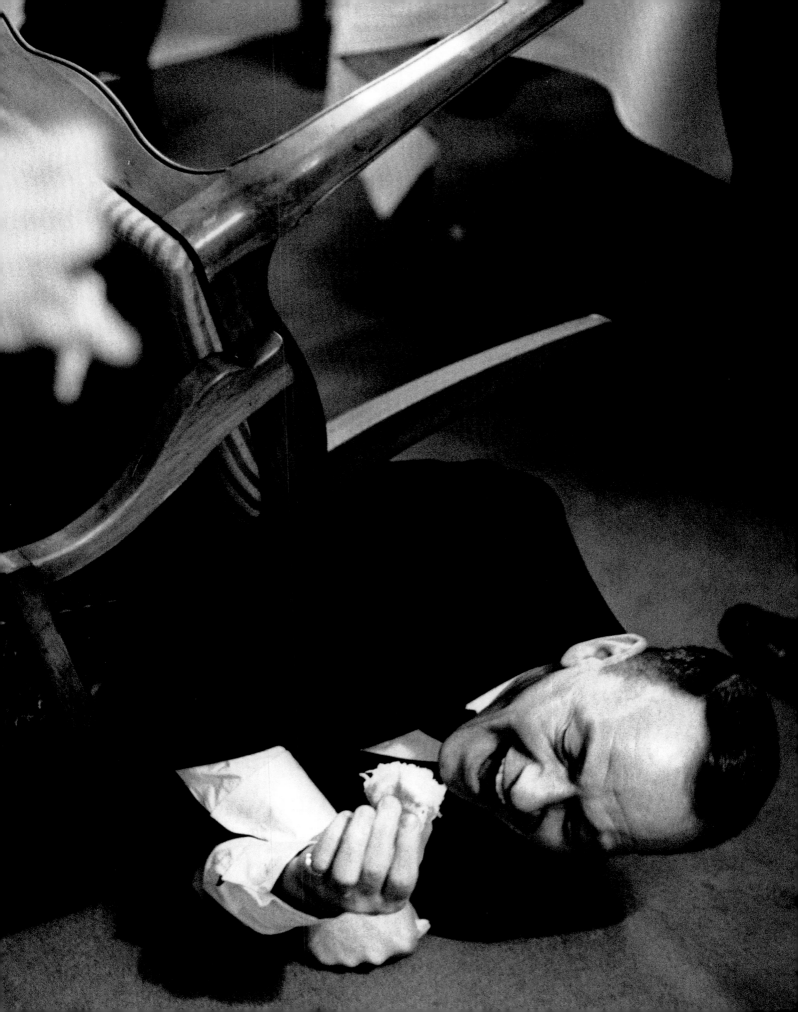

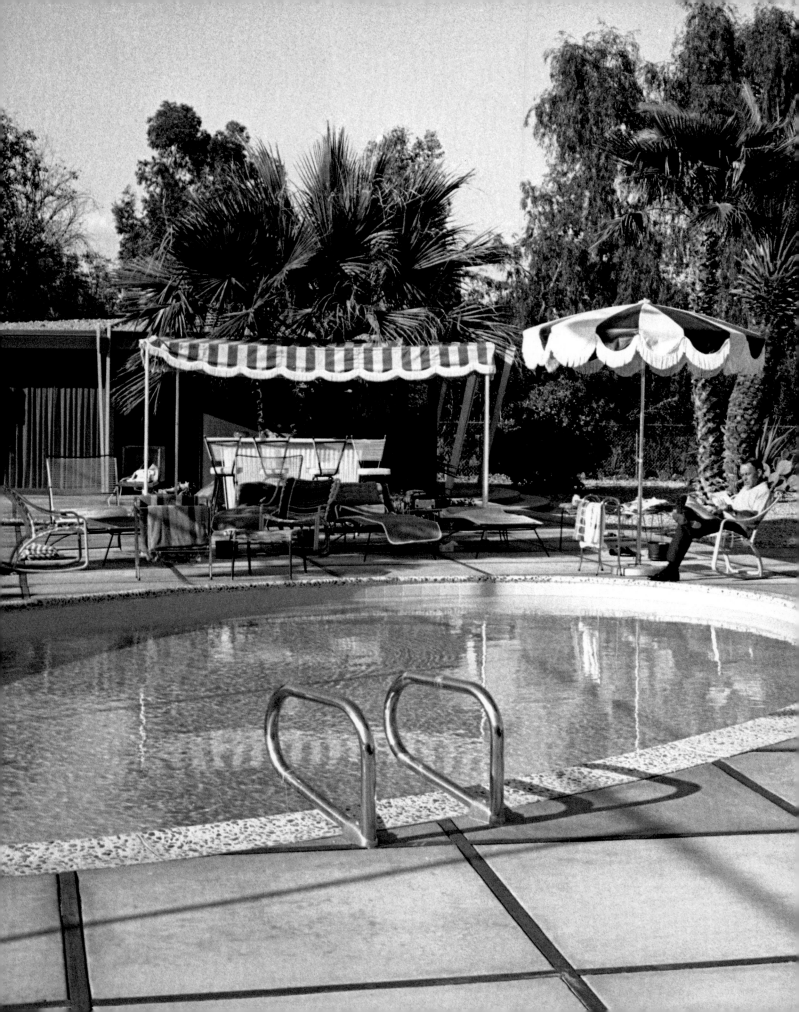

THE HOUSE I LIVE IN

IN 1946, SINATRA WON A SPECIAL Academy Award for "The House I Live In," a ten-minute film preaching tolerance. His message did not exactly square with the plaque he later hung outside his Palm Springs home: "Never Mind the Dog, Beware of the Owner." That home was both his delight and his despair – as in 1962, when President Kennedy ("That Old Jack Magic," as Frank sang) promised he would stay there on an upcoming trip, then changed his mind and stayed with – of all people! – Bing Crosby. Attorney General Robert Kennedy recommended the switch because of Sinatra's open affiliation with mobsters. Frank was mortified, then furious. Kennedy in-law Peter Lawford, who had to deliver the news, was brutally cut off by Sinatra and the other Rat Packers. Frank often cursed Bobby, too, but, touchingly, never the president himself.

What Sinatra considers his real home is this spread on Wonder Palms Road in Palm Springs, next to the 17th hole of the Tamarisk Country Club. It's got two bedrooms, tennis courts, a saltwater pool, a helicopter landing pad and two guest houses. The grimy corner of Fifth and Madison streets in Hoboken, where Frank was born, seems far, far away.

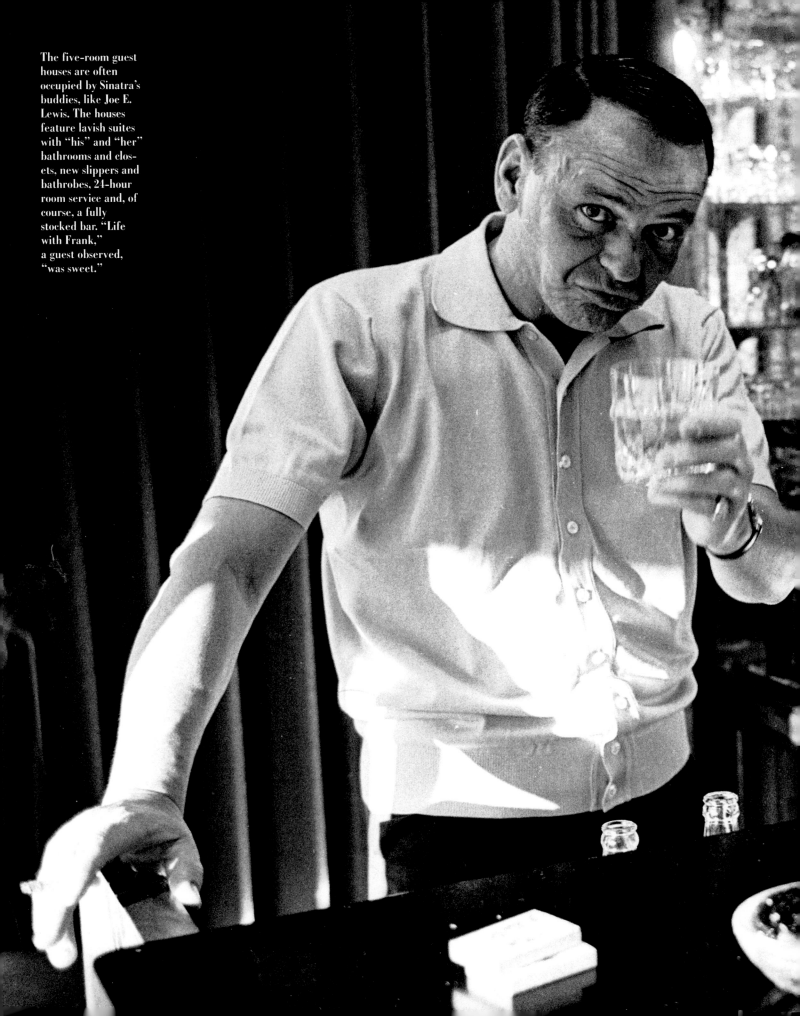

The five-room guest houses are often occupied by Sinatra's buddies, like Joe E. Lewis. The houses feature lavish suites with "his" and "her" bathrooms and closets, new slippers and bathrobes, 24-hour room service and, of course, a fully stocked bar. "Life with Frank," a guest observed, "was sweet."

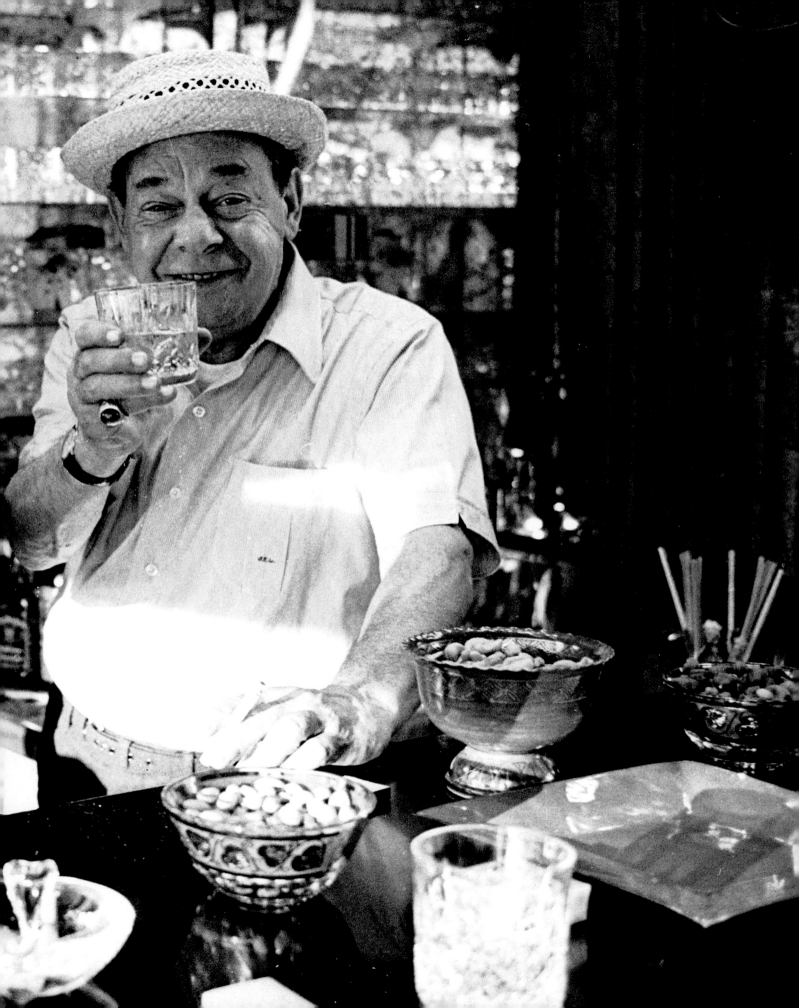

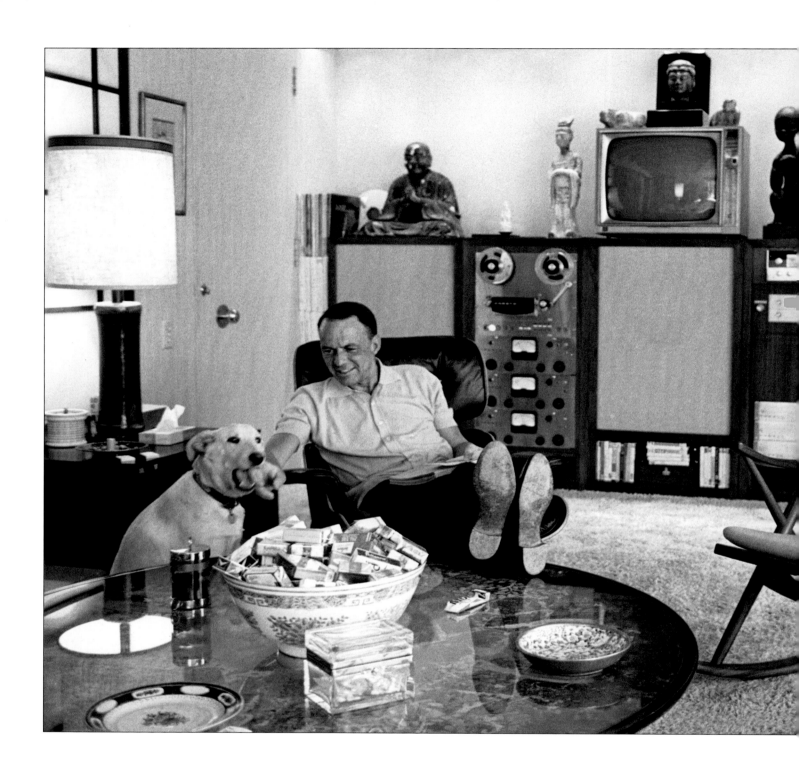

The Chairman is never bored in his desert home. He has $5,000 worth of hi-fi equipment to listen to (usually classical music, never his own records), Oriental and African sculpture to admire, his dog Ringo to play with, and bowls of cigarette packs and candy to dip into.



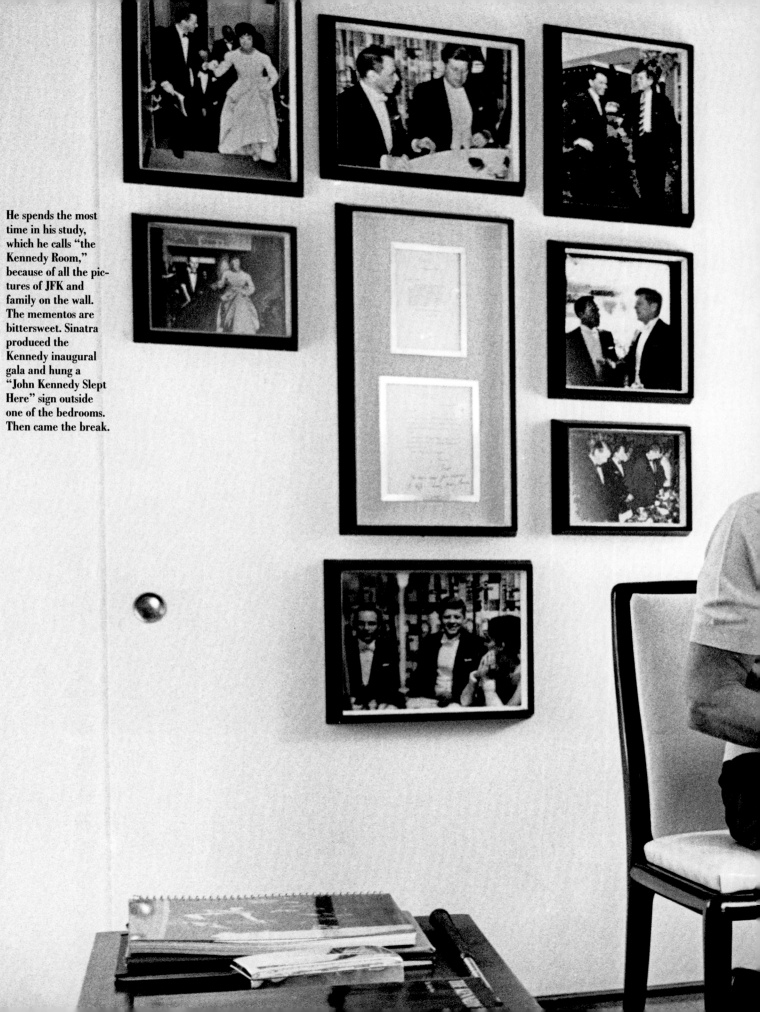

He spends the most time in his study, which he calls "the Kennedy Room," because of all the pictures of JFK and family on the wall. The mementos are bittersweet. Sinatra produced the Kennedy inaugural gala and hung a "John Kennedy Slept Here" sign outside one of the bedrooms. Then came the break.

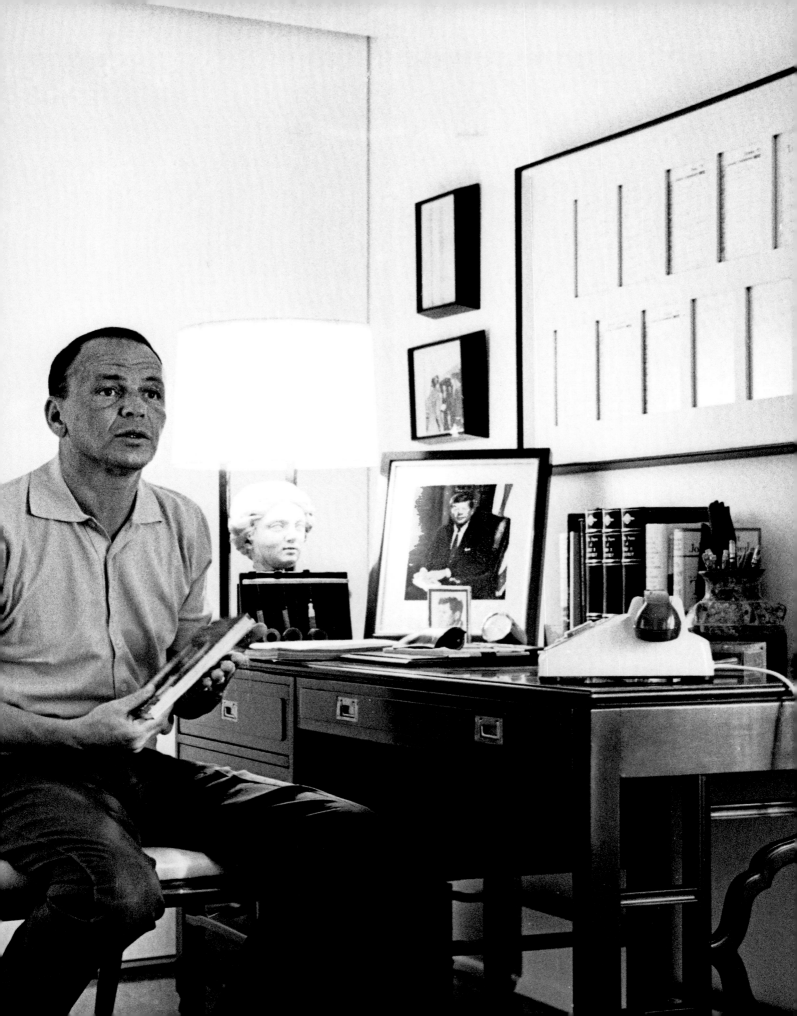

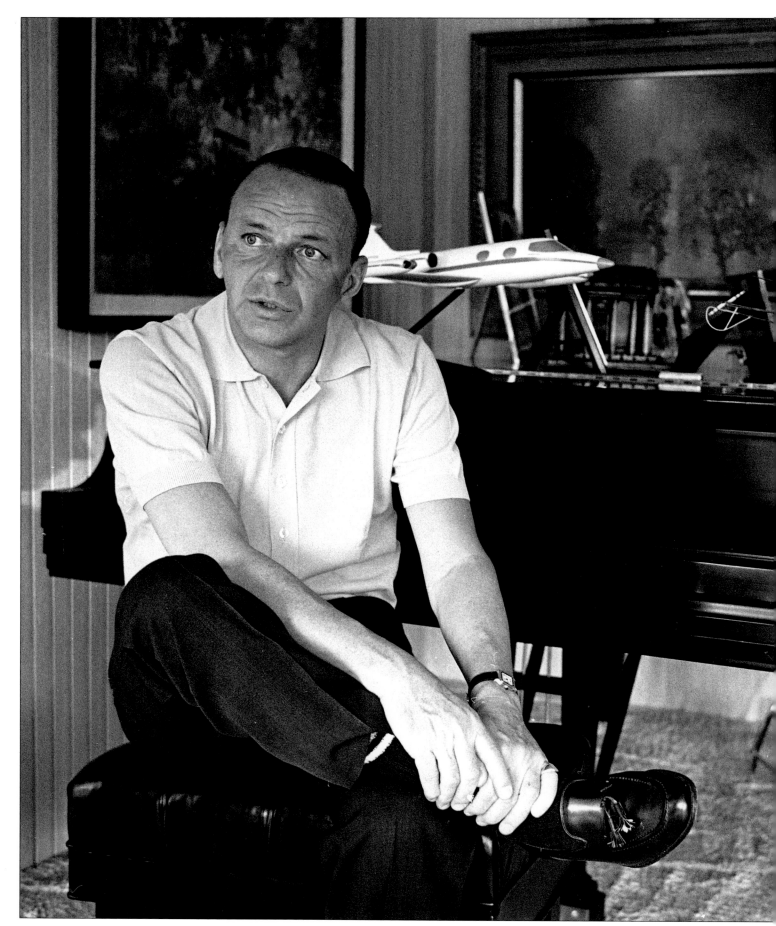

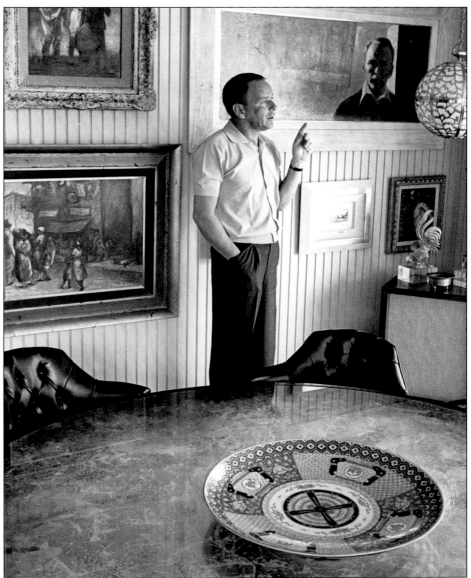

One of Frank's pricey "toys" is his personal jet, a model of which stands behind him. The piano is no toy. He uses it to warm up his voice, singing the phrase "Let us wander by the bay" over and over, progressing two notes at a time up the scale and back. He has an acutely sensitive ear, and orders any piano around him tuned frequently.

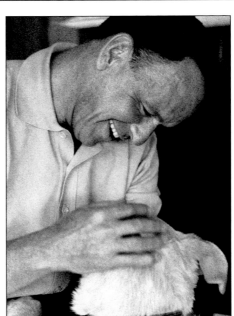

Sinatra's art appreciation began with visits to the Museum of Modern Art when he was in his 20s and singing at the Paramount. And though he competed with the Beatles for air time, Frank named his dog for the Fab Four's drummer.

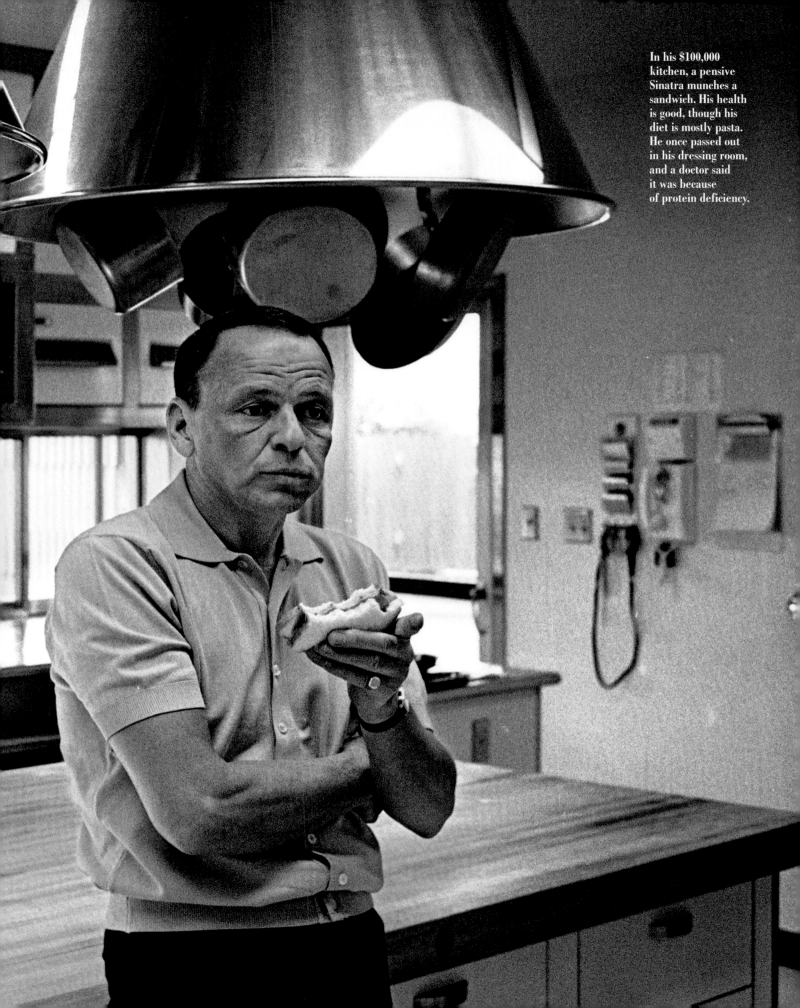

In his $100,000 kitchen, a pensive Sinatra munches a sandwich. His health is good, though his diet is mostly pasta. He once passed out in his dressing room, and a doctor said it was because of protein deficiency.

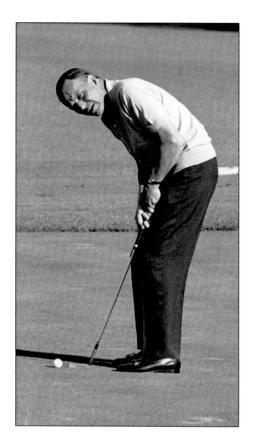

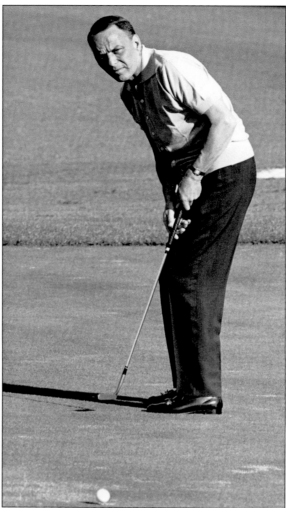

Though certainly no fitness buff, Sinatra likes golf and shoots in the mid-80s. "I haven't got a hobby," he says. "Either I do golf or I do nothing." (Not quite true: He reads voraciously.) The exclusive Tamarisk course is only a few steps from his house — where his putter, this day at least, isn't working.

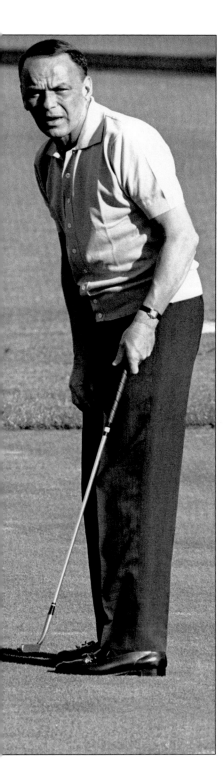

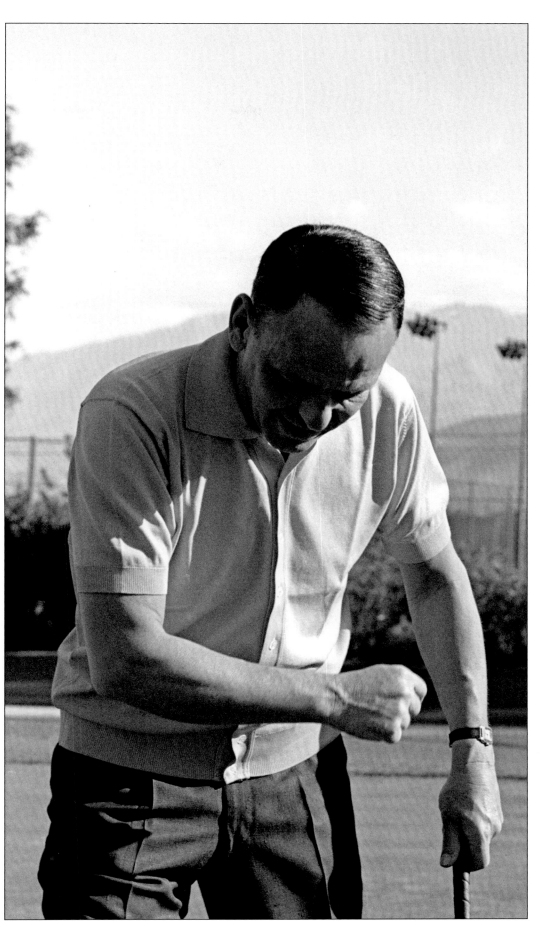

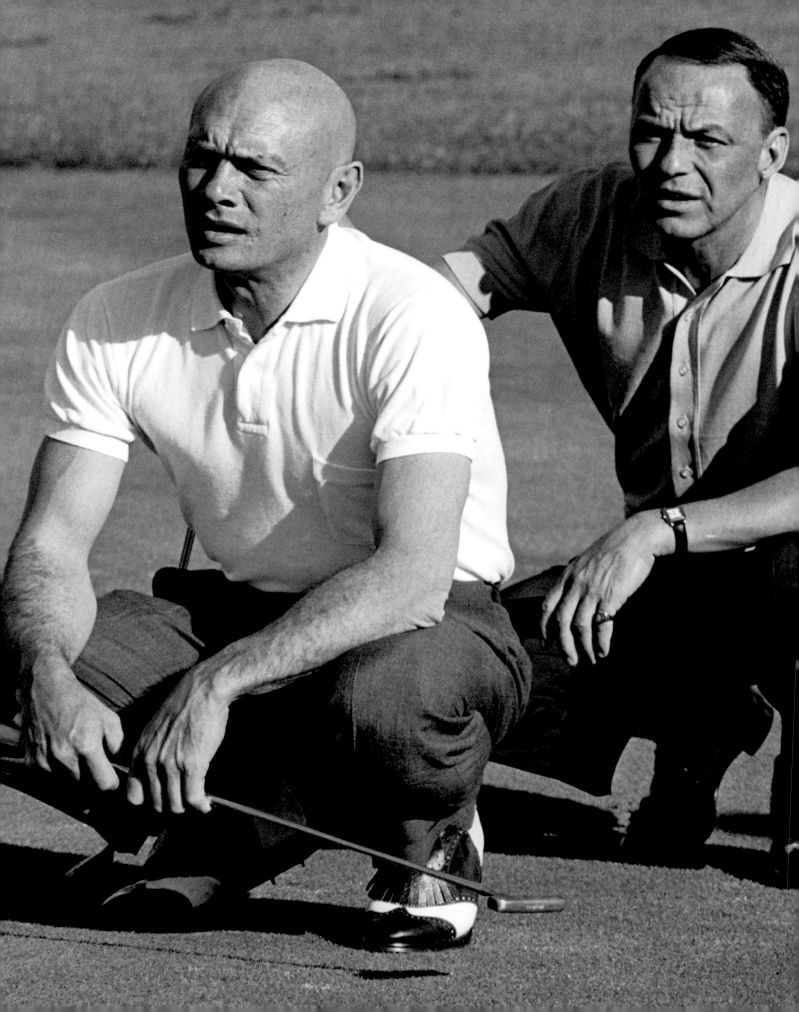

A favorite golf partner is actor Yul Brynner, whom Sinatra has given the affectionate nickname "the Chinaman." In 1966, they appeared together in the movie CAST A GIANT SHADOW. Before marrying Sinatra, his third wife, Mia Farrow, dated Brynner. "I love older men," she declared. "They're exciting, they've lived." At right is another Sinatra form of transportation, along with his jet and helicopter — a winsomely cartooned golf cart.

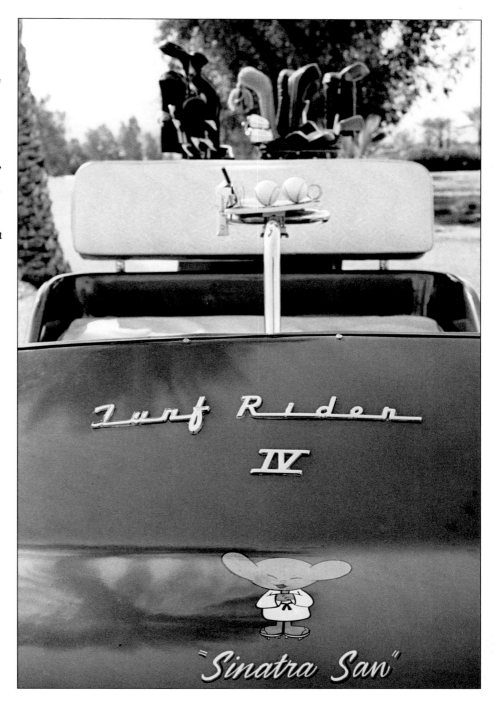

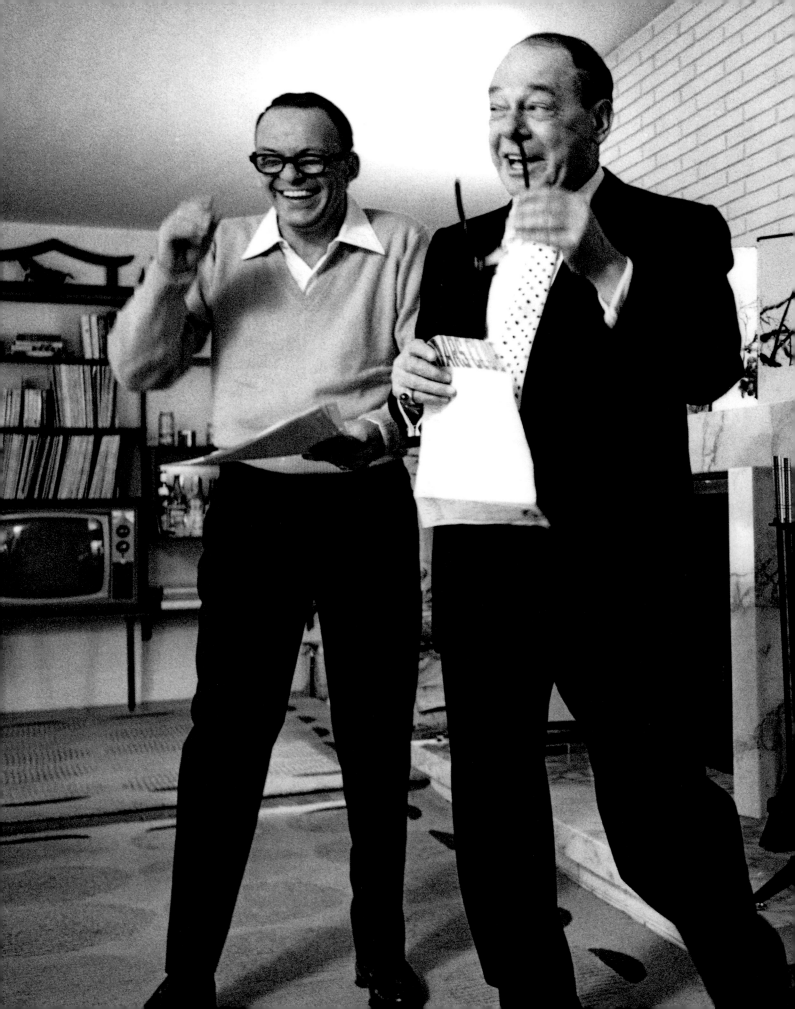

Sinatra's real estate holdings also include homes in Beverly Hills, Acapulco, London, and this five-room apartment overlooking the East River in Manhattan. Today it's a rehearsal space for Frank and Joe E. Lewis.

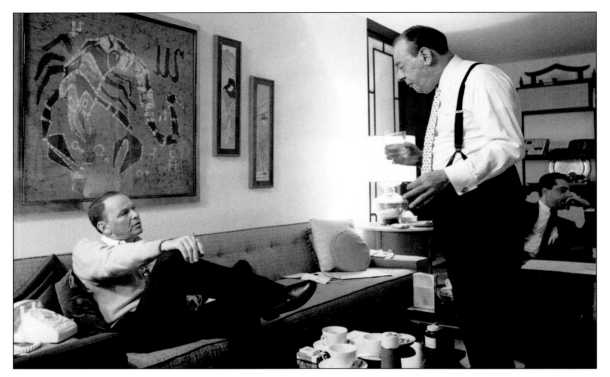

After working with Joe E. on their scripted patter, the singer gets on the phone, taking care of business. Being Sinatra is a complex enterprise — music, movies, television, investments. When speaking of his career, he sounds like a corporate titan: "I put out my fall line of albums while planning the spring line. I do all my general overall planning a year and two months ahead: album-wise, picture-wise, club-wise, concert-wise. It's the only way I can get all my work done."

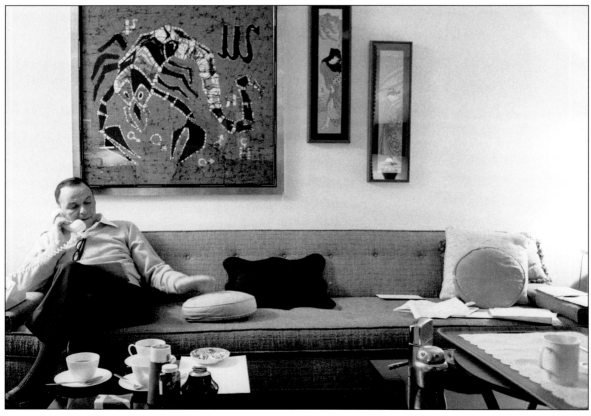

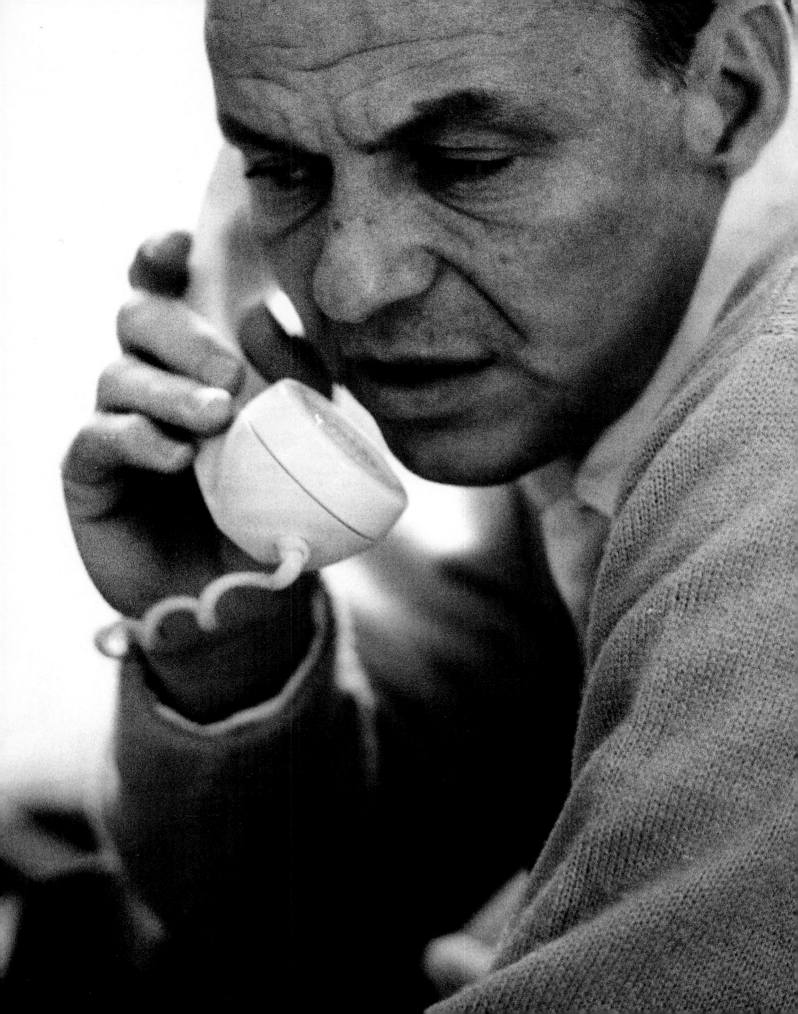

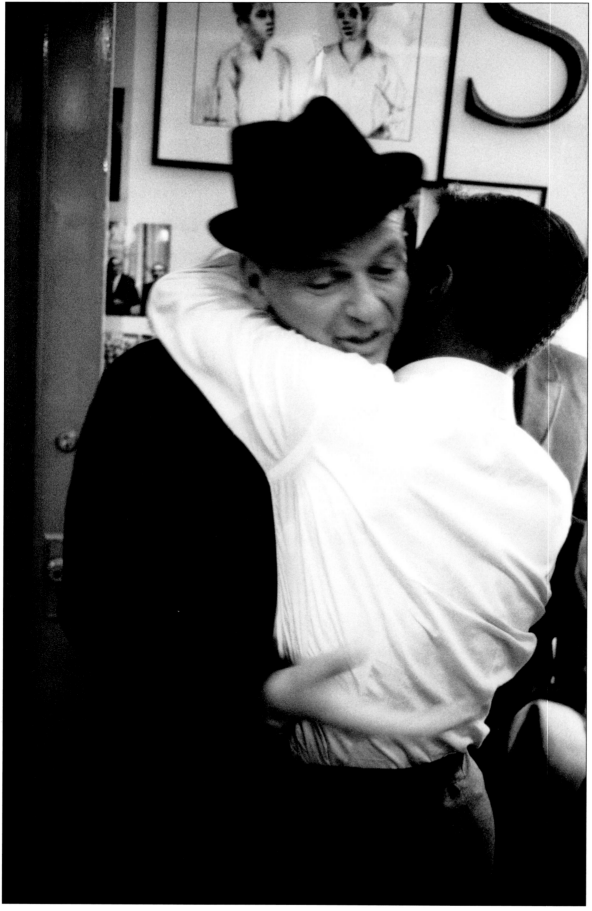

The world called it "the Rat Pack," a title Sinatra disliked. He preferred "Clan" or "Summit." By any name, he was the boss, and Sammy Davis Jr. was a charter member. (The others: Dean Martin, Joey Bishop and Peter Lawford, with Shirley MacLaine often described as "mascot.") The Pack dissolved in the mid-'60s, but the men stayed friends. Here Sinatra pays his respects to Davis, who is starring in the Broadway hit GOLDEN BOY. Before the show, Davis told his cast, "Be especially good tonight. My leader is out front."

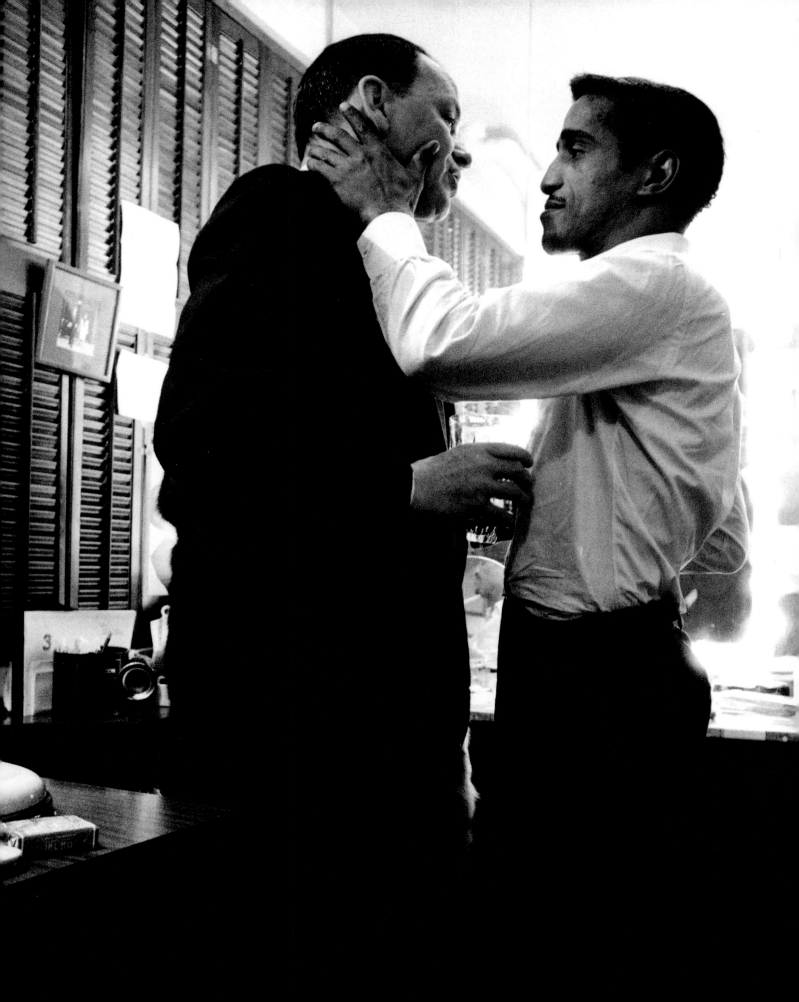

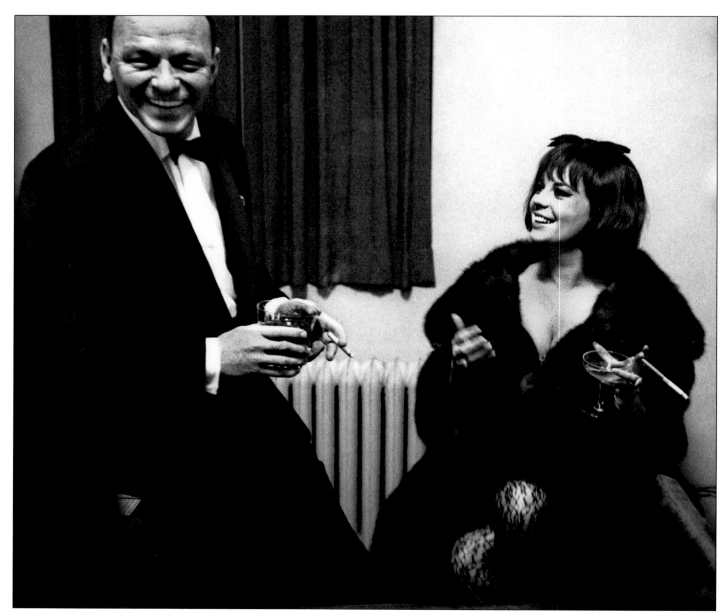

Sinatra's date for the show is actress Natalie Wood, with whom he starred in the 1958 movie KINGS GO FORTH, a part she got because of her relationship with Frank. Like most of his love affairs, theirs was stormy. He once berated her so mercilessly at a party in his home that she fled in tears. But as customary when he lost his temper, he repaired the damage with tenderness and gifts — in Natalie's case, 22 bouquets and 22 musicians to serenade her on her 22nd birthday. "He was Dr. Jekyll and Mr. Hyde," one woman friend remarked, "and you didn't know which one you were going to get." Natalie is puffing on a cigarette in spite of Sinatra's avowed prejudice against women "who smoke from the moment they open their eyes until they put out the light at night — that drives me batty."

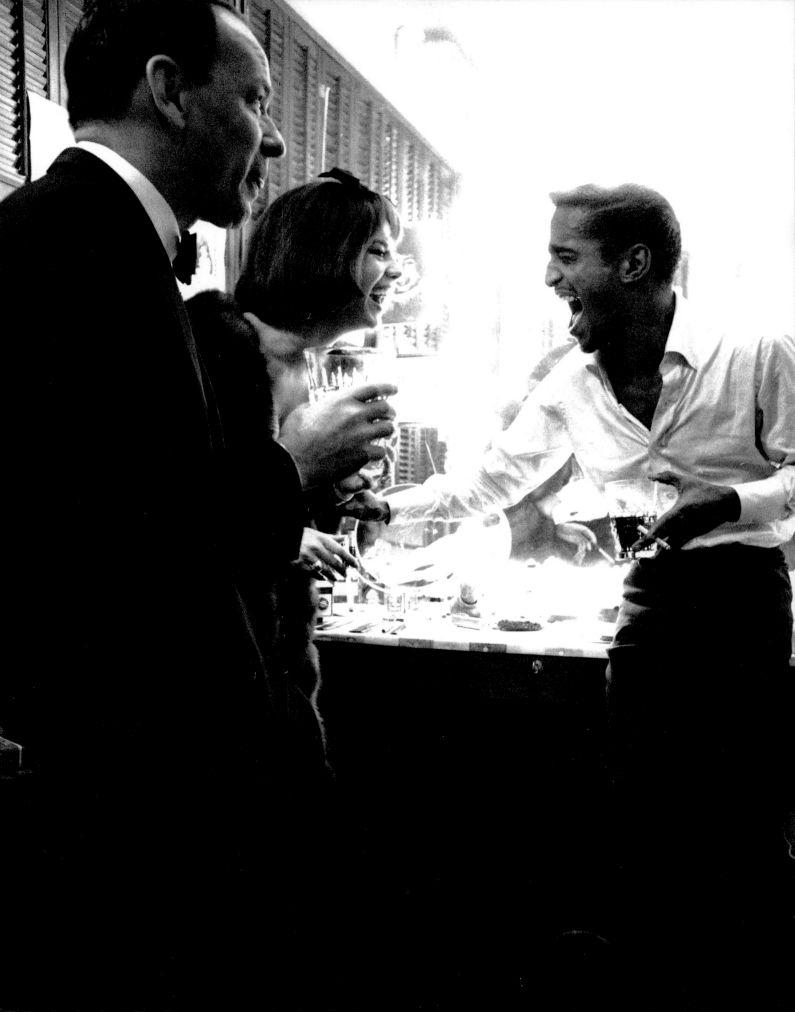

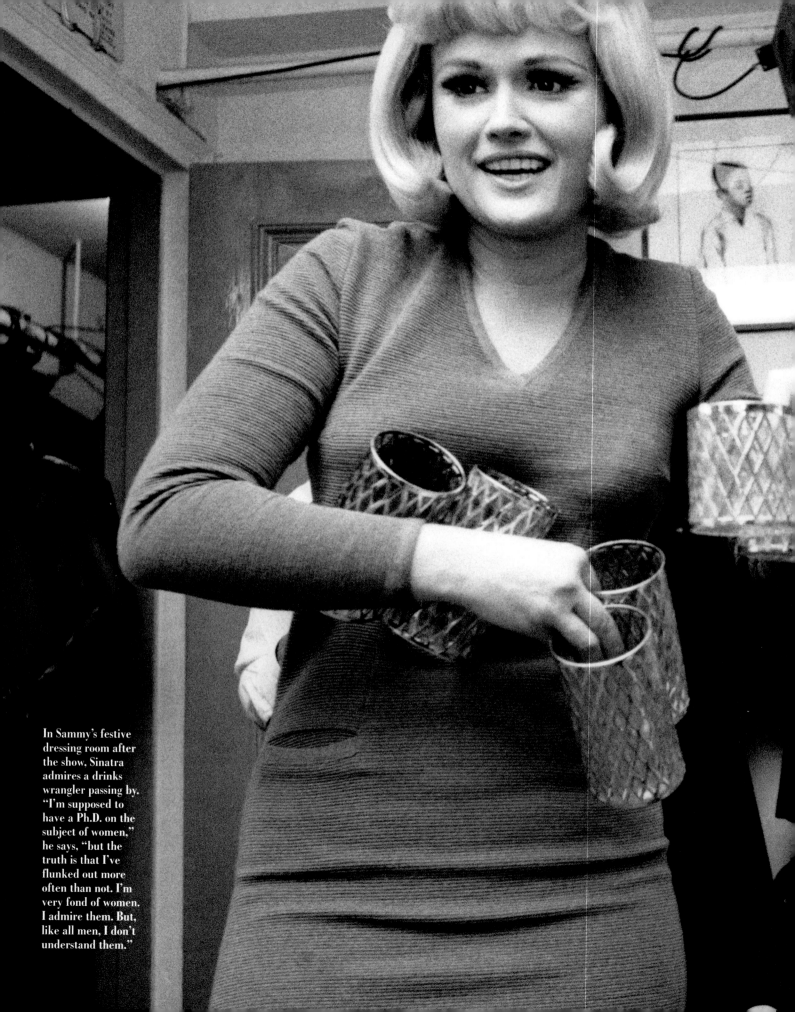

In Sammy's festive dressing room after the show, Sinatra admires a drinks wrangler passing by. "I'm supposed to have a Ph.D. on the subject of women," he says, "but the truth is that I've flunked out more often than not. I'm very fond of women. I admire them. But, like all men, I don't understand them."

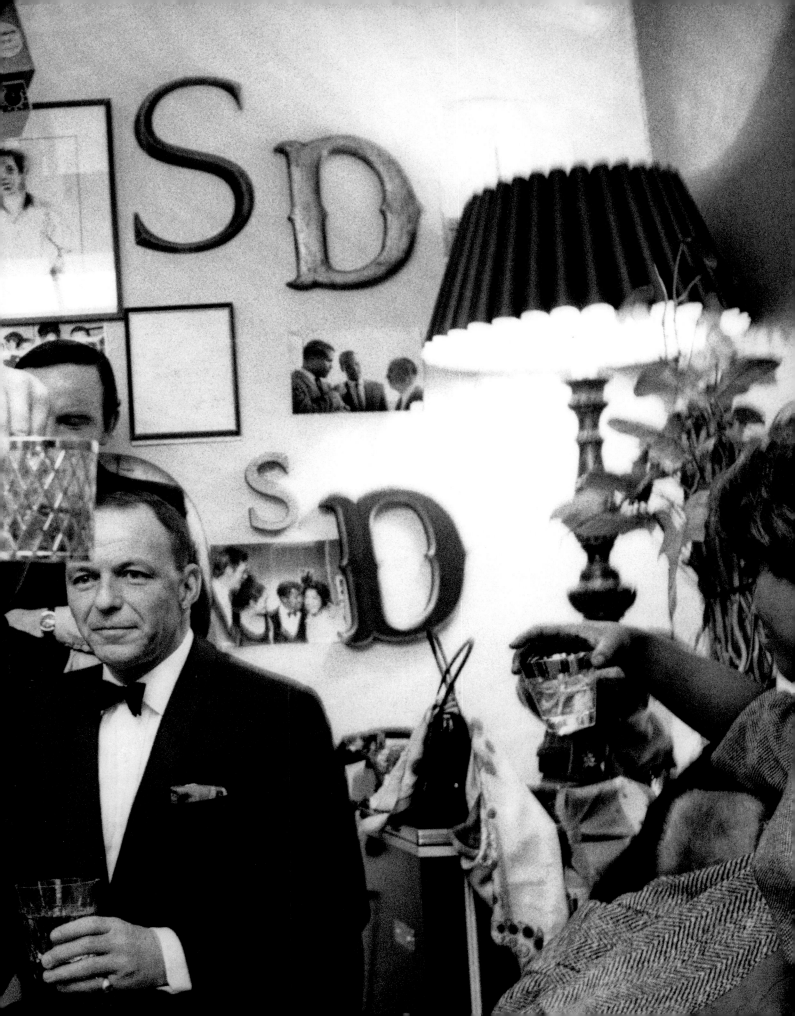

ALL OF ME

FROM WHAT HE RECALLS AS "THAT strange sound in the audience" (teenagers swooning), his career ascended unstoppably – singer, producer, label owner. In movies the path was the same: actor, director, producer. The high school dropout became Frank Sinatra, Tycoon. And he acted like one. His politics morphed from liberal to conservative, his musical opinions followed: He once called rock 'n' roll a "rancid-smelling aphrodisiac." In terms of charity, though, he was anything but a corporate skinflint. His acts of personal generosity were beyond counting (he offered Vegas pal and veteran actor George Raft a blank check "up to one million dollars" to settle back taxes). Even more impressive were his fund-raising performances, which collected millions – for civil rights, Israel, hospitals, schools, museums, children, and movie and TV charities.

Sinatra commutes from his Palm Springs home to the L.A. airport by personal jet (sixteen minutes), and from there to his office at Warner Bros. (six minutes) in this French jet helicopter, which set him back $120,000. With him is his pilot, Don Lieto. During the Cuban missile crisis in 1962, Sinatra put Lieto on round-the-clock notice and equipped his jet with a month's provisions, in case atomic war broke out and he had to evacuate.

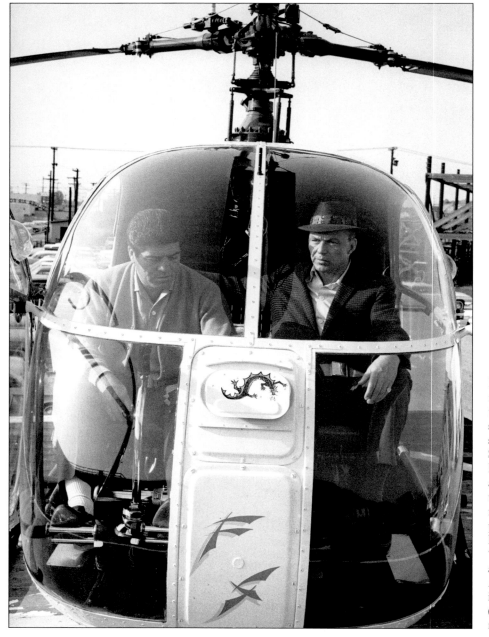

Frank Sinatra, business executive, goes to work in white shirt, tie and shoeshine. His company, Sinatra Enterprises, has interests in movie and record production, a private airline, missile and aircraft parts and real estate. His payroll includes 75 employees and advisers. His income? An informed estimate is $3.5 million a year (mid-'60s dollars, remember).

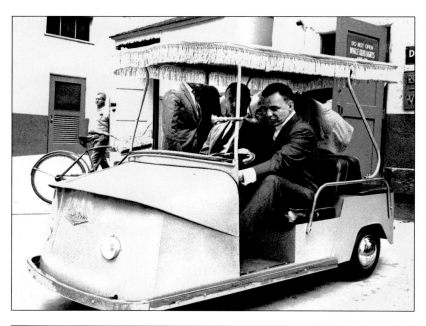

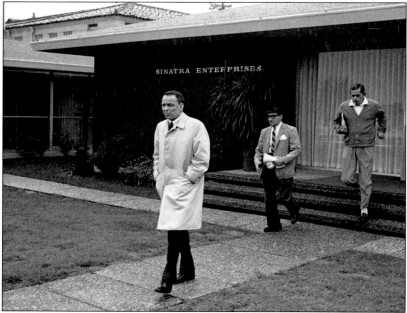

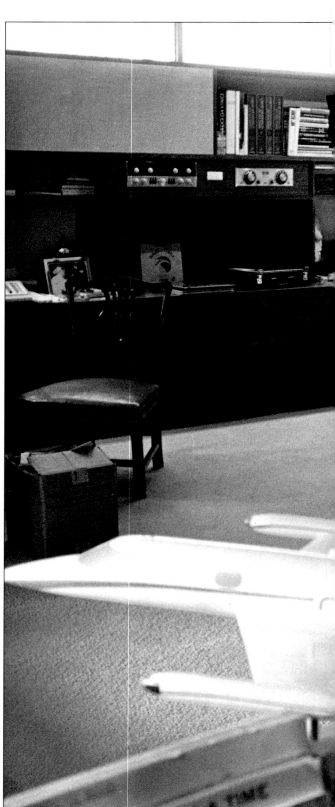

Sinatra feels at home at Warner's in Burbank — on backlot transportation or at his own office building on the studio grounds. In 1963, he sold two-thirds of his record label, Reprise, and his services as an actor in several movies, as well as some other ventures, to Warner Bros. The price was a reported $3.5 million. The deal also included Frank's casino holdings in Las Vegas, which Nevada officials insisted that he divest because of his Mob friendships.

Because his personal office includes a kitchen, Sinatra often uses it for business lunches — typically, prosciutto and melon, fruit salad, cheese, and chilled red wine. Surveying his life before his 50th birthday in 1965, Sinatra admits, "I guess I'm now financially secure."

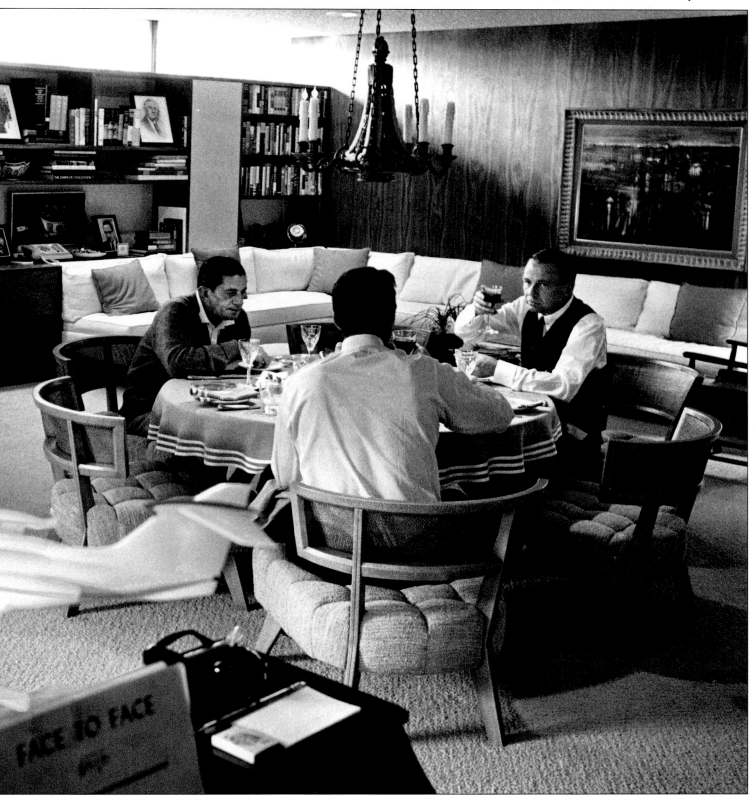

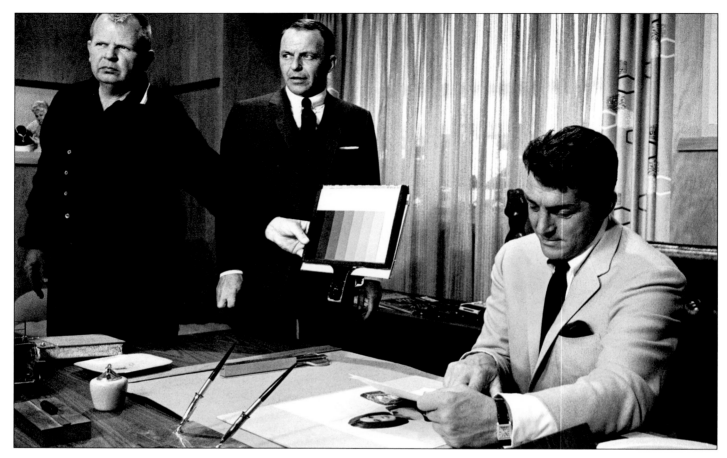

In his 38th film, Frank plays an advertising exec in MARRIAGE ON THE ROCKS, also starring Dean Martin — and as so often happens with these two, the scene dissolves into a goofy joke. The movie is produced by Sinatra's own company, Artanis (spell it backward). Of his films with Martin and other Rat Pack members, Sinatra concedes: "Of course they're not great movies. No one could claim that."

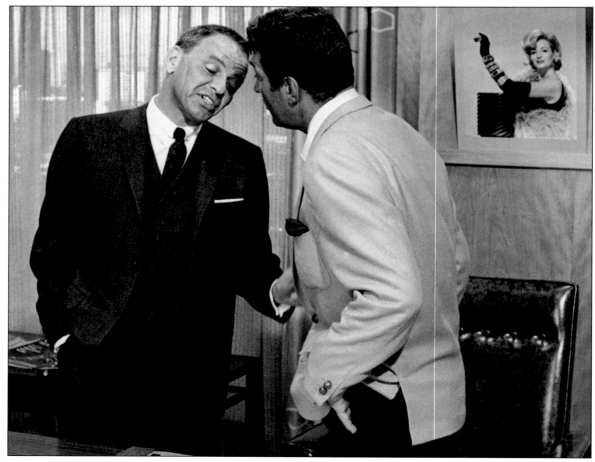

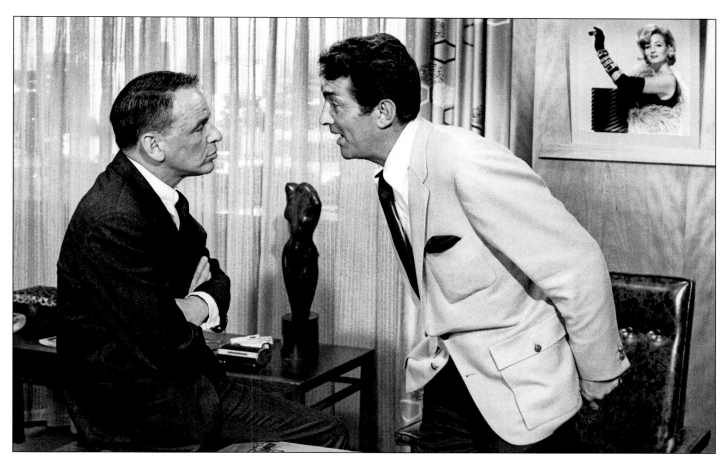

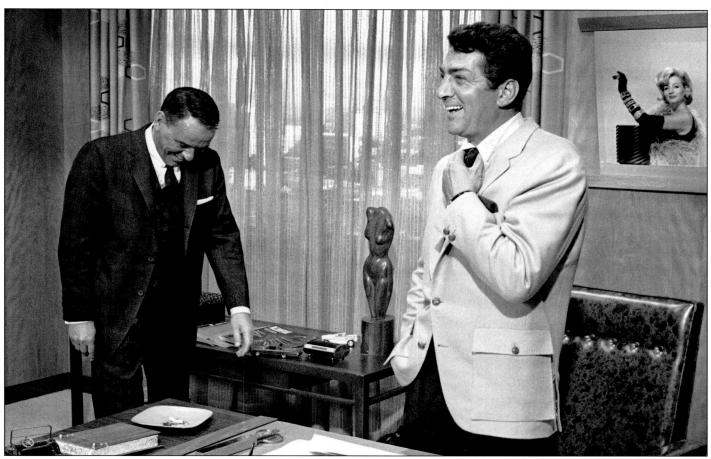

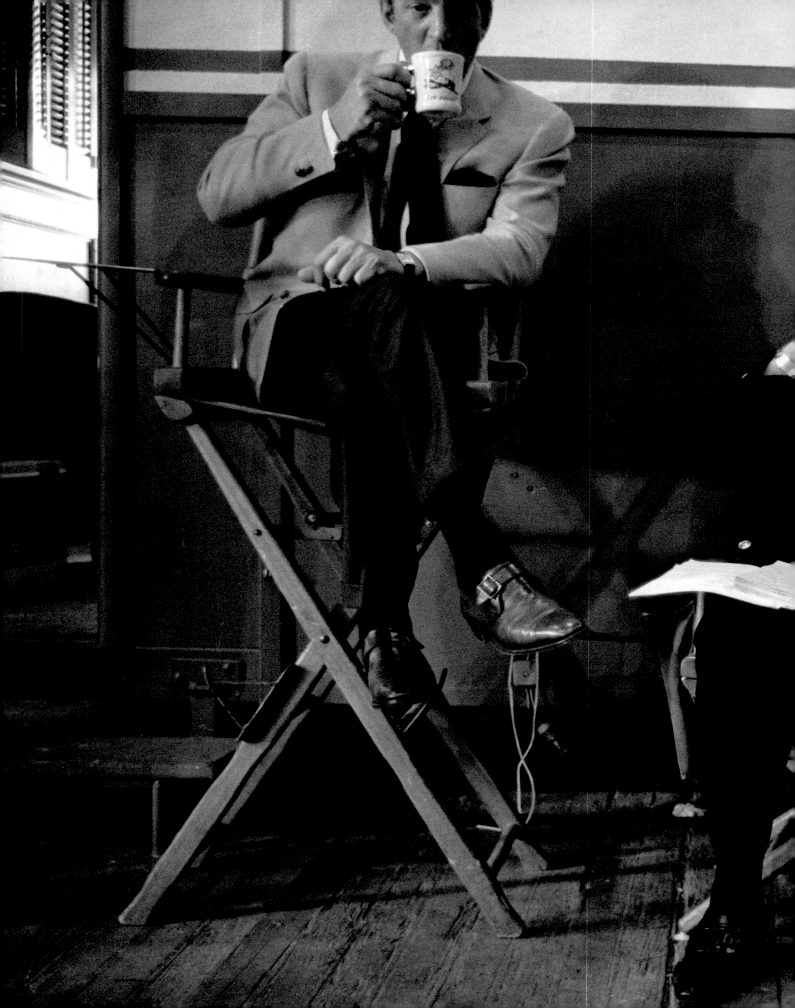

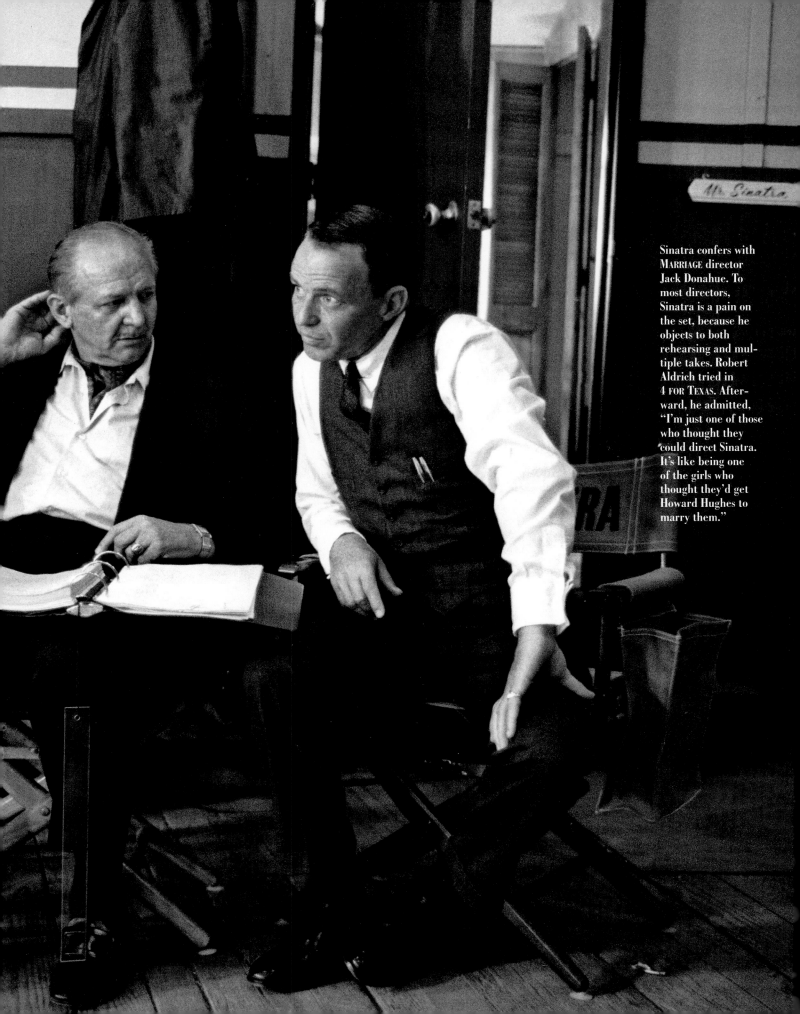

Sinatra confers with MARRIAGE director Jack Donahue. To most directors, Sinatra is a pain on the set, because he objects to both rehearsing and multiple takes. Robert Aldrich tried in 4 FOR TEXAS. Afterward, he admitted, "I'm just one of those who thought they could direct Sinatra. It's like being one of the girls who thought they'd get Howard Hughes to marry them."

Moviemaking is fuss-fuss, then wait-wait. Film crews generally like Sinatra, although his moods — depending on delays and hangovers — can be ugly. Frank's movie career is riding high now. Ten years earlier, it was in the absolute dumps. Then (with the help of his wife, Ava Gardner) he begged his way into the cast of FROM HERE TO ETERNITY, the powerful World War II drama, and won the Oscar for Best Supporting Actor in 1953. He earned only $8,000 for the role, but it was Hollywood's greatest comeback, and it changed his fortunes forever.

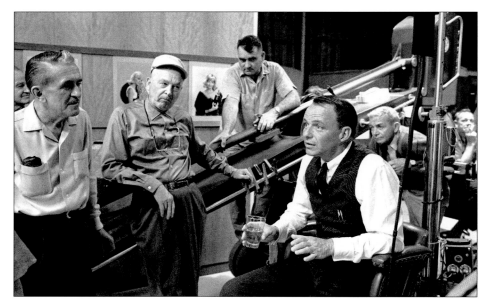

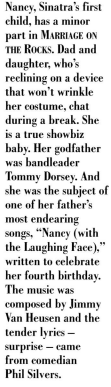

Nancy, Sinatra's first child, has a minor part in MARRIAGE ON THE ROCKS. Dad and daughter, who's reclining on a device that won't wrinkle her costume, chat during a break. She is a true showbiz baby. Her godfather was bandleader Tommy Dorsey. And she was the subject of one of her father's most endearing songs, "Nancy (with the Laughing Face)," written to celebrate her fourth birthday. The music was composed by Jimmy Van Heusen and the tender lyrics — surprise — came from comedian Phil Silvers.

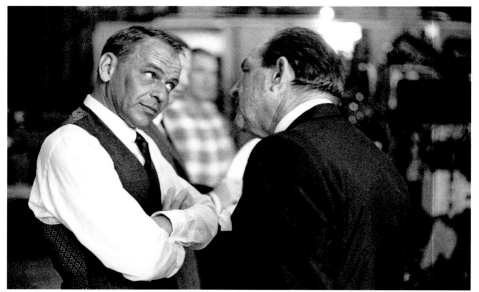

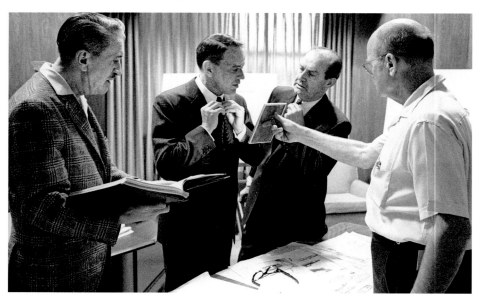

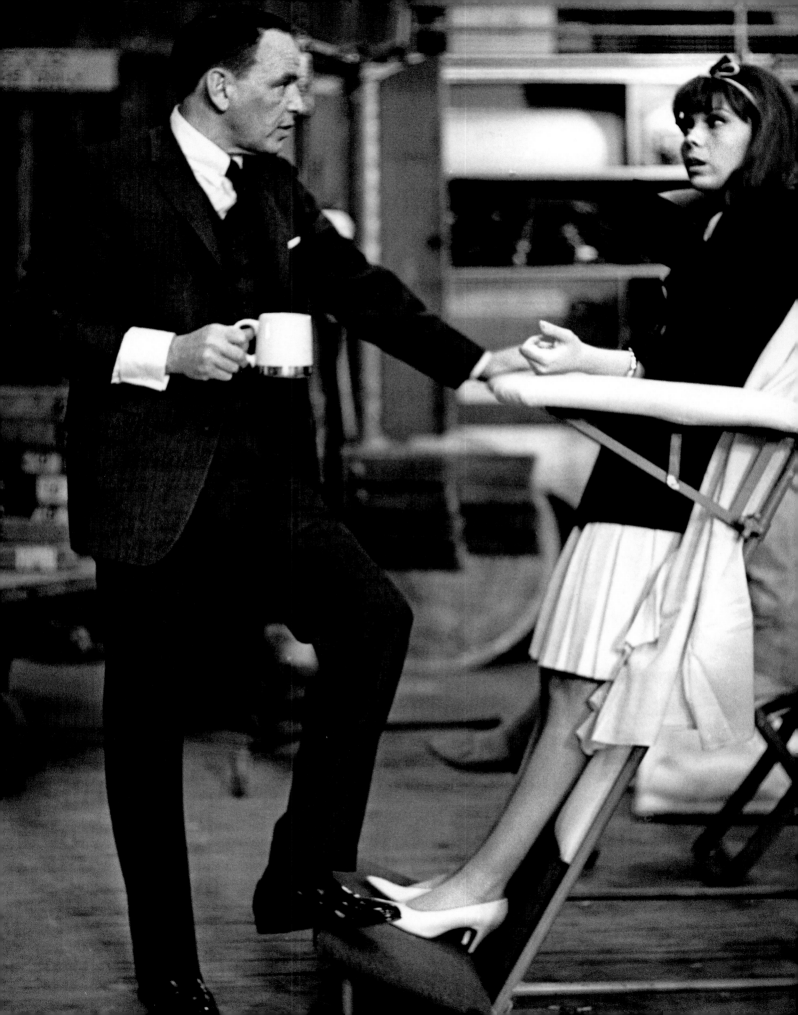

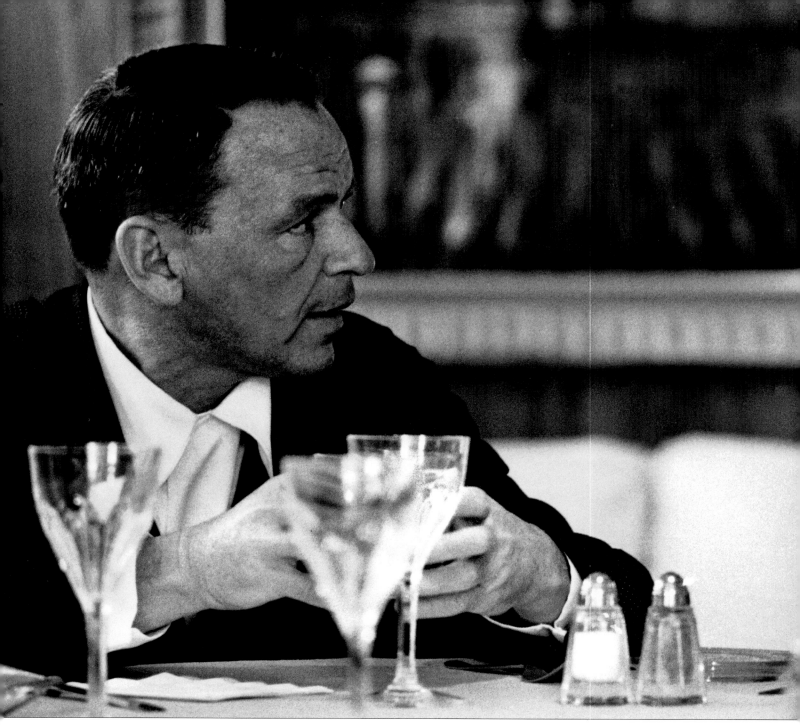

In a meeting of Hollywood titans, Sinatra and Jack Warner power lunch in the singer's office. The two men do a lot of business together and are friendly enough that Frank stays at Warner's house on the French Riviera. But their relationship is both warm and wary. Warner named Frank his "special assistant," but mostly to keep an eye on him. When the press carried rumors that Sinatra might try to succeed him as president or even buy the studio, Jack issued a cold, stern denial: "There is no evidence or reason for such speculation." Both Sinatra and Dean Martin are in pajamas and robes for their MARRIAGE movie roles.

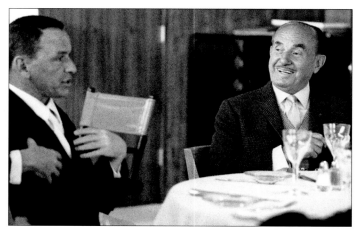

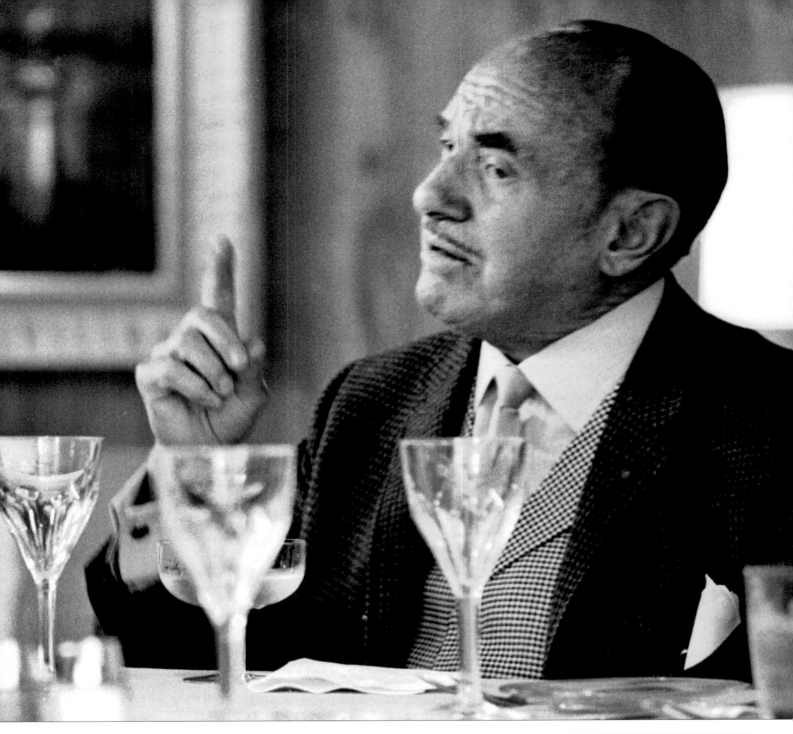

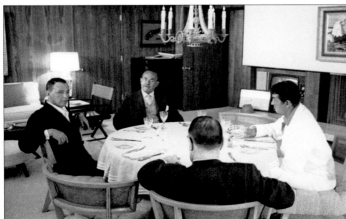

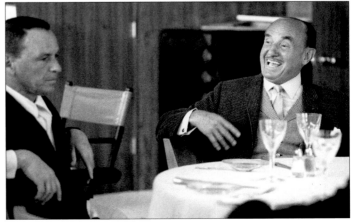

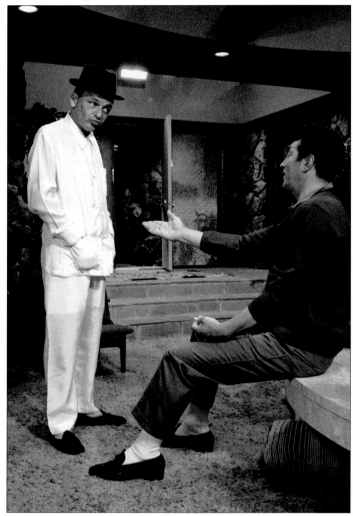

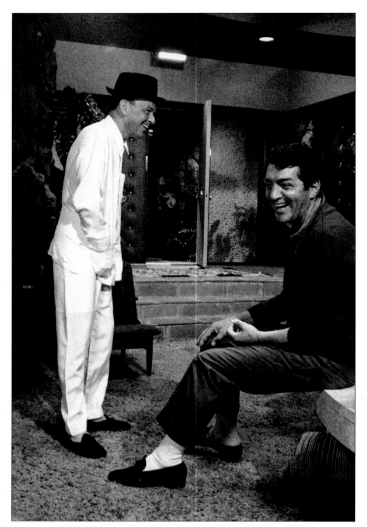

It's horseplay on the set again. The two pals tour, do TV and make records together in addition to movies. Dean feels comfortable enough to joke about his touchy friend — when

Frank fell for 19-year-old Mia Farrow, Martin cracked, "I've got Scotch older than her." Yet he is careful to respect Sinatra's moodiness and his obsession with privacy. By Martin's

account, their conversations are pretty circumscribed. "I don't discuss his girl with Frank or who he's going to marry. All I discuss are movies, TV, golf and drinking."

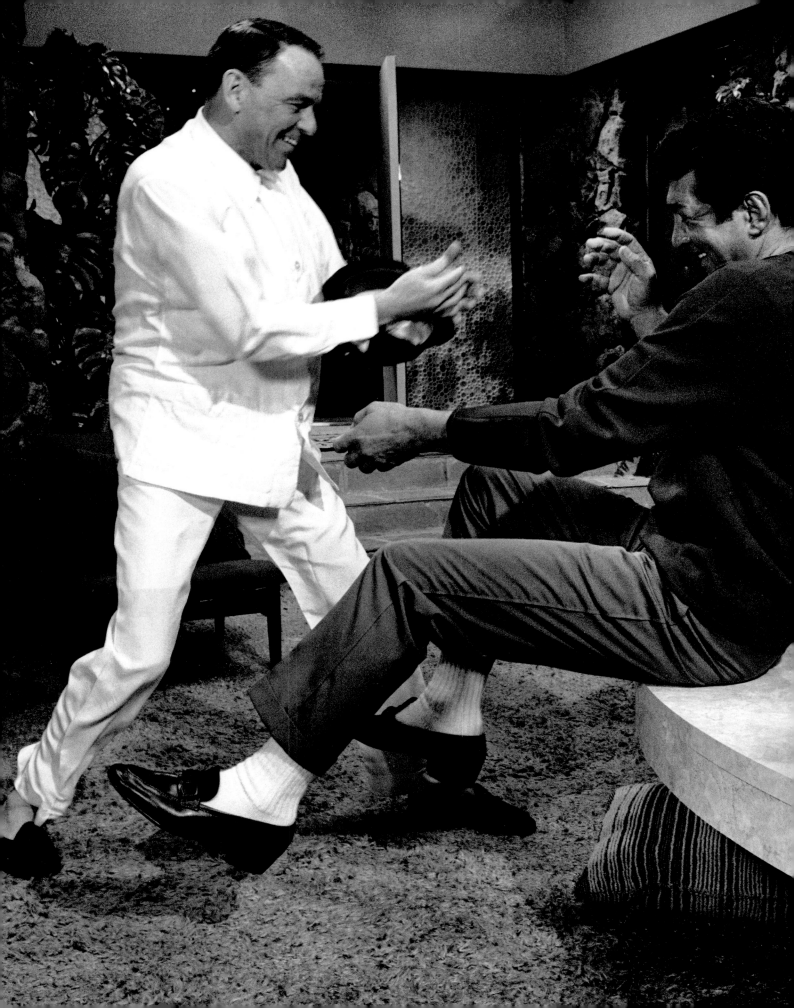

Sinatra can't resist jokes, at least with Dean, so he dons a Hitler mustache and a fedora, and pops through a door on the set. Martin is at first startled, then visibly appreciative. The two stars (plus Deborah Kerr) should probably have devoted more time to moviemaking than to mischief. The film turned out to be eminently forgettable. The NEW YORK TIMES critic called it "a tawdry and witless trifle about a bored married man."

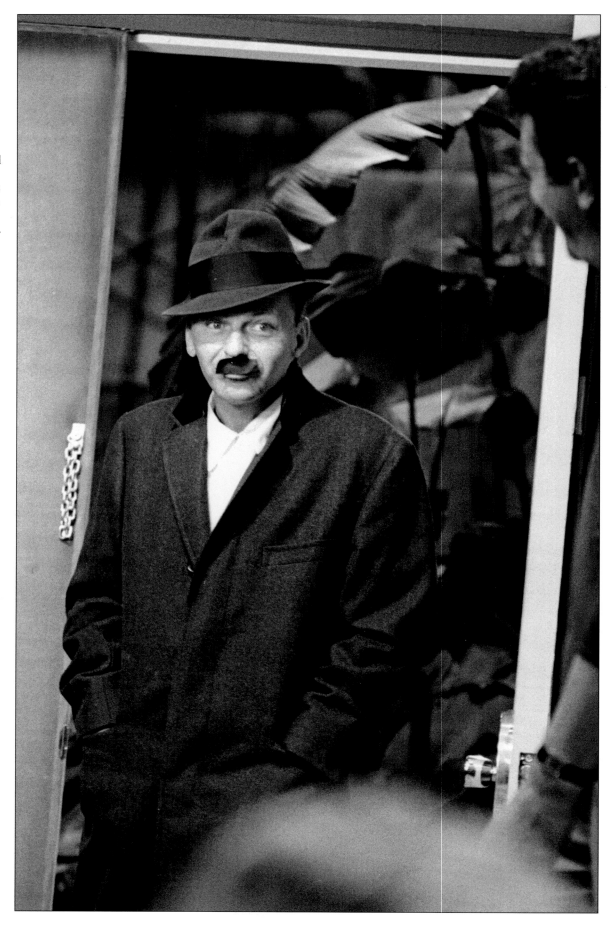

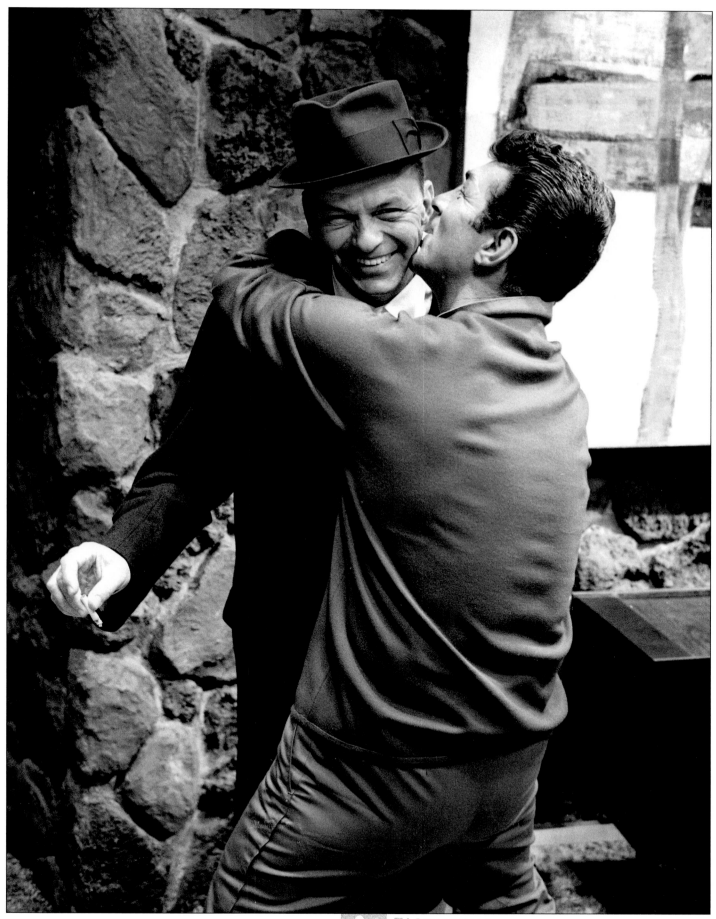

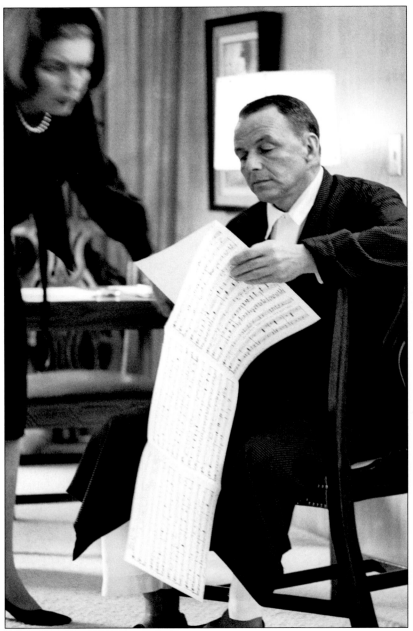

The nonchalance that characterizes his acting never slops over into his music. Quite the contrary. He is a meticulous craftsman about performing and recording. Above, while filming MARRIAGE, he takes time out to look over some song sheets with utmost seriousness. At right, a focused Sinatra is beginning rehearsals in Los Angeles with the Count Basie band for a big Las Vegas show in late 1964.

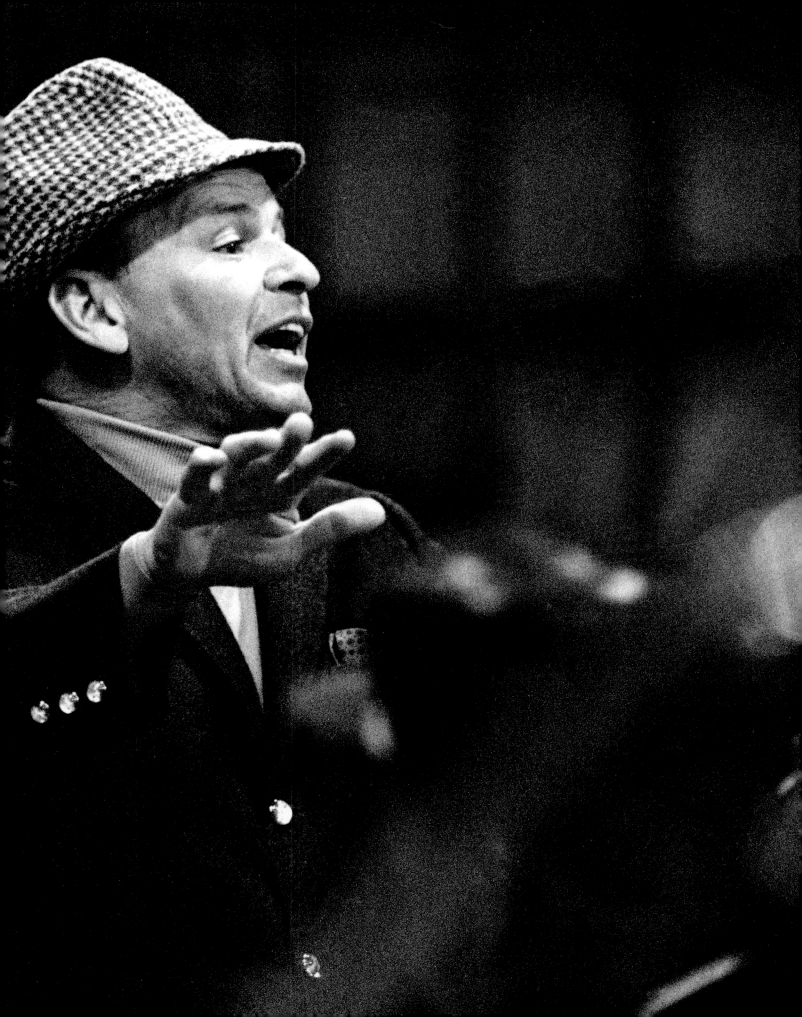

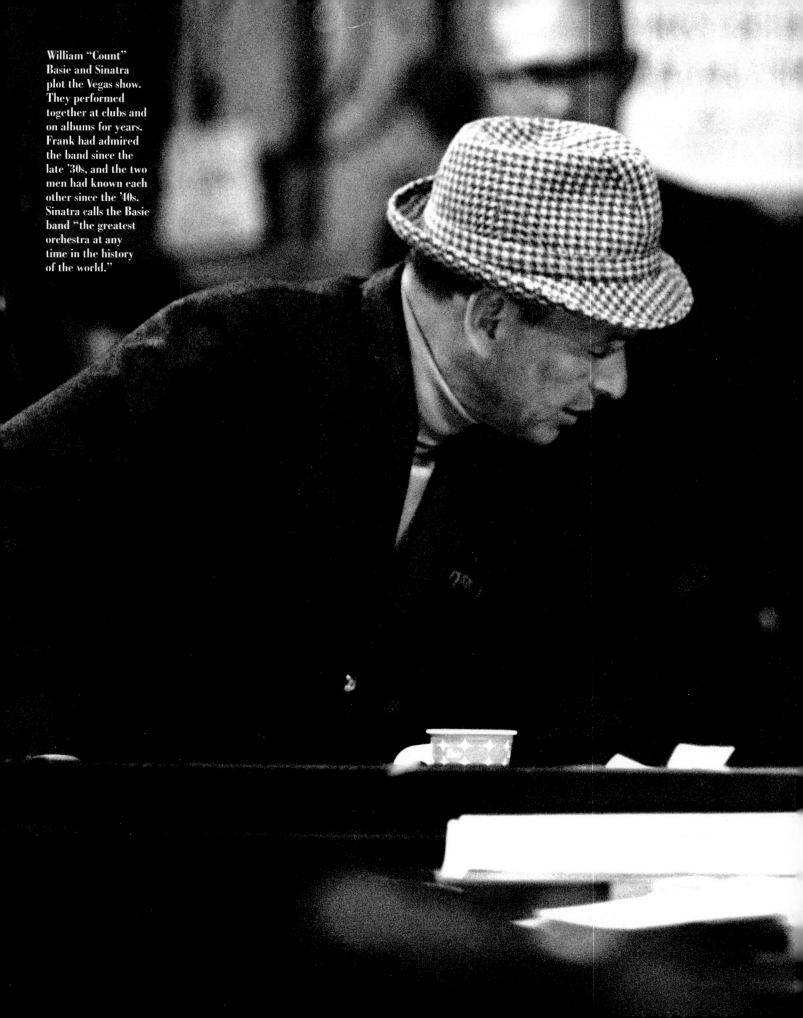

William "Count" Basie and Sinatra plot the Vegas show. They performed together at clubs and on albums for years. Frank had admired the band since the late '30s, and the two men had known each other since the '40s. Sinatra calls the Basie band "the greatest orchestra at any time in the history of the world."

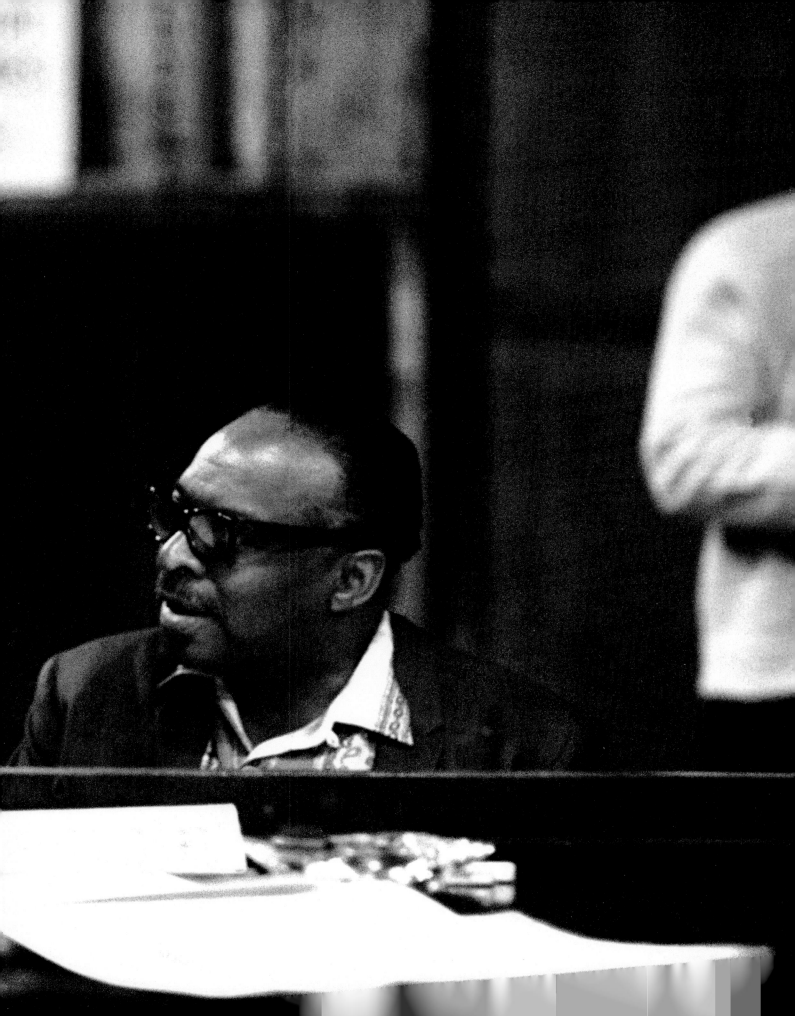

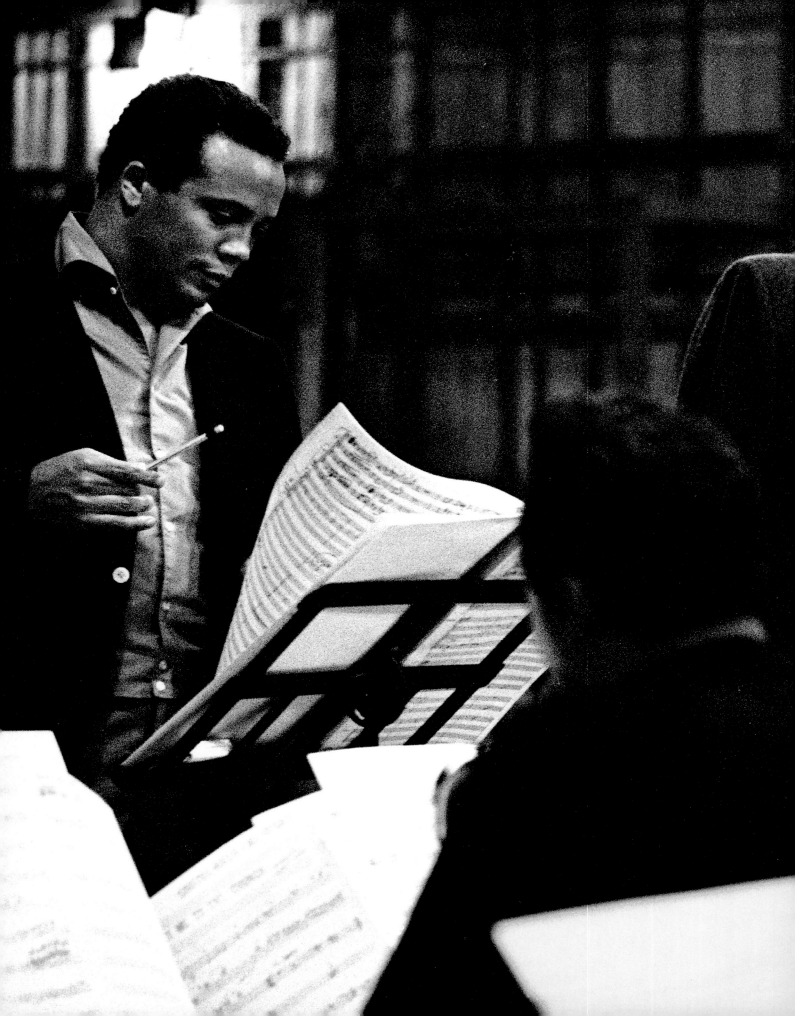

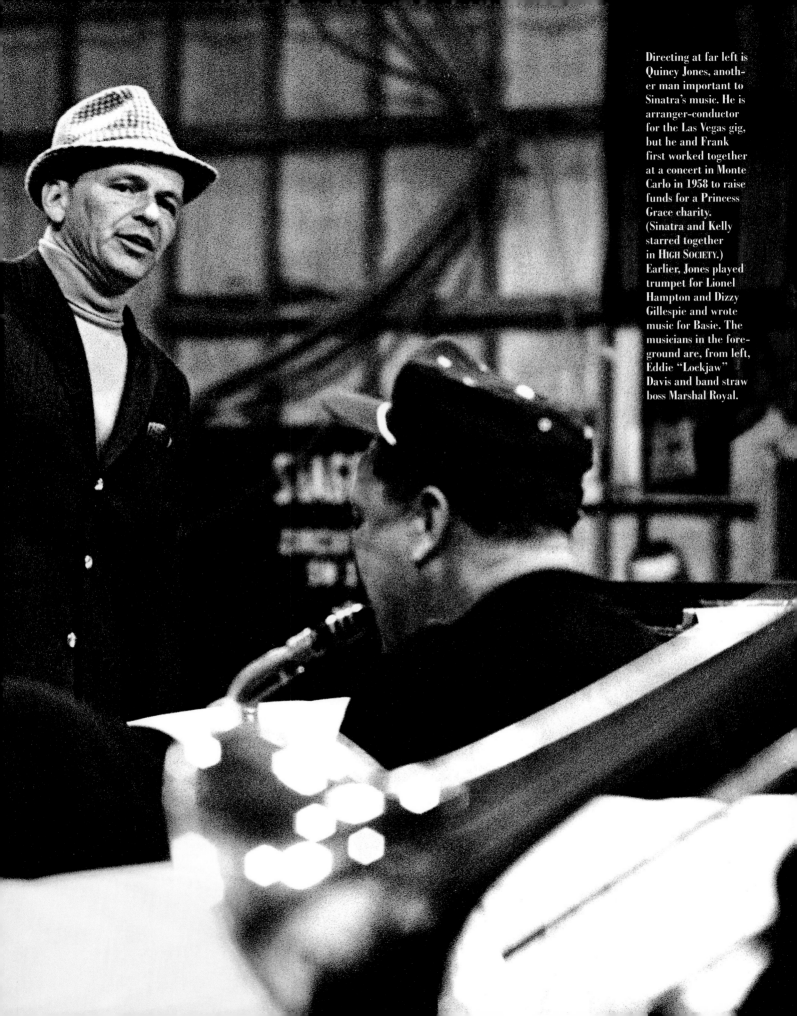

Directing at far left is Quincy Jones, another man important to Sinatra's music. He is arranger-conductor for the Las Vegas gig, but he and Frank first worked together at a concert in Monte Carlo in 1958 to raise funds for a Princess Grace charity. (Sinatra and Kelly starred together in HIGH SOCIETY.) Earlier, Jones played trumpet for Lionel Hampton and Dizzy Gillespie and wrote music for Basie. The musicians in the foreground are, from left, Eddie "Lockjaw" Davis and band straw boss Marshal Royal.

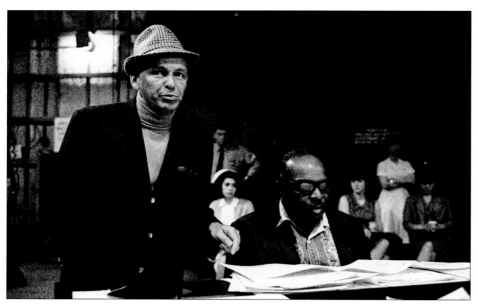

Because the rehearsal is on an L.A. soundstage, guests are allowed to come by and listen. Out of the collaboration among Sinatra, Basie and Jones came two albums, IT MIGHT AS WELL BE SWING and SINATRA AT THE SANDS. To plan the first album, Jones flew to Hawaii while Sinatra was producing, directing and starring in another war movie, NONE BUT THE BRAVE. Jones recalls that Sinatra's bungalow had a flag flying over it, bearing not the stars and stripes but a bottle of Jack Daniel's.

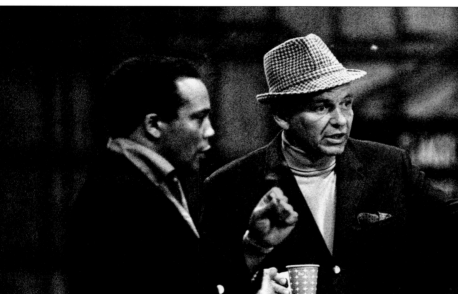

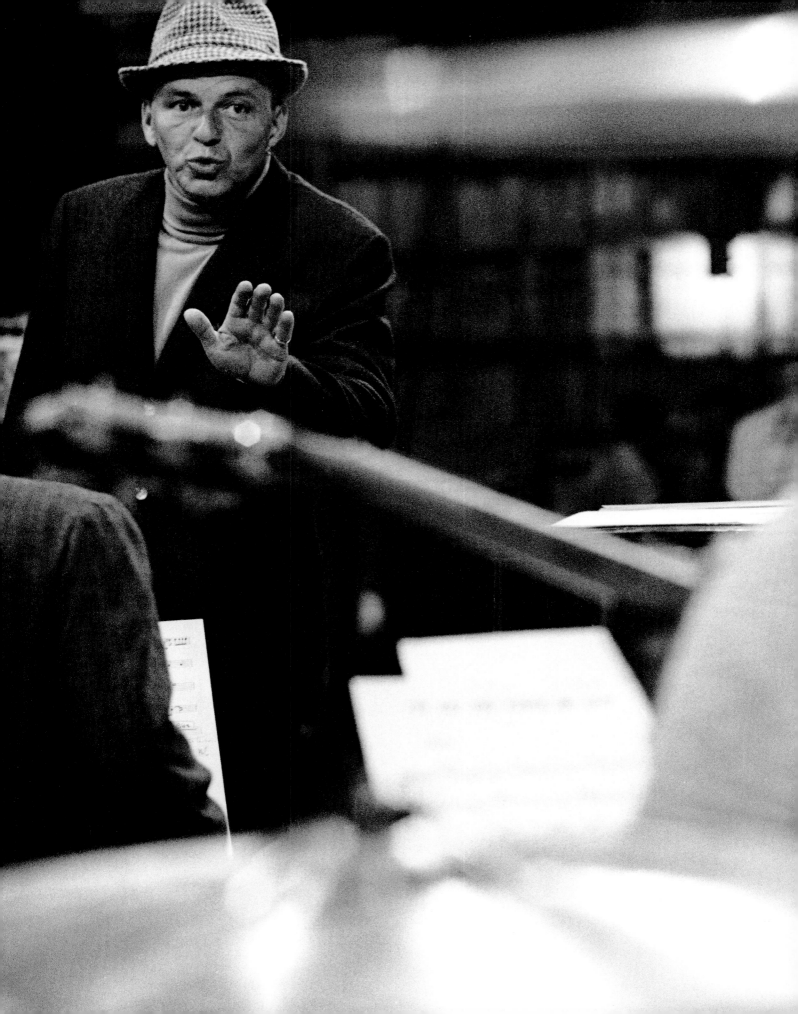

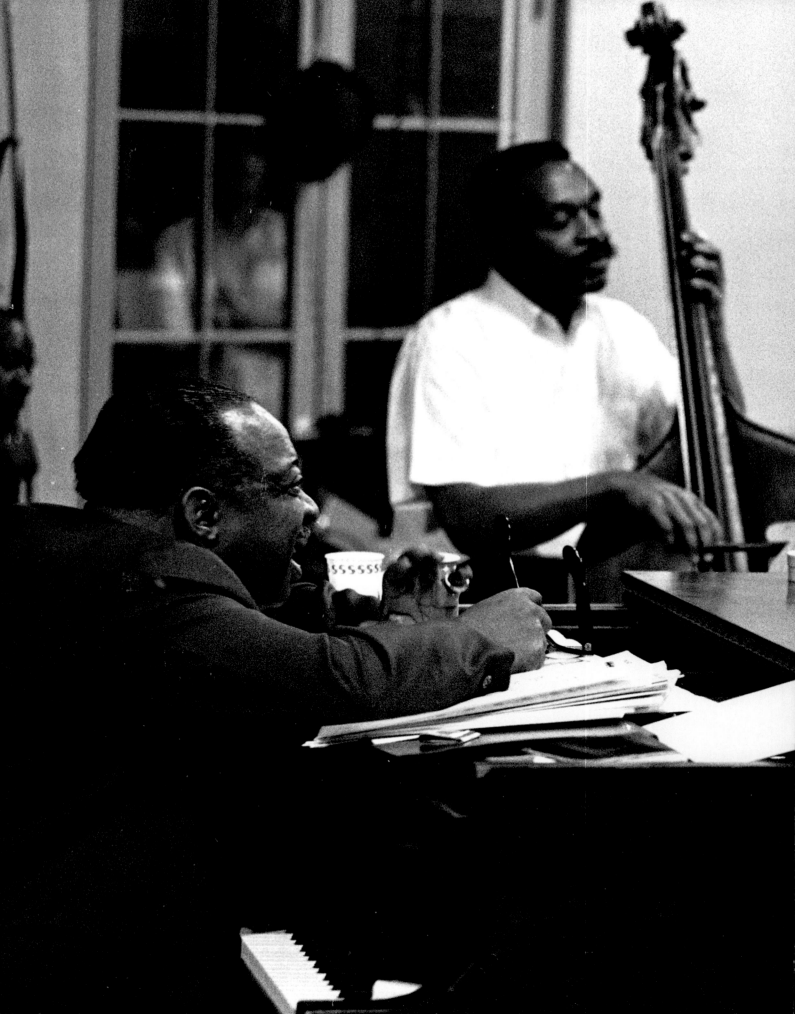

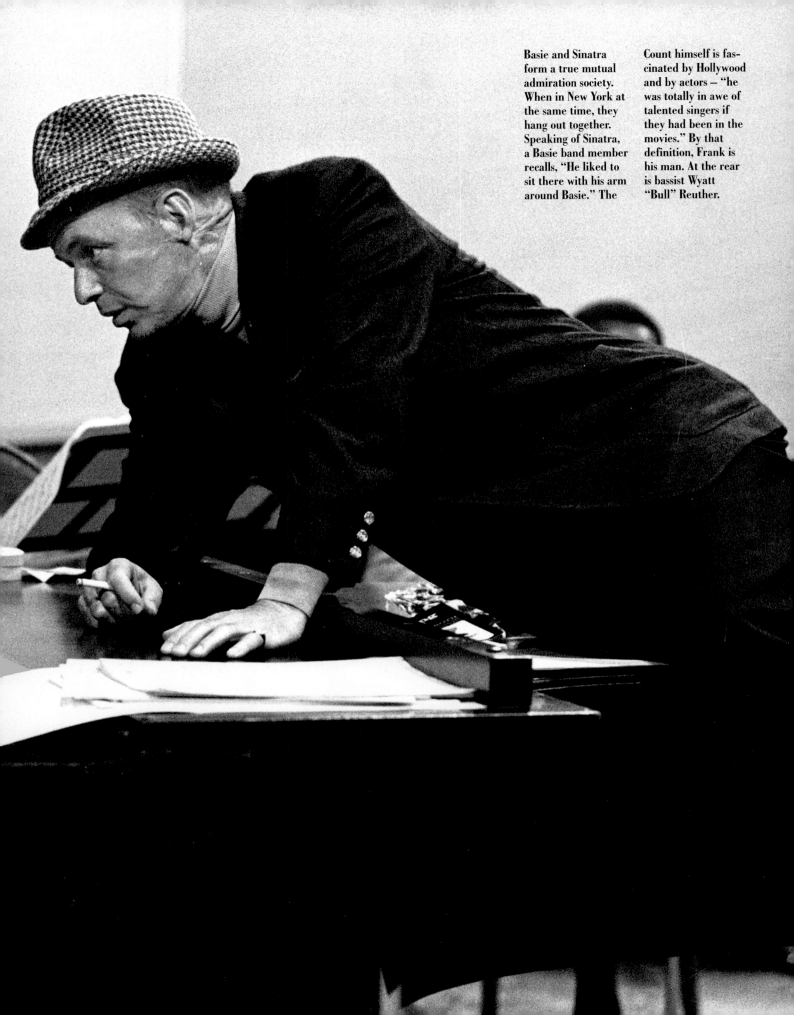

Basie and Sinatra form a true mutual admiration society. When in New York at the same time, they hang out together. Speaking of Sinatra, a Basie band member recalls, "He liked to sit there with his arm around Basie." The Count himself is fascinated by Hollywood and by actors — "he was totally in awe of talented singers if they had been in the movies." By that definition, Frank is his man. At the rear is bassist Wyatt "Bull" Reuther.

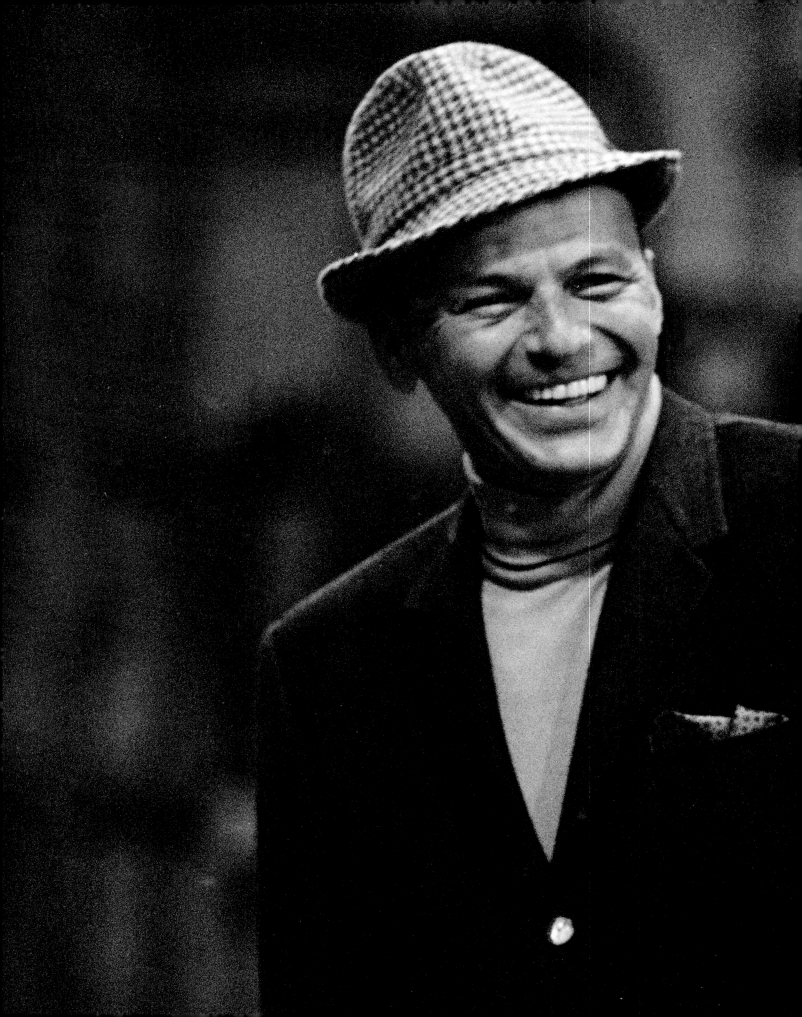

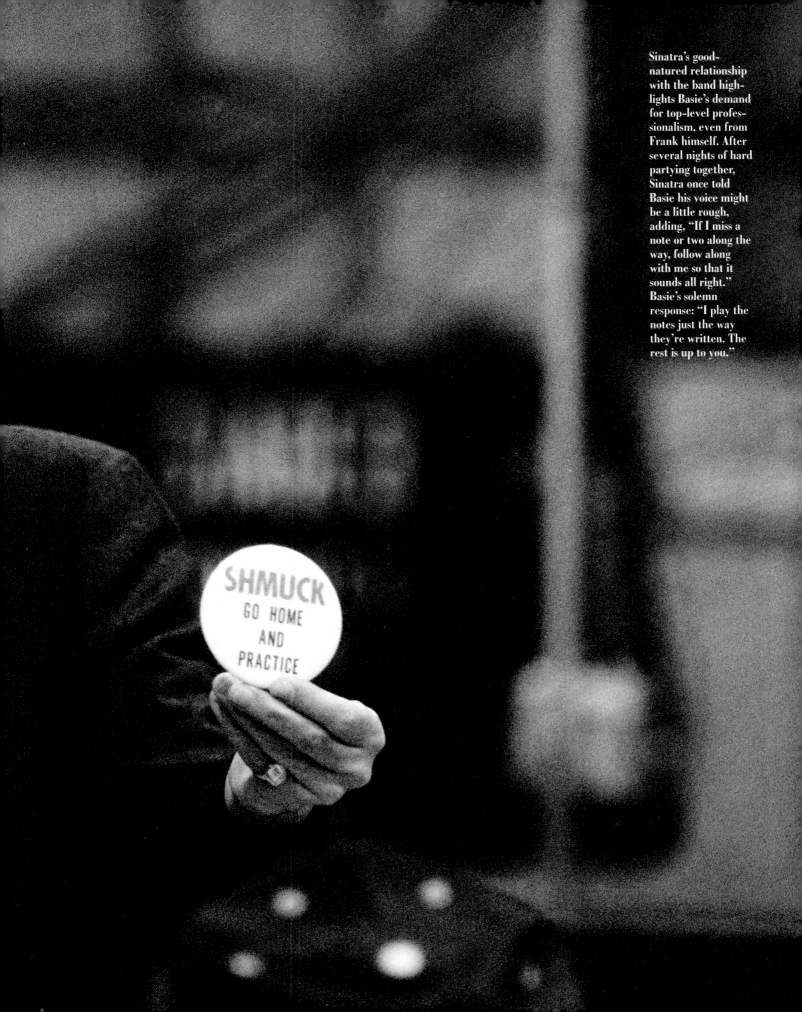

Sinatra's good-natured relationship with the band highlights Basie's demand for top-level professionalism, even from Frank himself. After several nights of hard partying together, Sinatra once told Basie his voice might be a little rough, adding, "If I miss a note or two along the way, follow along with me so that it sounds all right." Basie's solemn response: "I play the notes just the way they're written. The rest is up to you."

SHMUCK
GO HOME
AND
PRACTICE

TRY A LITTLE TENDERNESS

BESIDES THE PLATOONS OF GIRLFRIENDS (from household names to hatcheck girls) Frank Sinatra had four wives. The first was his hometown sweetheart, Nancy Barbato, and she gave him three treasured children. The second was Ava Gardner, the most tempting woman of her time, and she gave him heartburn (his one true love, friends say). The third was flower child Mia Farrow. She was 21, he was 50, and it was a classic generational mismatch. The last was Barbara Marx, former showgirl and comic Zeppo's ex, who gave him in his twilight years a Hollywood respectability he would have earlier scorned. To his male friends, Sinatra was something different – all testosterone and tension, an awesome, true and courageous man.

In his Miami hotel room, a nervous Sinatra watches his son emcee a TV musical. This is less than a year after Franklin Wayne (named for his dad's idol, FDR), then 20, was kidnapped from his Lake Tahoe hotel room in December 1963. Saying, "I'd give the world for my son," an anguished Sinatra paid $224,000 in ransom – most of which he got back after the three kidnappers were arrested. At their trial, defense attorneys claimed the abduction had been a p.r. stunt sponsored by the Sinatras themselves. (Frank responded: "This family needs publicity like it needs peritonitis.") The jury agreed, and the three were sentenced to long prison terms.

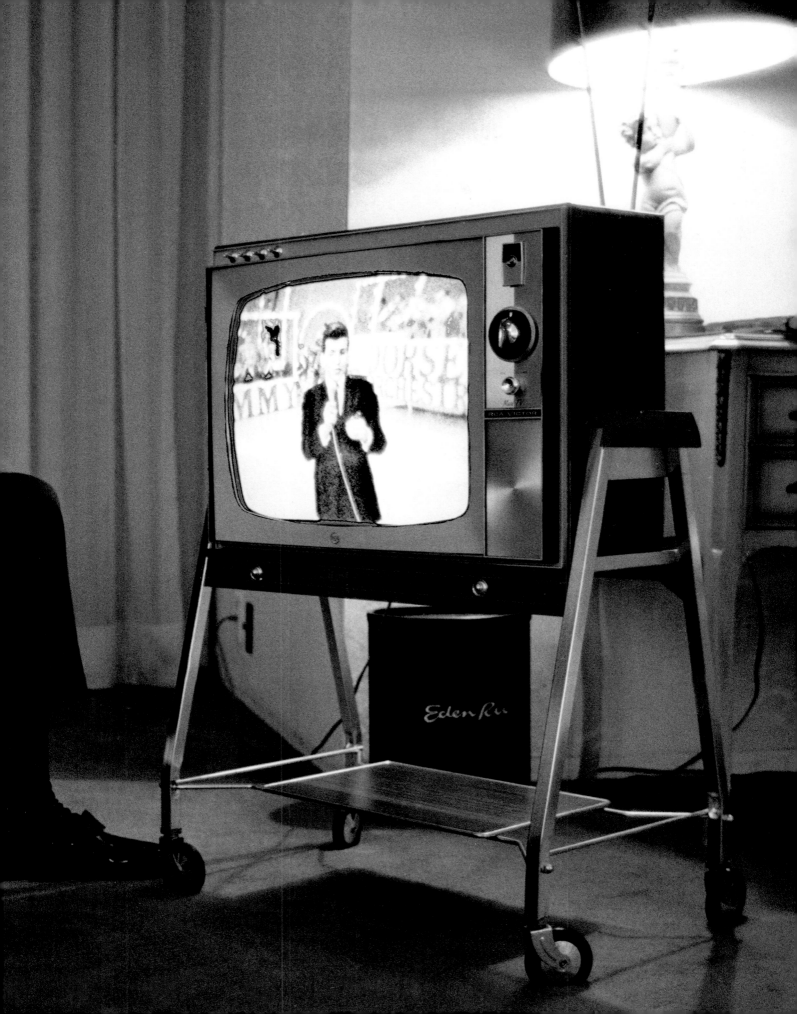

When Sinatra opened with Count Basie in Las Vegas in November 1964, he invited his three children to attend. Before the show, while bodyguard Ed Pucci stands by, Dad fastidiously arranges Frank Jr.'s pocket handkerchief (he wasn't really a junior, but the label stuck). The young man recovered from the kidnapping to become a creditable musician himself, occasionally singing duets with Senior and leading his band.

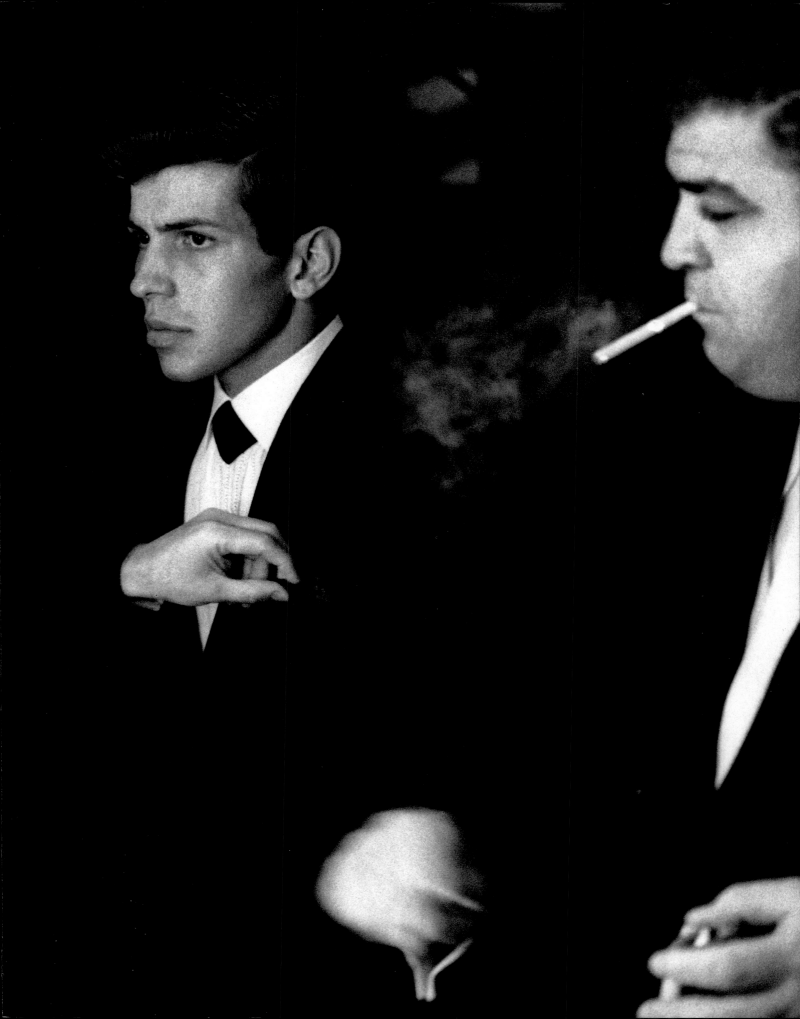

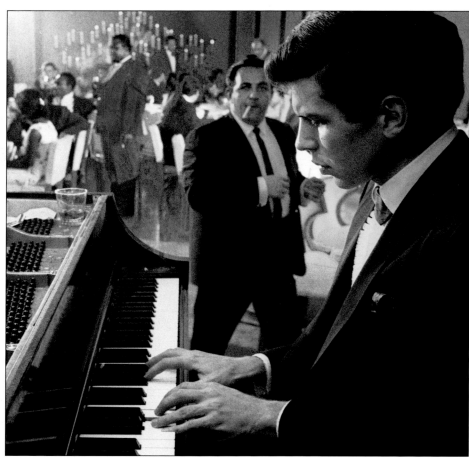

The youngest is Christina, 16. Sinatra is partial to his daughters; as a boy, Frank Jr. often felt neglected. Tina enjoyed her connections — her dad once called Soupy Sales, host of a popular children's TV series, and said, "I'm Frank Sinatra. My kid wants me to do your show." Later Tina dated Robert Wagner and Dino Martin Jr. Unlike her siblings, she avoided the music business, skipped college entirely (Nancy and Frank Jr. attended briefly) and went into television. In 1992, she produced a miniseries on her father's life. Sinatra was played by an Australian actor, but some of his songs were sung by Frank Jr.

At the Sands Hotel in Vegas, Frank Jr. muses at the keyboard. His professional life is that of an itinerant musician. He tours with a band, sings until two a.m., sleeps in hotels — and tries to live up to the inevitable comparisons. His father says: "In a funny kind of way, he's an old young man. He's got such a deep knowledge of music — history, harmonics, everything — that he makes me seem absolutely uneducated. I can't read music, and I never had any formal study. But the thing I do have is an ear. If a flute player in the back row hits a bad note, baby, I know it."

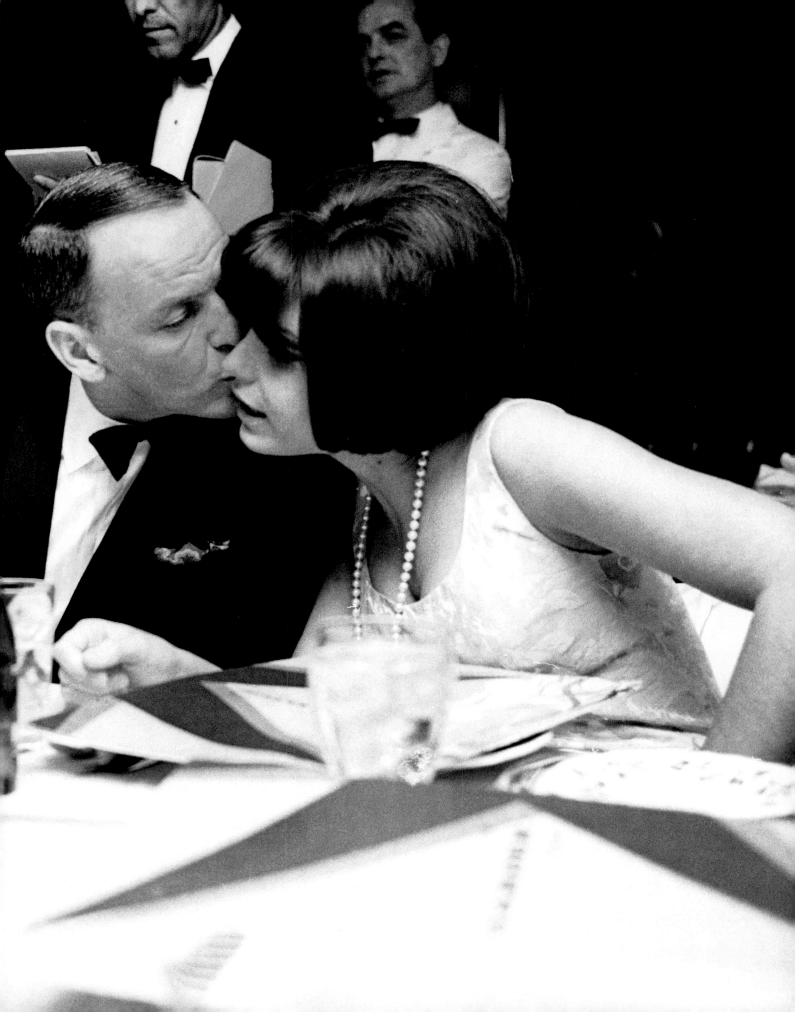

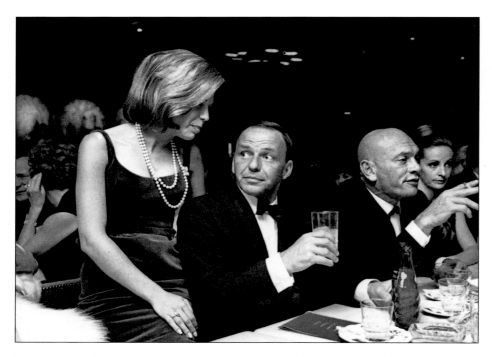

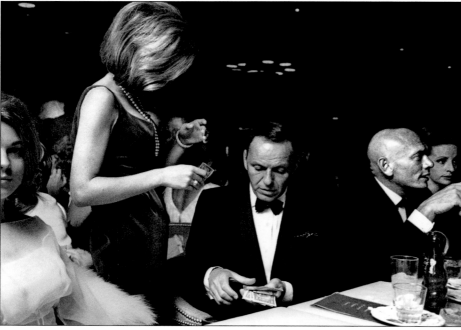

First child Nancy Sandra was known as Junior too (for her mother, Nancy Barbato, a plasterer's daughter from Jersey City and Sinatra's childhood sweetheart). Here Nancy, 24, a singer, interrupts Frank's after-show drink with Yul Brynner to relieve Daddy of a little gambling money. She got $50; he got a hug. Many friends think Nancy ("with the laughing face") is her father's favorite. For her 16th birthday, he gave her a mink coat; for her 17th, a pink Thunderbird. Her brother once described her as "the most normal" of the children. "Nancy was a cheerleader, went to summer camp, drove a Chevrolet." But because of her age, she was also hardest hit by her parents' divorce when she was ten.

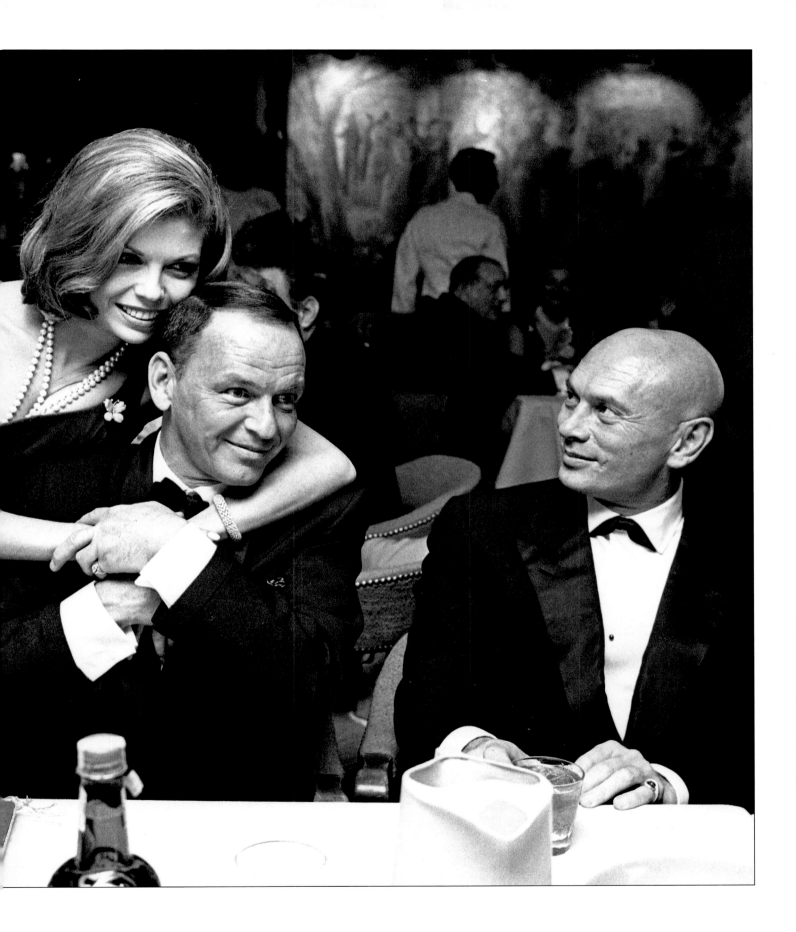

The family goes home after the Vegas opening. The only one missing is his former wife, Nancy; yet they stay on the best of terms. He credits her with raising the children "beautifully. She's given them their character, their poise, their ability to adjust. She's been wonderful." At right, Tina pecks Dad good-bye.

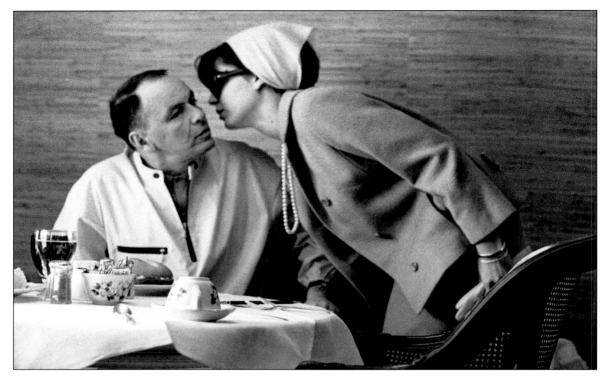

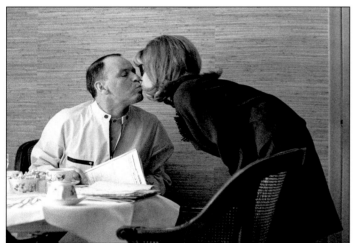

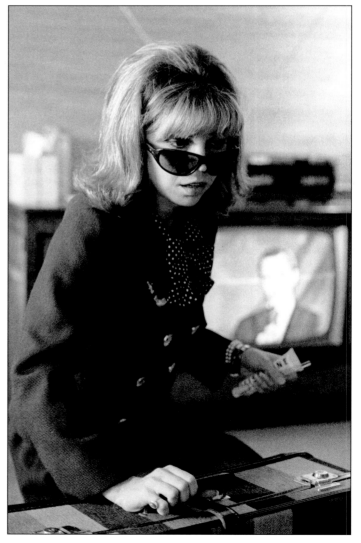

Frank is awarded another kiss from Nancy, who then heads back to L.A. His children have paid homage to Sinatra in their own ways: Nancy with two loving, sanitized biographies, in 1985 and 1995; Frank Jr. in music; and Tina with her TV series and a 2001 book, MY FATHER'S DAUGHTER, which created a fuss because of its bitter criticism of his last wife, Barbara.

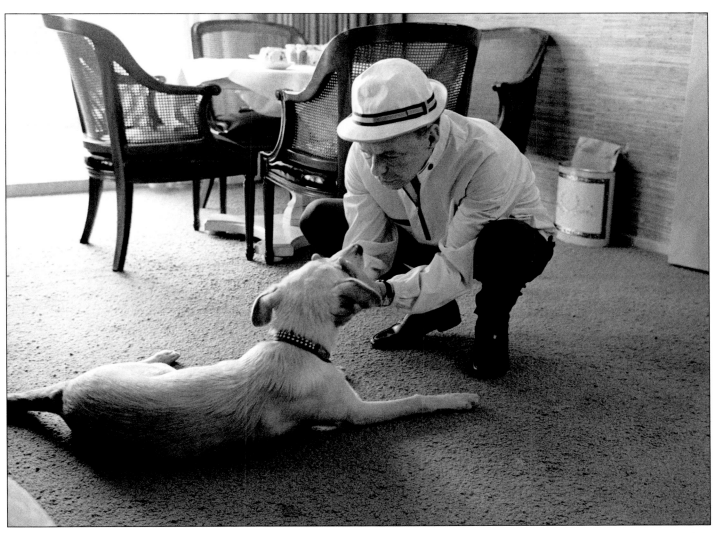

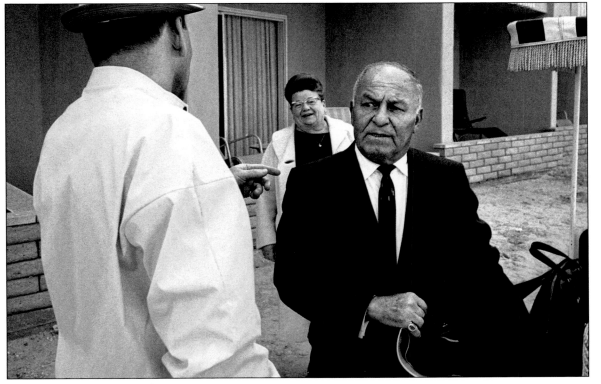

Sinatra arrives at his parents' Las Vegas apartment where they spend the winter, says hi to Ringo and prepares to take them to the airport for a return flight to New Jersey. His father, Martin, though a former firefighter and boxer (known as Marty O'Brien), is passive and quiet. His volatile mother, Natalie (nicknamed Dolly), a onetime Democratic political organizer, dominates the family. "I wanted a girl and bought a lot of pink clothes," she says. "When Frank was born, I didn't care. I dressed him in pink anyway."

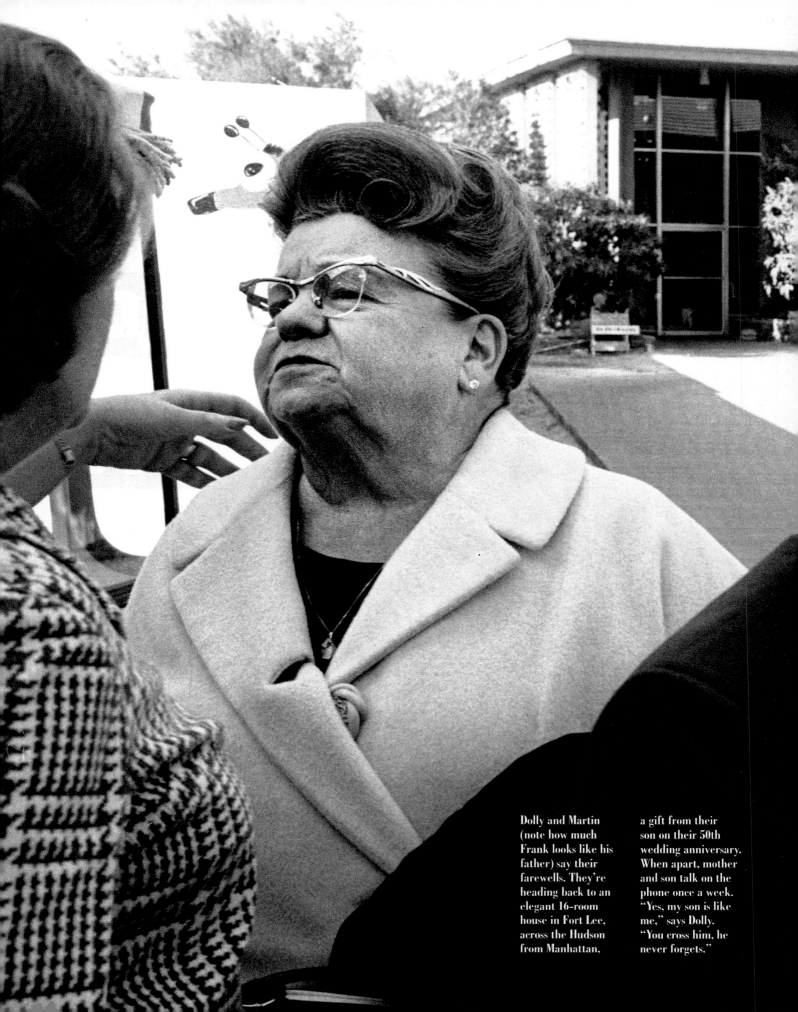

Dolly and Martin (note how much Frank looks like his father) say their farewells. They're heading back to an elegant 16-room house in Fort Lee, across the Hudson from Manhattan, a gift from their son on their 50th wedding anniversary. When apart, mother and son talk on the phone once a week. "Yes, my son is like me," says Dolly. "You cross him, he never forgets."

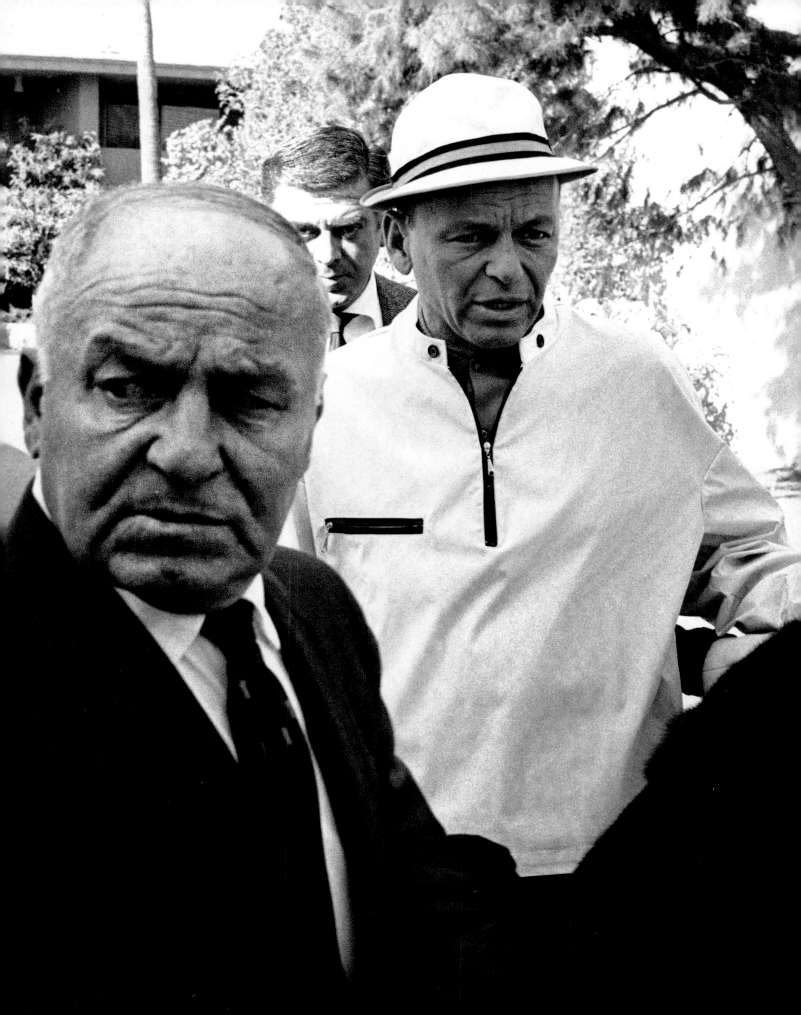

FOR THE GOOD TIMES

Frank Sinatra was blessed with a variety of unusual collaborations. The first was with his wartime fans, who swooned over this appealing surrogate for all the boys overseas. (Frank's eardrum was punctured during his birth and he was rejected by the army.) Then there were his close musical connections with great bands and talented arrangers. But perhaps Sinatra's most enduring relationship (excepting his kids) was not with people but a place – that wicked bauble in the desert, Las Vegas. There he was entertainer, casino owner, high roller, golf tournament sponsor, prodigious maker of money for himself and others. He used Vegas for his movies. He and the Rat Pack hung out in its gaudy hotels. And when he was in residence, he stayed in the Presidential Suite. Where else? In Vegas, Sinatra honed his philosophy: "You gotta love living, baby. Dying's a pain in the ass."

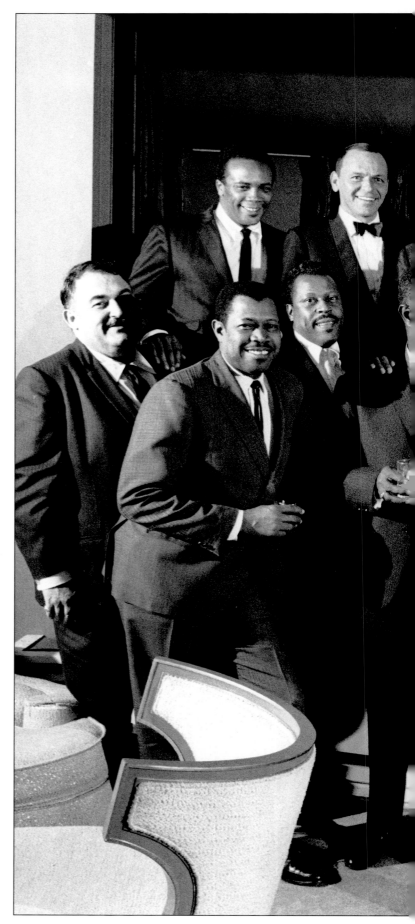

When Sinatra poses with Count Basie and his road band, the musical talent per square foot is breathtaking. In the back row, from left, are Quincy Jones, Sinatra and Basie. Other notables: The big man at extreme left is band manager Teddy Reig; next to him is trombonist Al Grey; then tenor sax player Eddie "Lockjaw" Davis; guitarist Freddie Green; next in front row is drummer Sonny Payne. At extreme right in the first row is trumpet virtuoso Harry "Sweets" Edison, who was with the original Basie band.

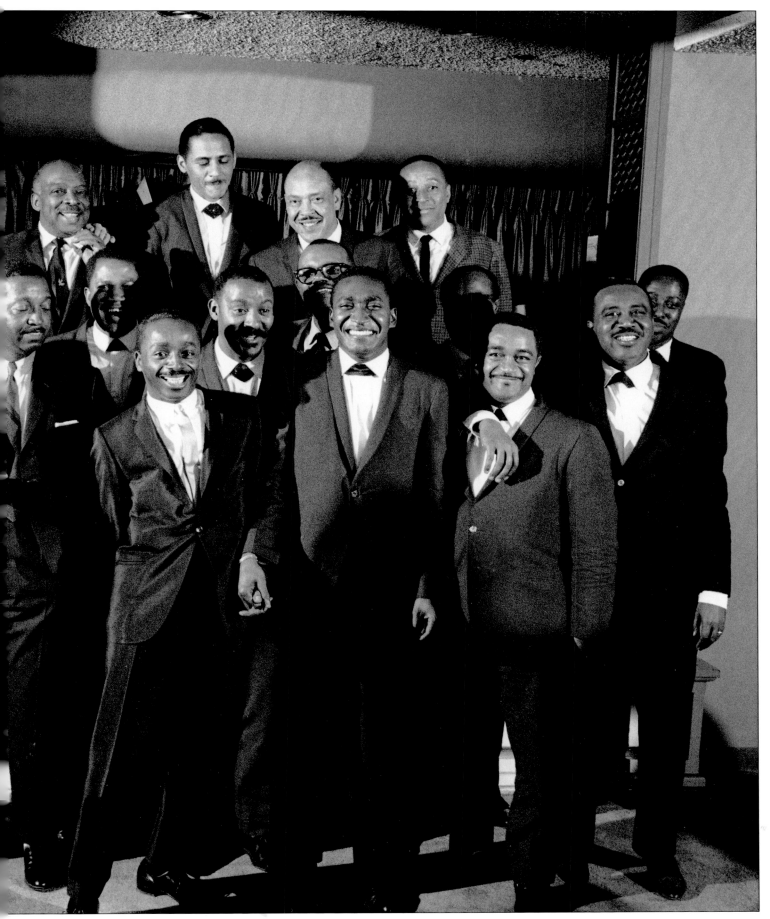

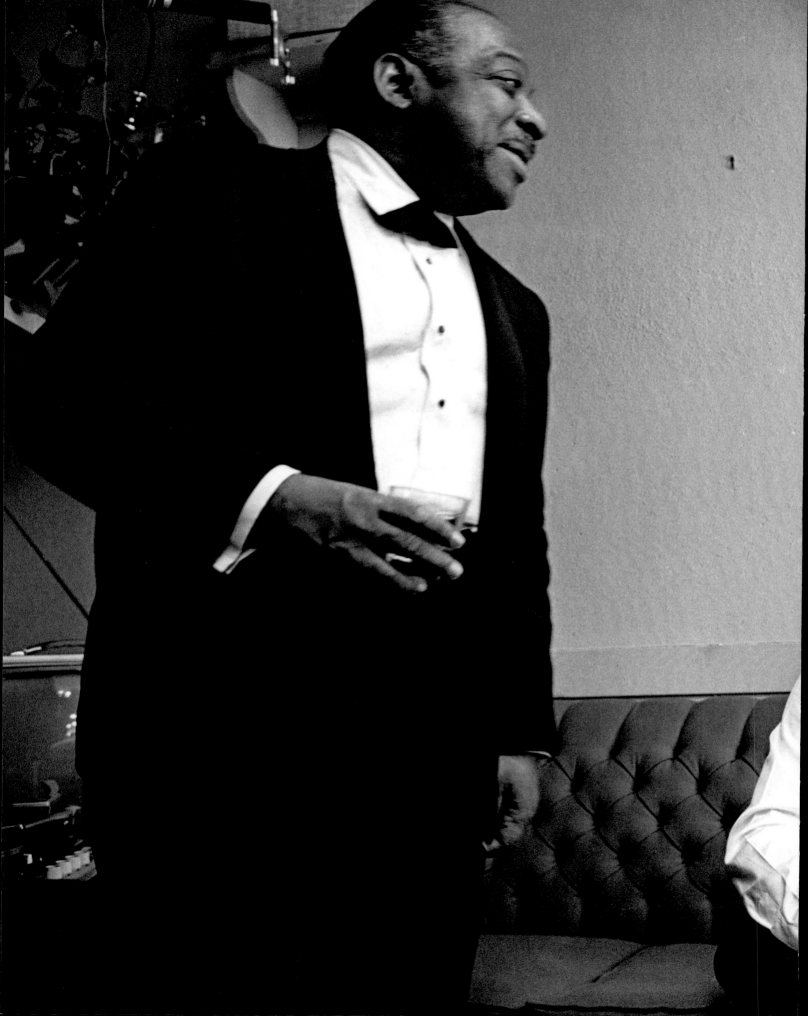

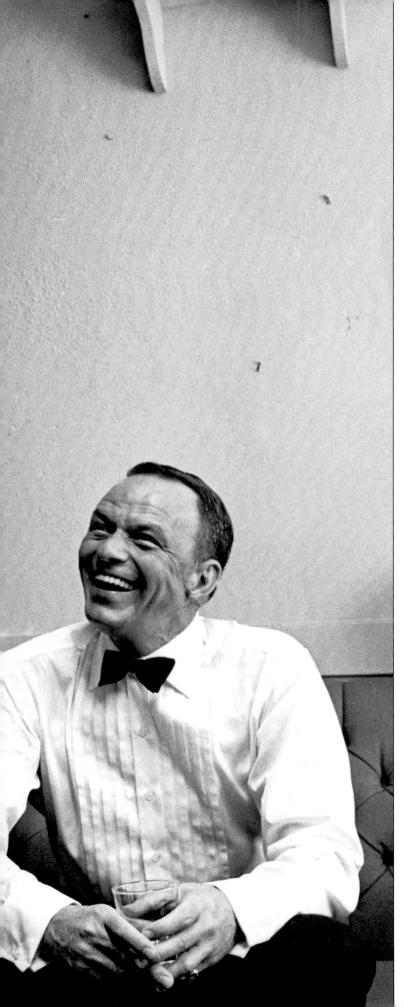

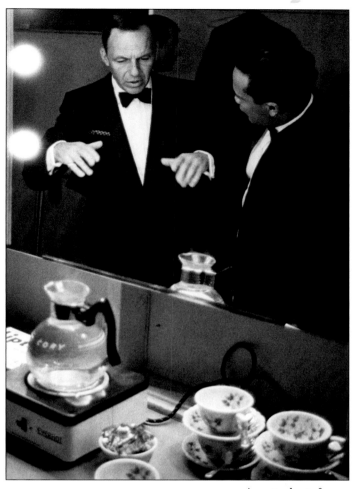

As water heats for the tea that soothes the Sinatra pipes preshow, Quincy Jones goes over last-minute details. The Sinatra-Jones relationship went on for years. When Frank set up his own record label, Reprise, in 1961, Quincy was an early collaborator. More than two decades later, they were still at it, with 1984's surprising L.A. IS MY LADY, where the band was mostly jazz players, including Lionel Hampton. A highlight was "Mack the Knife." When Frank finished recording it, he was so pleased that he triumphantly flung the music into the air.

Frank's friendship with and respect for Count Basie is unshakable. The singer deplores racism and will not allow the n-word to be used in his presence. But, typical of Sinatra's many contradictions, he has been known to tell racist jokes during his nightclub performances. Pointing to Basie's band, he once cracked: "I'd publicly like to thank the NAACP for this chess set they gave me."

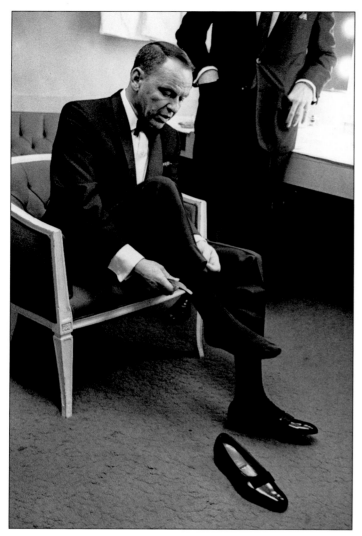
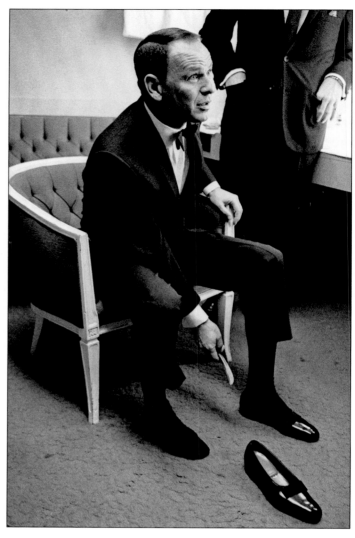

Suited up, minutes before the Sands show, Sinatra slips on the patent leather loafers he calls his "Mary Janes." He has always been careful — and astute — about his wardrobe. In his early years, he wore pleated trousers to make his skinny body look heftier and bow ties to feature his big smile and youthful face. More recently, he favors dark blue, black or charcoal gray suits. He despises brown, and Dean Martin often wears it just to bug him.

In his work clothes, the tux, he always shows a precise amount of shirt cuff and handsome, understated cuff links. "He has jillions of them," an expert on Sinatra style once said, most bought from a Florida jeweler. The rest of the outfit is just so: white linen handkerchief, mints in the inside jacket pocket, folded tissues in the outer left pocket, one key (which opens all his homes), a money clip heavy with new bills, no wallet and no credit cards.

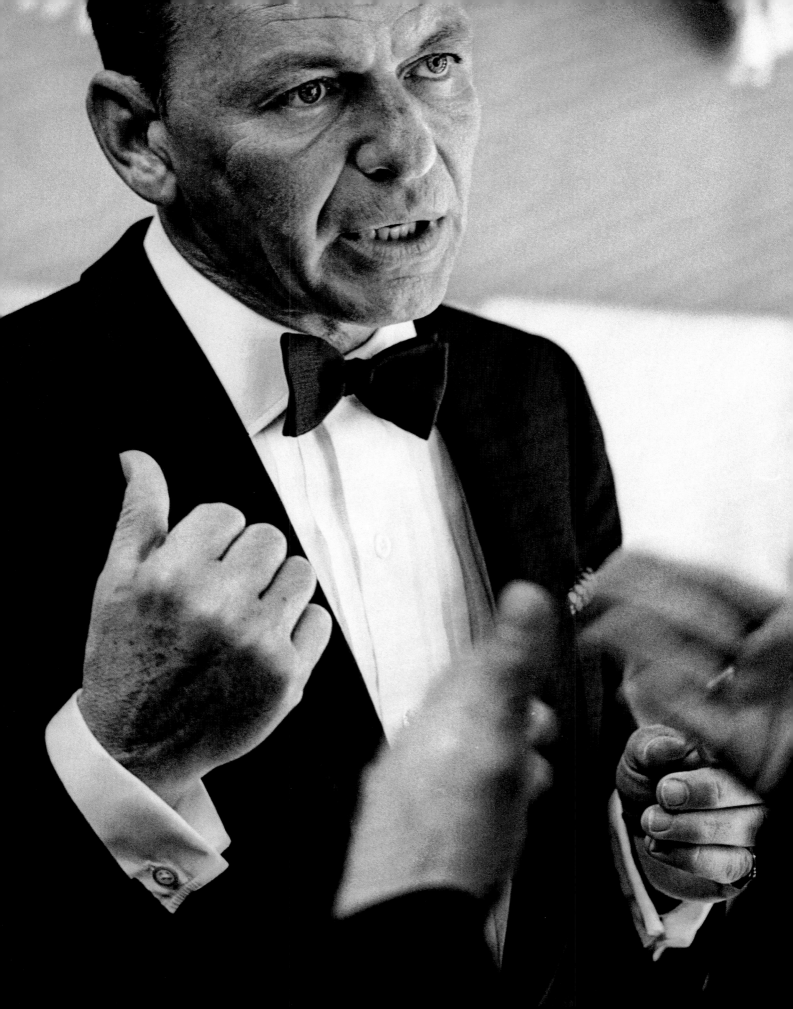

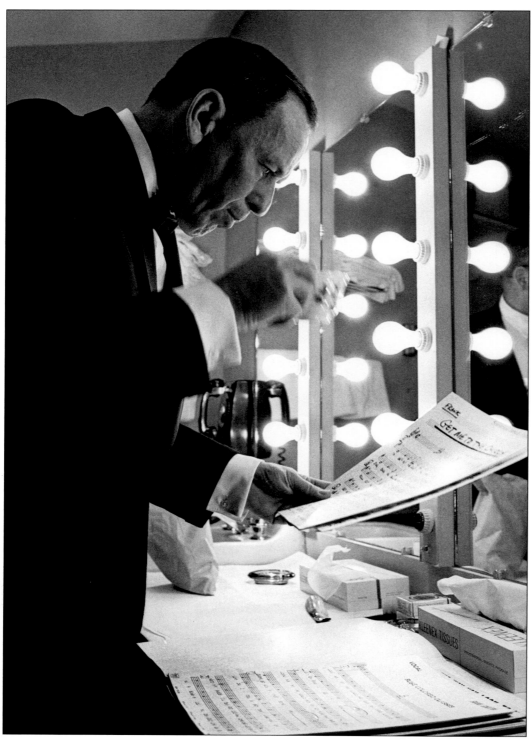

In his dressing room, Sinatra goes over one of his showstoppers, "Get Me to the Church on Time" from the Broadway musical MY FAIR LADY.

The song wound up on the 1966 landmark Sinatra-Basie album, SINATRA AT THE SANDS, the first live performance he ever released.

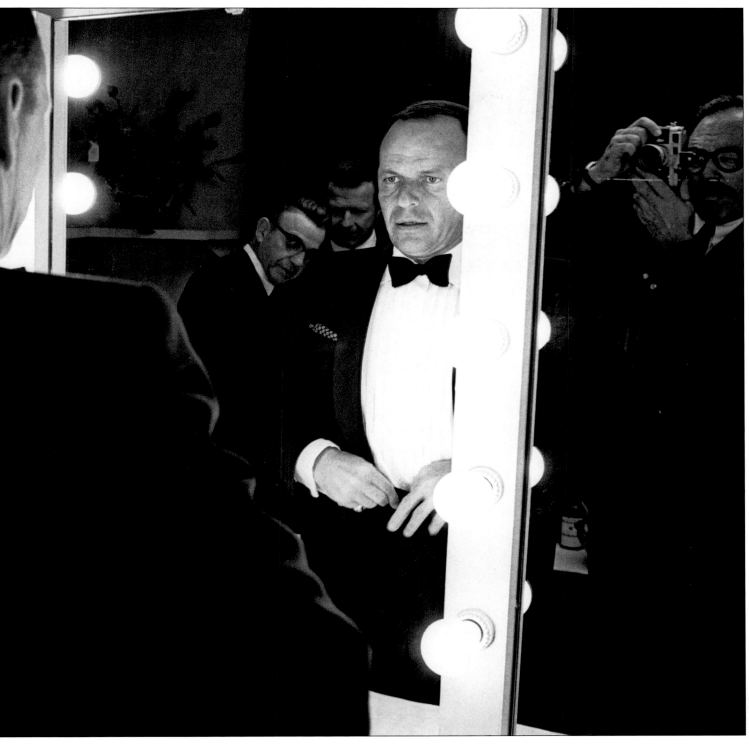

Tuck in the gut, make a final sartorial check, then it's show time. Sinatra's experience in nightclubs goes back to New Jersey roadhouses in the late 1930s. He first played Vegas in 1951 at the Desert Inn. For 15 years, he was a regular at the Sands, and was married to Mia Farrow there. But in September 1967, he angrily quit the club when his credit in the casino was cut off (after he had lost a reported $50,000). A few days later, he signed with rival Caesars Palace for $100,000 a week, the highest salary then paid in Vegas.

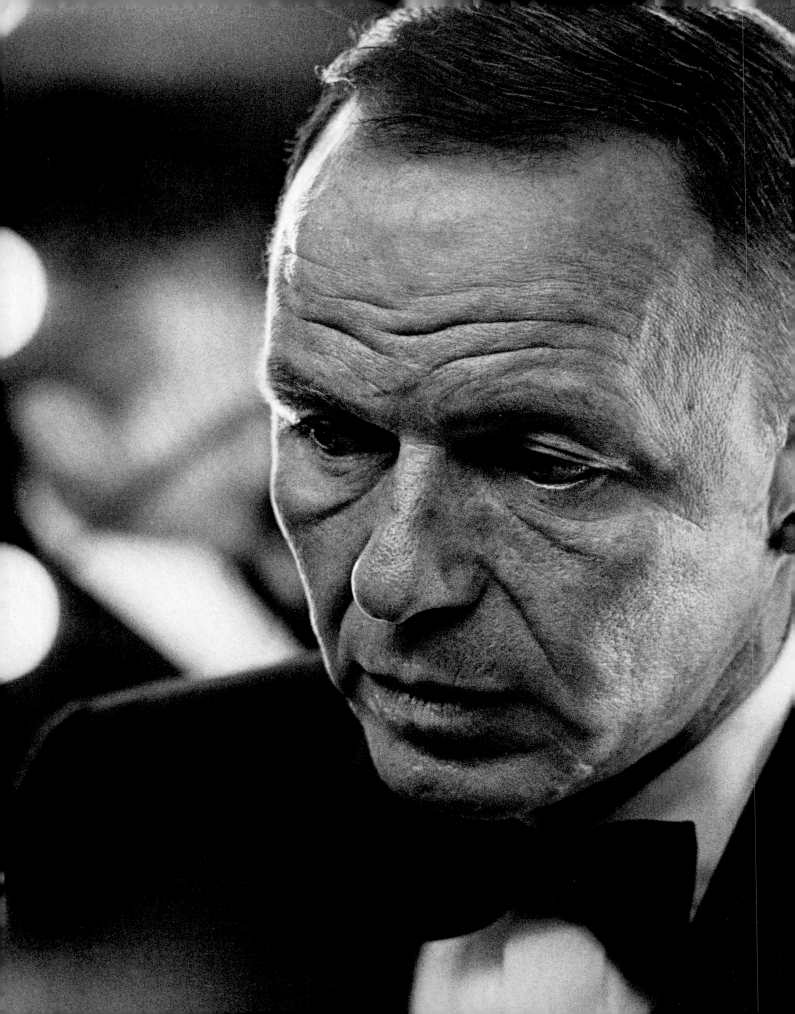

One of the things Sinatra worries about is going blank during a song, trying to remember a lyric. "I sometimes get sick before an engagement," he says, "worrying I'll forget words." He still recalls his embarrassment when famous composer Cole Porter visited the club where he was singing in the late '30s. In his honor, Frank tried to sing a Porter favorite, "Night and Day." By his own account, the singer "then proceeded to forget all the god-damn words, swear to God... I just kept saying, 'Night and day, night and day,' for fifteen bars."

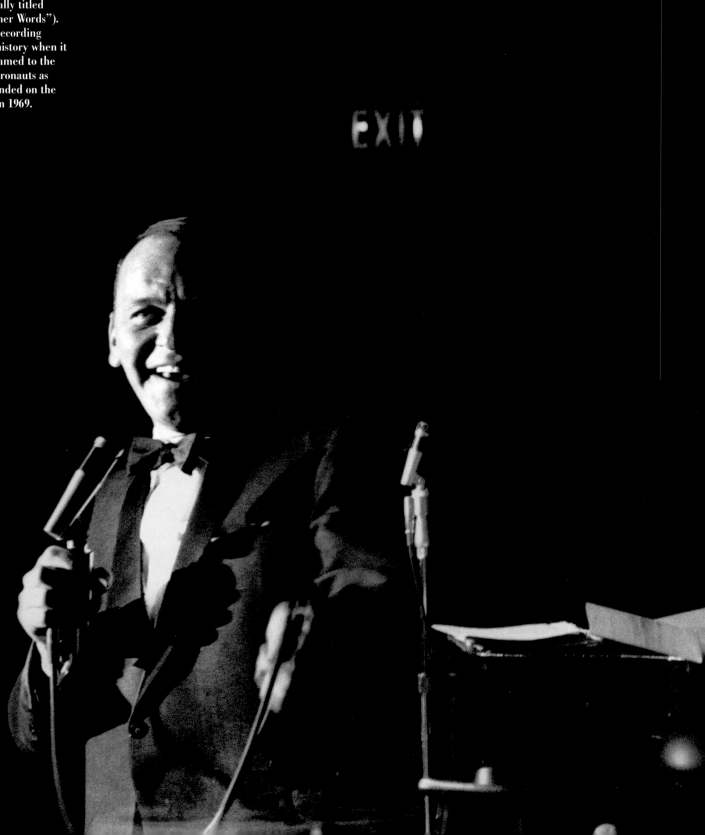

In this double exposure, Sinatra is seen with Basie at the piano and members of the brass and wind sections. One of the Basie-Sinatra nightclub standards is "Fly Me to the Moon" (originally titled "In Other Words"). Their recording made history when it was beamed to the U.S. astronauts as they landed on the moon in 1969.

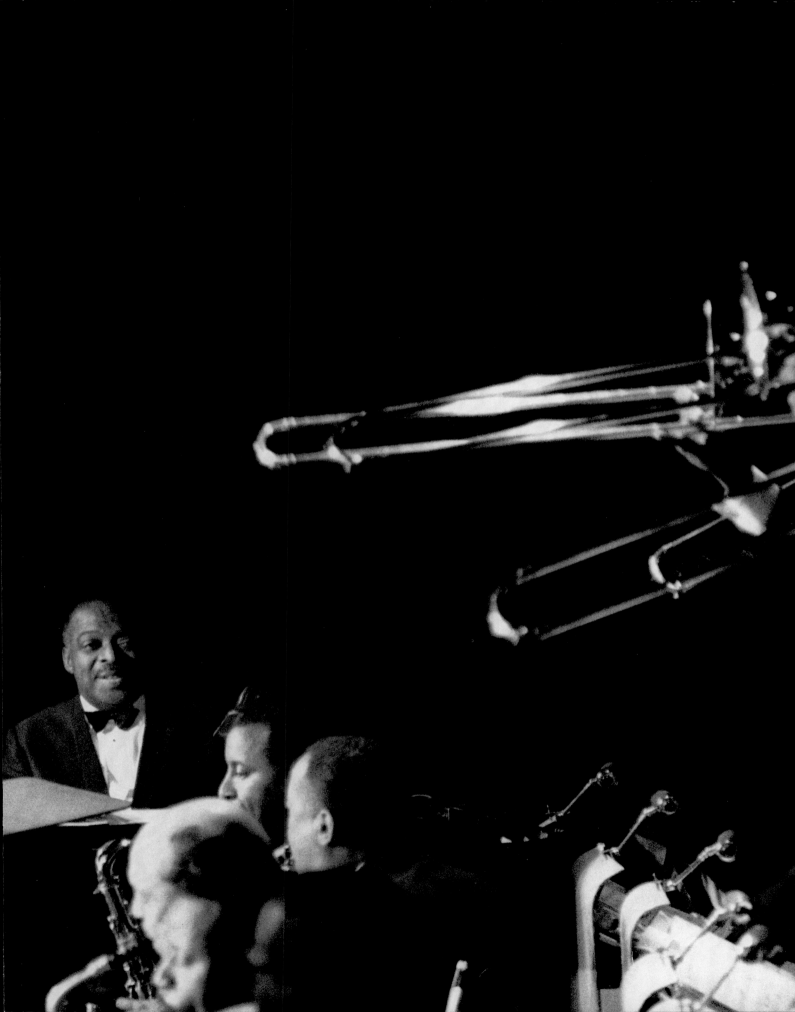

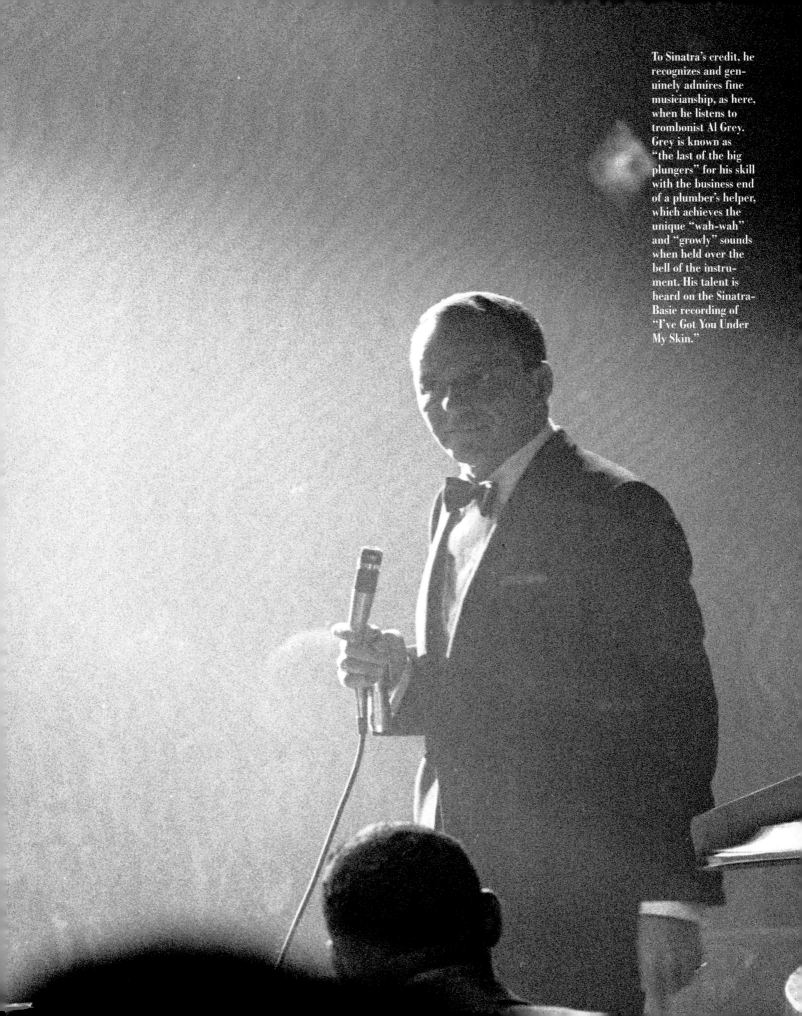

To Sinatra's credit, he recognizes and genuinely admires fine musicianship, as here, when he listens to trombonist Al Grey. Grey is known as "the last of the big plungers" for his skill with the business end of a plumber's helper, which achieves the unique "wah-wah" and "growly" sounds when held over the bell of the instrument. His talent is heard on the Sinatra-Basie recording of "I've Got You Under My Skin."

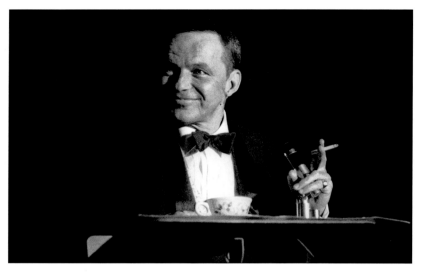

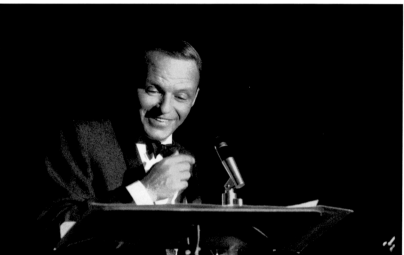

Halfway through the set, the band takes a break, and Sinatra sits down, has some tea and delivers a humorous monologue. Sample: "Marlon Brando was offered the part of God in a movie, but he wanted something bigger...." Critics don't always find it funny. Sinatra also uses his nightclub act to settle scores with journalists. After New York columnist Dorothy Kilgallen wrote about his love affairs in the mid-'50s, he often referred to her onstage as "the chinless wonder." Once, noting that she wasn't in the audience, he cracked, "I guess she's out shopping for a new chin." When Kilgallen died in 1965, he said, "Well, guess I got to change my whole act now."

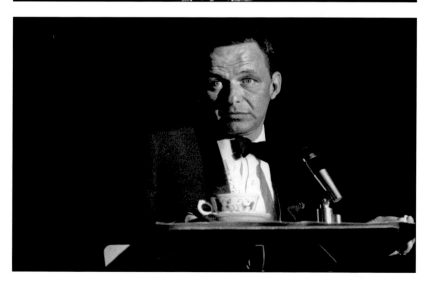

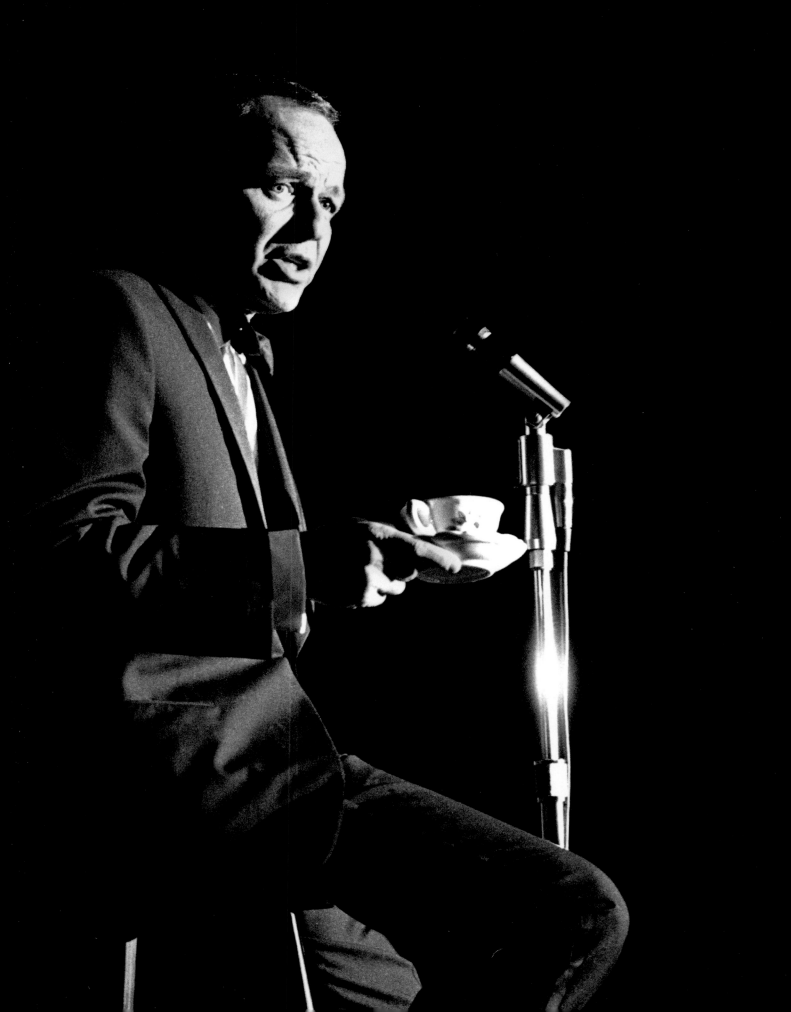

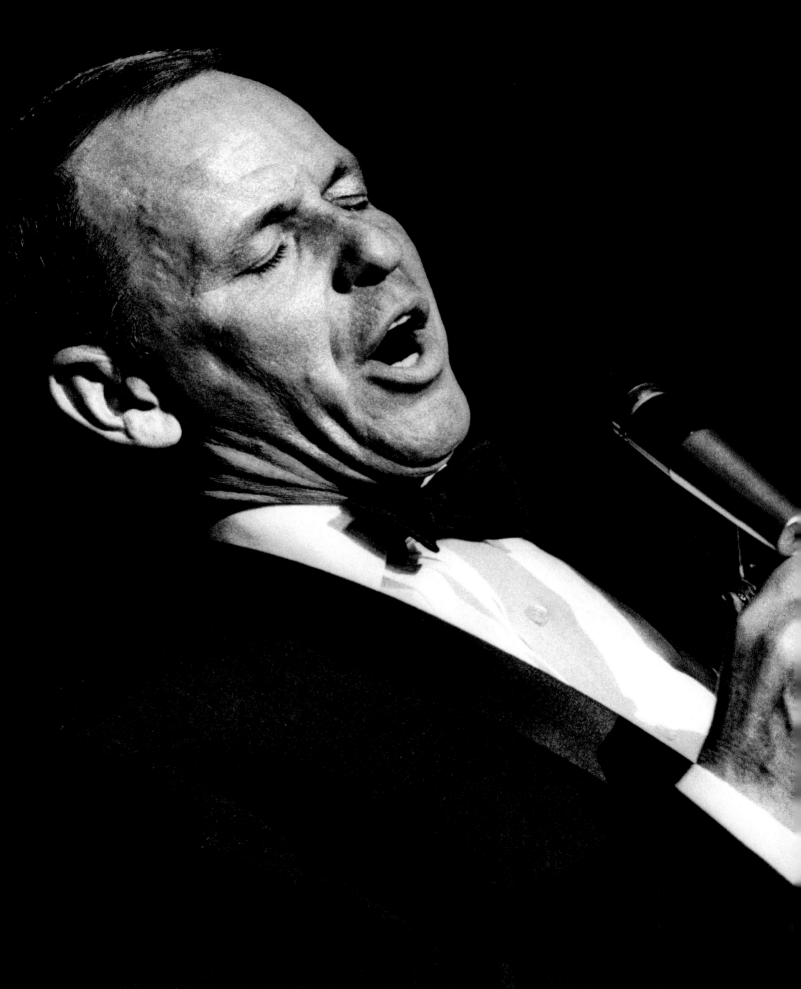

One unique characteristic in a Sinatra song is his breathing control, the ability to cover a six- or eight-bar line in a single breath — a technique he says he learned from Tommy Dorsey. This skill, Frank says, gives "the melody a flowing, unbroken quality, and that — if anything — was what made me sound different. It wasn't my voice alone. In fact, my voice was always a little high, I thought, and not as good in natural quality as some of the competition."

Using the microphone is a Sinatra art, one that he thinks other singers never learn. "A microphone is their instrument," he says. "Instead of playing a saxophone, they're playing a microphone." Frank prefers a black mike to blend into his dinner jacket, moves around with it but subtly, never lets an audience hear a popping "p" or intake of breath. "I guess a bad parallel would be that it's like a geisha girl uses her fan."

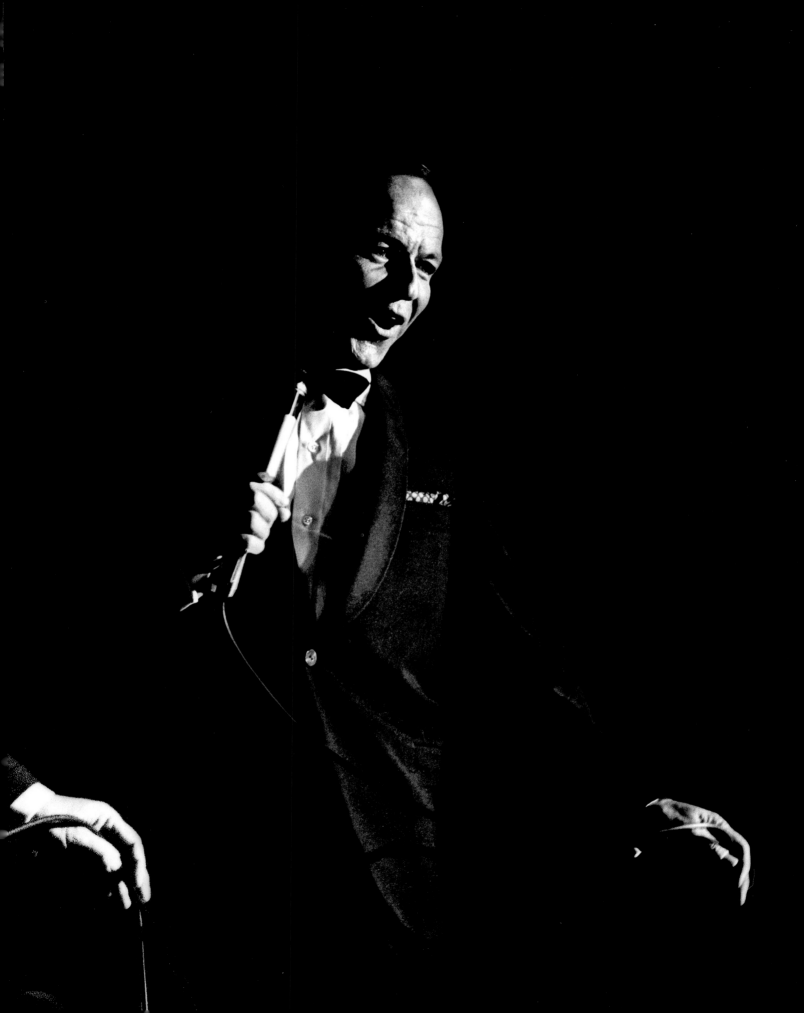

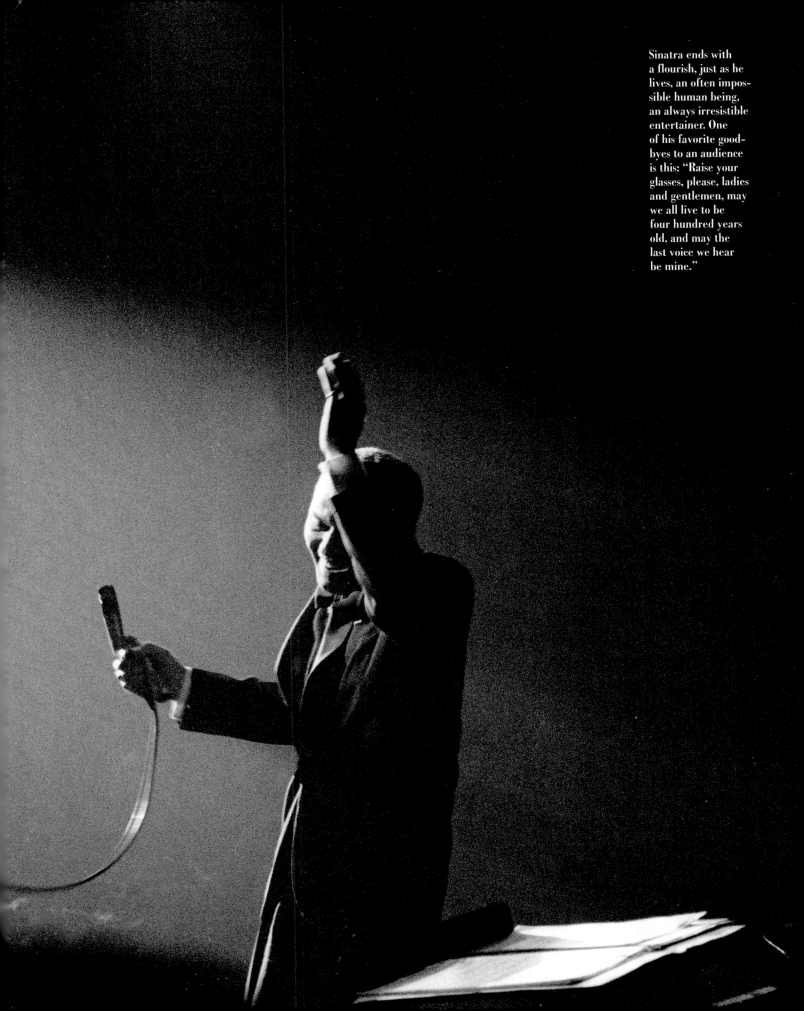

Sinatra ends with
a flourish, just as he
lives, an often impos-
sible human being,
an always irresistible
entertainer. One
of his favorite good-
byes to an audience
is this: "Raise your
glasses, please, ladies
and gentlemen, may
we all live to be
four hundred years
old, and may the
last voice we hear
be mine."

ACKNOWLEDGMENTS

THE CONTRIBUTIONS OF TWO LONGTIME friends and colleagues were essential in our efforts: Anne Hollister for research and Paula Glatzer for copyediting. I also want to thank Ira Gitler, author of THE BIOGRAPHICAL ENCYCLOPEDIA OF JAZZ (Oxford University Press, 1999), for sharing his immense musical knowledge, and to cite those sources, both magazines and books, that were especially helpful: LIFE (April 23, 1965), LOOK (December 14, 1965; October 31, 1967); PEOPLE Tribute (May-June 1988); ENTERTAINMENT WEEKLY Special Collector's Issue (Summer 1998); REMEMBERING SINATRA by Robert Sullivan and the Editors of LIFE (Time Inc. Home Entertainment, 1998); LIFE PHOTOGRAPHERS: WHAT THEY SAW by John Loengard (Bulfinch Press, 1998); SINATRA! THE SONG IS YOU by Will Friedwald (Da Capo Press, Inc., 1995); HIS WAY: THE UNAUTHORIZED BIOGRAPHY OF FRANK SINATRA by Kitty Kelley (Bantam Books, 1986); THE FRANK SINATRA READER, edited by Steven Petkov & Leonard Mustazza (Oxford University Press, 1995).

Richard B. Stolley, New York City

BOOKS CAN START IN ODD WAYS. ROLLER blading around Central Park some ten years ago, I ran into – but not over – John Dominis. Knowing John was an avid skier, I demonstrated how the movements in the two sports were similar. John remained skeptical, pointing out that snow is softer for falling. We started talking shop. I had recently seen a few of his Sinatra photos, which vividly brought to mind his famous LIFE story – a classic of celebrity photojournalism. It should be published as a book, I told him. John was pleased with my enthusiasm but thought it a long shot.

In early discussions with LIFE, John was asked to find out if Sinatra had any objections to the book. Word came back from a press aide that Frank very much admired John's photographs, thought the book a good idea and wished him luck.

A complex picture book is the work of many hands and heads. Not only had John Dominis succeeded in insinuating himself into the intimate space of a very press-aversive artist, and candidly and dramatically revealed his persona, but he went on to tackle crucial aspects of the book. He pored over and made selections from almost 4,000 photographs on contact sheets, reviewed layouts, racked his memory for details and scrutinized text for accuracy. All along the way, Anne Hollister was unstinting with her generosity. She shared her interviews, located photos, prodded John's memory and was never less than cheerful and enthusiastic.

Dick Stolley, a journalist's journalist, graces these pages, weaving his word wizardry and his consummate skills at wrangling pictures and text, enlarging and deepening John's picture portrait.

Will Hopkins and Mary K. Baumann directed a bewildering array of pictures into a series of jazzy, harmonious riffs.

At the monthly LIFE, Isolde Motley gave the project her blessing and Bobbi Baker generously extended her support and encouragement through the project's long gestation. As always, Kathi Doak in Time Life's Picture Collection was extremely cooperative, and Penny Hays responded promptly and gracefully to our too numerous requests and helped us find our way through the labyrinth of the archive.

Rebecca Karamehmedovic at TimePix was patient, resourceful and calm under stressful circumstances. Adam Sall superbly demonstrated his expertise in the arcane art of scanning.

In the process of producing the book, Mary Beth Brewer, with her usual professional aplomb, oversaw the initial presentation. Mary Dempsey was supportive and ingeniously resolved numerous perplexities. Media maven Judy Twersky kept us up to date on Sinatra's continuing popularity. Photographer Christopher Cataldo lent his sophisticated eye to improving the quality of the reproduction.

My pal, the great LIFE photographer John Loengard, cheered us on and gave both John and me sage advice and many useful suggestions.

Constance Herndon, ardent champion of picture books, overcame her initial skepticism as soon as she saw the photo layouts. We are in her debt for her unwavering support all through the roller coaster ride to publication.

Bob Adelman, Miami Beach